Photography

Over the past 25 years, photography has moved to centre stage in the study of visual culture and has established itself in numerous disciplines. This trend has brought with it a diversification in approaches to the study of the photographic image.

Photography: Theoretical Snapshots offers exciting perspectives on photography theory today from some of the world's leading critics and theorists. It introduces new means of looking at photographs, with topics including:

- a community-based understanding of Spencer Tunick's controversial installations
- the tactile and auditory dimensions of photographic viewing
- snapshot photography
- and the use of photography in human rights discourse.

Photography: Theoretical Snapshots also addresses the question of photography history, revisiting the work of some of the most influential theorists such as Roland Barthes, Walter Benjamin, and the *October* group, re-evaluating the neglected genre of the carte-de-visite photograph, and addressing photography's wider role within the ideologies of modernity. The collection opens with an introduction by the editors, analysing the trajectory of photography studies and theory over the past three decades and the ways in which the discipline has been constituted.

Ranging from the most personal to the most dehumanized uses of photography, from the nineteenth century to the present day, from Latin America to Northern Europe, *Photography: Theoretical Snapshots* will be of value to all those interested in photography, visual culture and cultural history.

J. J. Long is Professor of German at Durham University. He is the author of *The Novels of Thomas Bernhard* and of *W. G. Sebald: Image, Archive, Modernity* and has published widely on German literature and photography. He was awarded a Philip Leverhulme Prize in 2005.

Andrea Noble is Professor of Latin American Studies at Durham University, author of *Mexican National Cinema* and co-editor of *Phototextualities: Intersections of Photography and Narrative*.

Edward Welch is Senior Lecturer in French at Durham University, and author of *François Mauriac: The Making of an Intellectual*. His research interests include post-war French visual culture and documentary photography and he is a regular contributor to *Source* photography journal.

Photography

Theoretical snapshots

Edited by J. J. Long,
Andrea Noble
and Edward Welch

Routledge
Taylor & Francis Group

LONDON AND NEW YORK

First published 2009
by Routledge
2 Park Square, Milton Park, Abingdon, Oxon OX14 4RN

Simultaneously published in the USA and Canada
by Routledge
270 Madison Ave, New York, NY 10016

Routledge is an imprint of the Taylor & Francis Group, an informa business

Editorial selection and material © 2009 J. J. Long, Andrea Noble
and Edward Welch.

Individual chapters © 2009 the contributors

Typeset in Bembo by
Bookcraft Ltd, Stroud, Gloucestershire

Printed and bound in Great Britain by
TJ International, Padstow, Cornwall

British Library Cataloguing in Publication Data
A catalogue record for this book is available from the British Library

Library of Congress Cataloging in Publication Data
Photography : theoretical snapshots / edited by J.J. Long, Andrea Noble,
and Edward Welch. — 1st ed.
 p. cm.
 Includes bibliographical references and index.
 1. Photography—Philosophy. 2. Images, Photographic. I.
 Long, J. J. (Jonathan James), 1969– II. Noble, Andrea. III.
 Welch, Edward, 1973–
TR183.P4985 2008
770.1–dc22 2008028835

ISBN10: 0-415-47706-9 (hbk)
ISBN10: 0-415-47707-7 (pbk)

ISBN13: 978-0-415-47706-2 (hbk)
ISBN13: 978-0-415-47707-9 (pbk)

Contents

Figures

Contributors

Geoffrey Batchen is a Professor in Art History at The Graduate Center of the City University of New York. His most recent books include *Forget Me Not: Photography and Remembrance* (Princeton Architectural Press, 2004) and *William Henry Fox Talbot* (Phaidon, 2008). He is currently editing an anthology of essays about *Camera Lucida* titled *Photography Degree Zero* (to be published in 2009 by The MIT Press).

Kelly Dennis teaches modern and contemporary art and photography at the University of Connecticut, Storrs. Her work on photography, pornography and performance art have been published in *Art Journal*, *History of Photography*, *Analecta Husserliana* and *Strategies*, as well as in numerous anthologies. Her books include *Art/Porn: A History of Seeing and Touching* (Berg Publishers, 2009) and an edited volume, *Defining the Digital Canon*.

Elizabeth Edwards is Professor and Senior Research Fellow at the University of the Arts London. Originally trained as an historian, she has written extensively about the relationship between photography and history, especially in cross-cultural contexts. She edited *Anthropology and Photography 1865-1920* (Yale, 1992); her most recent books are *Raw Histories: Photographs Anthropology and Museums* (Berg, 2001), an edited volume *Photographs Objects Histories: On the Materiality of Images* (Routledge, 2004, with Janice Hart), and a further volume on material culture and the senses, *Sensible Objects* (Berg, 2005, with Chris Gosden and Ruth Philips). She is currently working on a book on the relationship between photography, collective memory and Englishness between 1890 and 1914.

Louis Kaplan is Associate Professor of History and Theory of Photography and New Media in the Graduate Department of Art at the University of Toronto and Director of the Institute of Communication and Culture at the University of Toronto Mississauga. He has published widely in the fields of photography studies, art history, pop and media culture, and Jewish studies. His books include *Laszlo Moholy-Nagy: Biographical Writings* (Duke

University Press, 1995) and *American Exposures: Photography and Community in the Twentieth Century* (University of Minnesota Press, 2005). The latter thinks about the relationship of photography and community through the lens of the French philosopher Jean-Luc Nancy. Kaplan's new book on the birth of spirit photography examines *The Strange Case of William Mumler, Spirit Photographer* (University of Minnesota Press, 2008). His current research involves the counter-cultural artist Wallace Berman at the inter-sections of film and photography, and of Kabbalah and Surrealism.

J. J. Long is Professor of German at the University of Durham. He is author of *The Novels of Thomas Bernhard: Form and its Function* (Camden House, 2001) and *W. G. Sebald: Image, Archive, Modernity* (Edinburgh University Press and Columbia University Press, 2007). He has co-edited two further volumes on W. G. Sebald and has published widely on German literature and contemporary photography.

Andrea Noble is Professor of Latin American Studies at the University of Durham. She is author of *Tina Modotti: Image, Texture, Photography* (University of New Mexico Press); *Mexican National Cinema* (Routledge); and co-editor of *Phototextualities: Intersections of Photography and Narrative* (University of New Mexico Press). She is currently completing a book on photographic icons of the Mexican Revolution.

Donald Preziosi was trained in Art History, Linguistics, and Classical Archaeology at Harvard University and has taught at several American universities, including Yale, M.I.T. and the University of California, Los Angeles. In 2000–1 he was Slade Professor of Fine Art at Oxford, and his Slade Lectures were published under the title *Brain of the Earth's Body: Art, Museums, and the Phantasms of Modernity* (University of Minnesota Press, 2003). He has published widely on the historiography of the disci-pline of art history: *Rethinking Art History: Meditations on a Coy Science* (Yale University Press, 1989), *The Art of Art History* (Oxford University Press, 1998), *Subjects, Objects, and Object-Lessons* (Routledge, forthcoming); on museology, *Grasping the World*: *The Idea of the Museum*, jointly with Claire Farago (Ashgate, 2004); and on ancient art: *Aegean Art & Architecture* (Oxford University Press, 1999). In addition to the subjects represented by these books, his research, writing and teaching is focused upon the interwoven histories of aesthetics, ethics, and the politics of modern state formation.

Shawn Michelle Smith is Associate Professor of Visual and Critical Studies at the School of the Art Institute of Chicago. Her books include *Photography on the Color Line: W. E. B. Du Bois, Race, and Visual Culture* (Duke University Press, 2004), *American Archives: Gender, Race, and Class in Visual Culture*

(Princeton University Press, 1999), and most recently *Lynching Photographs* (University of California Press, 2007), co-authored with Dora Apel. She is also a visual artist and has exhibited her photo-based artwork in a number of venues in the United States.

John Tagg is Professor of Art History and Comparative Literature at Binghamton University, New York. He has published widely on photography and contemporary critical theory. His publications include *Grounds of Dispute: Art History, Cultural Politics, and the Discursive Field* (University of Minnesota Press, 1992) and *The Burden of Representation: Essays on Photographies and Histories* (Macmillan, 1988), as well as many essays, chapters and other contributions on photography. His forthcoming book, *The Disciplinary Frame: Photographic Truths and the Capture of Meaning* (University of Minnesota Press), focuses on the discursive and institutional relations of power. that frame photographic meaning and capture the viewer.

Edward Welch is senior lecturer in French at the University of Durham. He is author of *Francis Mauriac: The Making of an Intellectual* (Rodopi, 2006) and has published widely on aspects of contemporary French culture.

Catherine Zuromskis is Assistant Professor of Art and Art History at the University of New Mexico. She received her doctorate from the Program in Visual and Cultural Studies at the University of Rochester. Her writing on American photography and visual culture has appeared in *Art Journal, American Quarterly, and The Velvet Light Trap* and she is currently completing a book manuscript titled Intimate Exposures: *The Social Life of Snapshot Photography.*

Acknowledgements

Many of the chapters in this volume began life as contributions to an international conference entitled 'Re-Thinking Photography', held at Durham University in 2005. The conference was financially supported by the British Academy and the School of Modern Languages and Cultures at Durham University, and thanks are due to both these organisations. The editors would also like to thank Heather Fenwick for her administrative assistance. J. J. Long's editorial work on the volume was supported by the Leverhulme Trust.

Introduction

A small history of photography studies

Edward Welch and J. J. Long

This book sets out to highlight the scope, breadth and variety of current thinking on photography, a cultural form that has been the subject of intense academic investigation in recent years. But it does so with a deliberate nod to *Thinking Photography*, the volume of essays on photography edited by Victor Burgin and first published in 1982. Burgin's book was intended explicitly to establish a theoretical framework for the study of photography. It featured contributions from both contemporary writers and critics such as John Tagg, Allan Sekula and Burgin himself, as well as essays by Walter Benjamin and Umberto Eco chosen by Burgin as necessary reference points for thinking about photography. To a certain extent, the very fact that we can now talk comfortably in terms of photography as a field of study suggests that the work of academic and intellectual legitimation to which *Thinking Photography* was intended to contribute has paid off.

Since the publication of *Thinking Photography*, what we now call photography studies has steadily accumulated the signs and accoutrements of a recognized domain of enquiry. A series of landmark academic publications – such as *Thinking Photography* or John Tagg's *The Burden of Representation* (1988) – have come to form the touchstones and reference points of subsequent work and have allowed the theoretical armature of the discipline to take shape. Conferences and seminar series on photography are now legion; numerous university courses have been established to teach both the practice, and more recently, the theory of photography; and the existence of such courses has, in turn, generated a variety of critical introductions, readers and other textbooks (e.g. Wells 1997, 2003). Lest further evidence be necessary that photography studies have come of age, 2008 saw the launch of two new journals devoted to the medium in the form of *Photography and Culture* (Berg) and *Photographies* (Routledge). Given both the rapid expansion in the field in recent years and the passing of a significant anniversary for Burgin's volume, it would seem a timely moment to consider where and how photography studies now finds itself. What does the landscape of the discipline look like twenty-five years or so after Burgin's intervention? And is it quite the landscape he might have imagined at the time?

The late 1970s and the early 1980s can be seen, in retrospect, to mark a turning point in the fortunes of photography as an academic discipline. First, in terms of publishing history, several key texts appeared in the years either side of 1980. Susan Sontag's *On Photography*, published in the United States in 1977 and in Britain in 1979, though not in any sense a work of theoretical rigour and coherence, was nevertheless an intervention by a major intellectual with considerable stature – both inside and outside the academy – as a commentator on the arts. Alan Trachtenberg's anthology *Classic Essays on Photography* (1980) collected many of the most significant writings on photography from the nineteenth century to the present. Its importance in establishing a 'canon' of theoretical writings is implicitly acknowledged by Burgin's including the book in his design for the cover of *Thinking Photography*. Such developments were not restricted to the Anglophone academy. In Germany, for instance, the first two volumes of Wolfgang Kemp's four-volume anthology *Theorie der Fotografie* appeared in 1979 and 1980, to be followed by a third volume in 1983 (and a fourth, edited by Hubertus von Amelunxen, in 2000). Meanwhile, in France, in addition to the work of Roland Barthes outlined in more detail below, Philippe Dubois' neglected *L'Acte photographique* was published in 1983.

A second important factor was the gradual infiltration of continental critical theory into Anglo-Saxon academic discourse over the course of the 1970s. While the Anglophone world had been slow to embrace structuralism, it made up for this by an eager reception of those thinkers who are, in one sense or another, post-structuralists and whose major works appeared in French from the mid-1960s: Derrida's *Writing and Difference* and *Of Grammatology* (both 1967), Lacan's *Écrits* (1966) and *The Four Fundamental Concepts of Psycho-analysis* (1973), Foucault's *Archaeology of Knowledge* (1969) and *Discipline and Punish* (1975). Added to this is the reception history of the works of Walter Benjamin. Benjamin's influence on photography studies – lucidly outlined in Kelly Dennis's contribution to the present volume – can be traced to the republication, in a cheap paperback edition, of the 'Work of Art' essay in German in 1965 (see Krauss 1988), and its English translation, as part of the collection *Illuminations*, in 1969. In embracing these recent developments in sociopolitical thought, linguistics, semiotics, psychoanalysis and discourse analysis, *Thinking Photography* was self-consciously conceived as a foundational gesture. It was an attempt to establish a rigorous and coherent theoretical framework for the analysis of the photographic image, to set out the ways in which photography should be thought about, and to challenge the ways in which it had been thought about until that point. *Thinking Photography* was thus predominantly a future-oriented project. As Burgin states on the first page of his introduction, the essays in his volume are intended as 'contributions towards photography theory'; and he continues: 'I say "towards" rather than "to" as the theory does not yet exist' (Burgin 1982: 1).

Few would now deny the existence of photography theory. But the relationship between *Thinking Photography* and the corpus of writings that would

now be classified as 'photography theory' is not quite the one envisioned in Burgin's 'Introduction'; for there is an implicit teleological moment in Burgin's claim to be 'contributing towards photography theory', even though '*the* theory does not yet exist'. The implication is, of course, that photography theory, as a unified and unitary body of thought, is the goal towards which contributors to *Thinking Photography* are working. Subsequent developments suggest that this utopian faith was, in one sense, misplaced. Photography's emergence as a central object of study in the humanities and social sciences has in fact been accompanied by a vast proliferation of theoretical approaches to the subject that exceed the notion of 'photography theory' espoused by Burgin. It is to this very plurality and diversity that this volume responds.

At the same time, despite the intensive theoretical and critical activity that photography has generated in recent decades, one of the most interesting aspects of photography studies remains its relative youth. It is true that many of the disciplines making up what we now tend to think of as the 'arts and humanities' are relatively young in terms of the history of scholastic and academic study. Even the grandest and seemingly most established of subjects, such as English Literature, only really acquired academic legitimacy at the end of the nineteenth century, as Terry Eagleton for one reminds us, and did so after a long struggle (Eagleton 1983: 17–53). Nevertheless, contemporary generations of English scholars now find themselves entering a discipline carrying a heavy weight of tradition and history, whose canons and critical orthodoxies must be negotiated and acknowledged even by those who might want to challenge or resist them. Photography studies remains a discipline in formation, one which has properly taken shape over only two or three generations of academic activity, a lifetime which we can measure by the fact that those scholars who were taught by, or encountered, the pioneers in the field (figures such as Burgin and Tagg) are now themselves engaged in teaching a new generation of academics. The still-youthful status of photography studies arguably leaves those working within it in a distinctive and valuable position as they contribute to shaping the direction of photography studies and its theoretical foundations. They can, at the same time, remain aware of the ways in which other, older disciplines have taken shape, and remain alert to the ways in which the sediments of critical ortho-doxy were able to accumulate around them.

Indeed, the very nature of photography as a cultural phenomenon may well militate against the coalescence of critical orthodoxies. John Tagg notes that in the 1970s people were attracted by photography as an object of study precisely because it was not bound by a specific institutional canon: if it could boast an aesthetics then this exceeded the paradigm of art history because its prac-tices were both too diverse *and* formulaic (Tagg 1992: 76). This diversity is so broad that any attempt to enumerate photographic practices would be sense-less. The point to note, perhaps, is that this very diversity means that while 'photography studies' can lay claim to a high degree of disciplinary legiti-macy, it does so without a fixed institutional home. While English literature is

taught largely in departments of English, there are few departments of photography. Instead, photography is studied in departments of art history, but also of modern languages, English, anthropology, sociology, comparative literature, media studies, cultural studies, geography, history and many others. Given that most of these disciplines already had their established methodologies – their own specific ways of formulating both their objects of study and the questions they asked of those objects – it is only to be expected that the approaches to photography developed within each discipline should draw, not only on the 'foundational' texts of photography studies itself, but on particular disciplinary traditions. The theoretical plurality discussed above, then, is a function of both the diverse and dispersed nature of photographic practices and the nomadic status of 'photography studies', which is perhaps ultimately less a discipline than a trans-discipline. Its plurality is not contingent but structural and embodies contradictions that can be neither resolved by the establishment of theoretical orthodoxy nor sublated in a teleologically conceived 'photography theory' of the future.

One of the aims of this volume of essays is to give an indication of current thinking about, and approaches to, photography. It demonstrates the range of critical paradigms and perspectives that have come to inform discussion of the photographic image in recent years, and the range of disciplines engaging with it – whether it be those, such as art history or visual studies, which have long had purchase on photography, or those, such as anthropology, which increasingly recognize the need to see the photograph no longer as an unproblematic source of evidence and empirical data, but as playing a complex role in our encounter with other cultures and societies. In his discussion of Spencer Tunick (chapter 8), Louis Kaplan draws on the work of philosopher Jean-Luc Nancy to foreground the ethical questions raised by Tunick's images in relation to questions of community, subjectivity and identity. He argues that Tunick's images, through their staging of nakedness in urban space, require us to interrogate the nature of human coexistence, or 'being-with', in the modern world. Kaplan's approach demonstrates the fruitful confrontations between photography and ethics and the insights to be gained from reading each through and with the other.

While Kaplan considers how photography allows us to interrogate the nature of human coexistence, the essays by Elizabeth Edwards (chapter 2) and Geoffrey Batchen (chapter 5) explore the complex relationship between humans and photographic objects, and the role played by photography in mediating social relations. While her focus on the social uses of photography might echo the agenda set down by *Thinking Photography*, Edwards rejects the textual reductionism that Victor Burgin (1982: 144) performs when he writes that 'the putatively autonomous "language of photography" is never free from the determinations of language itself. [...] Even a photograph which has no actual writing on or around it is traversed by writing when it is "read" by a viewer'. Burgin makes this point even more radically in a later essay (1986b: 51)

photography is 'invaded by language in the very moment it is looked at: in memory, in association, snatches of words and images continually intermingle and exchange for one another'. For Edwards, on the other hand, language is but one of many factors in the reception and use of photographs. Her essay encourages us to understand the photograph not solely (indeed, not in the first instance) as a visual phenomenon, but as an object which mobilizes and engages with the full range of human senses. Photographs, she reminds us, are 'handled, caressed, stroked, kissed, torn, wept over, lamented over, talked to, talked about and sung to in ways that blur the distinction between person, index, and thing'. For Edwards, thinking about photography becomes a privileged site for thinking more generally about the ways in which social relations are mediated by material culture, and about the relationship between people and things, human and non-human.

In his contribution, Batchen turns his attention to the social phenomenon of nineteenth-century cartes-de-visite. He suggests that, while we may be tempted to overlook them as marginal or aesthetically worthless, they in fact offer a revealing insight into the ways in which bourgeois society envisioned itself in the nineteenth century. At the same time, Batchen argues that exploring the meanings and functions of objects such as the carte-de-visite represents a challenge to a history of photography, which might want to construct itself solely around singular artists producing 'Great Works'. In doing so, his intervention carries on the debate first launched, as John Tagg indicates in chapter 1 and as we shall be discussing later in this introduction, by *Thinking Photography* itself. It also makes clear, as does Edwards's essay, that the battle between different conceptions of photography – as a branch of art history or visual studies on the one hand, and as a complex social object on the other – continues to be fought two decades later.

At the same time, the volume also sets out to reflect critically on the ways in which photography studies has taken shape in the years since Burgin published *Thinking Photography* and consider how and why certain thinkers or critical tropes have come to dominate thinking about photography. Thus, Shawn Michelle Smith (chapter 6) offers a reading of Barthes' *Camera Lucida*, which draws out what she sees as the text's blind spot in relation to the question of race and its representation. She goes on to argue that Barthes' response to race, which emerges in his discussion of some of the images in *Camera Lucida*, resonates with another anxiety which can be detected in the book, that of his relationship as a gay male to the family as a unit of biological and social reproduction. In her analysis of images from Abu Ghraib, and their status as examples of snapshot photography, Catherine Zuromskis (chapter 3) revisits Susan Sontag's work on photography to argue that the nature of the snapshot, and its social roles, complicate the relatively straightforward moral frameworks and relationships of power which Sontag attributes to photography. Kelly Dennis (chapter 7) explores the canonization of Walter Benjamin's writing on photography, suggesting that he 'might have needed inventing by photog-

raphy studies had he not existed in translation'. The process is one in which *Thinking Photography* itself undoubtedly played a part, of course, opening as it does with Benjamin's essay 'The Author as Producer'. Burgin's intention in beginning the collection with Benjamin's essay was to focus attention on the political responsibility not only of the cultural producer but also of the cultural critic. As Dennis points out, engagement with Benjamin's work since then has focused far more on notorious concepts such as 'aura' while remaining 'discreetly silent', as she puts it, about the political dimension of his thinking on photography.

Indeed, as we will be discussing later in this introduction, it has sometimes seemed, in the years since the publication of Burgin's volume, that the radical, politically-inflected engagement with photography, which it set out to promote, has been lost from sight in favour of work that focuses on the personal, the local and the specific in relation to photography. However, a number of the contributors to the current volume, including Smith and Zuromskis, remain faithful to the notion that, as Smith reminds us, 'the personal is political' and that it is in getting to grips with the small-scale and the local uses of photog-raphy – in relation to the family, for example – that its political functions can be brought to light. What interests Zuromskis in her discussion of the Abu Ghraib images, for example, is the location of the snapshot on the border between the private and the public spheres, and its role as a space not where power is exercised, but where dialogue can be initiated. For Zuromskis, the impact of the Abu Ghraib images is located in the fact that they foreground the social, affective and dialogic functions of snapshot photography precisely by displaying and acting out the perverse disruption of those functions. Andrea Noble, on the other hand, explores the way in which family snapshots are mobilized in the context of human rights protests in Latin America (chapter 4). Echoing the imperative voiced by Elizabeth Edwards to pay attention to the material nature and presence of the photograph, Noble draws out the forms of agency specific to the photographic image – that is to say, to the social, political and emotional effects (such as shame) which are dependent on and mobilized by the photo-graphs, and would not exist in these contexts without them. At the same time, she argues for the need to rethink some of the assumptions and orthodoxies around the politics of family photography that have taken hold over the past few years.

In their contributions, John Tagg (chapter 1) and Donald Preziosi (chapter 9) locate photography in its wider cultural context, and consider its central role in the modern world's 'regimes of representation', to borrow Preziosi's phrase. In his essay, Tagg explores the workings of two contemporary technolo-gies of visualization (traffic congestion charging schemes and radio telescopy) in order to question the widespread assumption (one displayed by *Thinking Photography* itself, as he points out) that 'the subject always finds itself at home' in the photographic process. His interrogation of the nature of photographic agency produces a rather more unsettling account of the way in which human

subjectivity, rather than governing the processes of photographic meaning, is accommodated and managed by them. In doing so, it reasserts the persistence and continued relevance of questions that Tagg first examined in his own contribution to *Thinking Photography*.

In the volume's closing essay, Donald Preziosi re-situates photography within a broader history of the institutions of visual culture. Examining the 'dream worlds' of the museum and the culture industries, and their role in creating the phantasmagoria of the modern world, Preziosi calls on us to interrogate the social functions not just of photography and art, but of the disciplines which frame our understanding of them. He reminds us of the need to engage with representation and artifice not simply as a defining feature of the artistic realm, but as constitutive of social organization and modes of perception in general; he reminds us too of the political imperative of doing so.

In inviting us to think more generally about the modern world's 'regimes of representation', and the professions and institutions which underpin them, Preziosi contributes to another aim of this volume, which is to encourage a more self-reflexive approach to the discipline of photography studies, or to participate in what the sociologist Pierre Bourdieu terms a 'science of science' (Bourdieu 2001). Throughout his work, Bourdieu underlines the need for those involved in an academic discipline to pay attention to the ways in which it constructs and defines its objects of study, and the social mechanisms that govern the knowledge it produces. Central to this process are the battles for authority which take place between different actors in the field as they try to impose the conditions in which legitimate statements about the object of study can be made; decide who has the right to speak about it; and legislate on the validity of what is said (Bourdieu 1984).

Maintaining what Bourdieu calls 'epistemological vigilance' (2001: 178) – a critical awareness of the discourses, interpretative frameworks and relationships of power governing a field of enquiry over time – is arguably of particular importance in relation to photography studies if it is to maintain the relative hybridity and fluidity which has defined it so far, and avoid as much as possible the sclerosis of critical orthodoxy. As Kelly Dennis observes in this volume, 'it is undoubtedly useful to rethink the field of study as it becomes increasingly institutionalized and thus subject to the dogmatism, cult value, and embeddedness of any institutionalized field of study'. After all, the strength and distinctiveness of photography studies lies in its radical and inevitable interdisciplinarity, one to which it is condemned by the very nature of a medium that pervades all aspects of life and therefore must come to the attention of a multitude of fields of enquiry. The next section of the introduction sets out to contribute to that process of critical reflection by revisiting the pivotal moment of the early 1980s represented, amongst other things, by the publication of *Thinking Photography*, in order to consider its role in defining the direction of photography studies and to sketch out the broad trajectory of the discipline since then. It emerges that while Burgin's volume certainly sets out to revolutionize both understanding

and analysis of the photographic image, his attempt to impose his theoretical model is made difficult by the simultaneous appearance on the scene of what would prove to be a powerful and problematic rival for theoretical legitimacy and authority – namely Roland Barthes' *La Chambre claire* (1980), the English translation of which (*Camera Lucida*) was first published a year before *Thinking Photography*.

Thinking photography and defining a discipline

In his contribution to the current volume, John Tagg reminds us that the essential components of the theoretical framework in which Burgin wants to 'think photography' are laid bare on the cover of his book: Burgin's Leica camera is shown supported and framed by a range of volumes, including Saussure's *Cours de linguistique générale*; the issue of *New Left Review* in which the English translation of Jacques Lacan's essay on the 'mirror stage' was first published; and Walter Benjamin's essays on Brecht. From the moment we encounter Burgin's volume, therefore, two things are made clear: in the first place, it is arguing for a particular mode of analysis informed by semiotics, psychoanalysis and cultural materialism; and in doing so, secondly, it is positioning photography studies itself as an explicitly *political* project. As far as the Burgin of 1982 is concerned, photography studies should play a leading role in a broader process of ideological critique and political intervention, in working to expose the mechanisms by which the dominant social and economic order sustains and reproduces itself. As Tagg observes, the book appeared at a moment when it was felt not just that social and cultural revolution was possible, but that 'the first brick could be thrown by photographic theory'.

It was nevertheless within the realm of academic study where the brick of photographic theory would cause the most disruption, as Burgin set out to stage a revolution in the discipline by formulating and positioning his ideas in opposition to the dominant modes of reception and interpretation he refers to – dismissively – in the introduction to *Thinking Photography* as 'criticism' and 'history' (Burgin 1982: 3). He aligns the existing approaches of photography criticism and history with traditional art historical criticism, whose understanding of culture is based on the principle of singular figures transcending their historical and social conditions to produce works of timeless beauty, and whose role is to identify and regulate the hierarchy of artistic genius. As such, they are fatally complicit with the cultural, economic and ideological status quo. For Burgin, they are modes 'in which the main concern is for reputations and objects, and in which the objects inherit the reputations to become commodities: a history and criticism to suit the saleroom' (1982: 4). Yet by 1982, such modes had nevertheless acquired substantial authority by dint of their sheer longevity, on the one hand, and the location of their main advocates within powerful cultural institutions such as the Museum of Modern Art in New York, on the other.

The theoretical positions adopted by Burgin, and his explicit alignments with Marxist cultural materialism especially, placed him in clear and antagonistic opposition to the dominant modes of thinking exemplified by conservative critics such as John Szarkowski, the notoriously influential curator of MoMA's photography collection. Furthermore, Burgin's theoretical positions were homologous with his institutional position at the time as a lecturer at the Polytechnic of Central London (now the University of Westminster), an establishment on the radical margins of the British academic field, in stark contrast to the august organizations such as MoMA where the dominant figures in the world of photography criticism held sway.

In order to clarify further Burgin's strategy in the opening pages of *Thinking Photography*, and his positioning of photographic theory in relation to history and criticism, it is useful to return briefly to the work of Bourdieu, and in particular his discussion of the emergence and status of sociology as a discipline. Bourdieu's analysis arguably holds good for any embryonic field of study, and all the more so in the case of photography studies since, from Burgin's perspective at least, it could be described quite happily as a social science.

One of the essential criteria defining any field of academic study or artistic activity, for Bourdieu, is its relative autonomy in relation to the broader field of power – that is to say, its ability to resist those external pressures and influences, be they political, economic or social, which can have a bearing on its specific processes and products (knowledge, art, literature and so on). Relative autonomy is the condition in which, Bourdieu would argue, 'disinterested' science – in other words, science pursued and regulated not in accordance with outside interests, but by what he calls the 'mutual censorship' of a peer group – can take place (Bourdieu 2001: 171). Bourdieu cites the examples of astronomy and physics, recognized today as highly autonomous and self-regulating disciplines, but which, in the early stages of their development, were profoundly implicated in broader political and religious debates and subject to political interference as a result (2001: 169).

Furthermore, Bourdieu argues, the less autonomous a discipline is, the more likely it is for the actors who populate it to align themselves with, or succumb to, those external pressures; and those who do will have greater power and influence over their discipline, and accrue greater social capital, than those who do not (2001: 170–1). Such a situation was reflected in the domain of photography studies as Burgin found it by those producing his 'history and criticism to suit the saleroom', those whose work of criticism and interpretation consolidated the commodity value of the photographic image rather than contributing to our 'scientific' understanding of it.

The publication of *Thinking Photography*, which allowed Burgin to gather in one place the elements he saw as essential to a theory of photography, represented an attempt on his part to initiate a trend towards greater autonomy in the discipline, and so establish a relationship to the object of study less contaminated by external pressures. Indeed, the very appeal to the notion of a photog-

raphy 'theory' is an essential part of this process. Burgin's aim is to relocate the authority to speak about photography in domains (linguistics, psychoanalysis, cultural materialism) lying beyond the reach of existing experts and agents of legitimation – domains, moreover, into which he could be sure such experts would refuse to venture because of the challenge they represented to their vision of creative practice and the way in which they revealed photography not as innocent art form, but as implicated in complex processes of signification within society.

The body of ideas on which Burgin drew had already proved their effectiveness elsewhere, of course. In reality, Burgin was doing little more than restaging a revolution which had begun in the realm of literary studies in the 1950s and 1960s, as French theorists such as Roland Barthes and Jacques Derrida rediscovered and thought through the implications of Saussurian structuralist linguistics, and took seriously Saussure's call for a 'science of signs'. The attractiveness of 'theory' can be traced to the fact that it offered what academic study of the arts had lacked for so long, namely, frameworks and methodologies which acquired the aura of scientific explanation by making the business of dealing with cultural objects a question of identifying and analysing observable phenomena (e.g. narrative structures and combinations of signifiers) rather than elaborating on the impressionistic and subjective responses of the viewer or reader. The principle of scientific responsibility is one which Burgin is quick to lay claim to in his introduction in his efforts to underline the validity of his approach: 'photography theory is not exempt from the call made upon any theory to identify observable systematic regularities in its object which will support general propositions about the object' (1982: 2). For Burgin, traditional criticism advanced 'assertions of opinions and assumptions' disguised as arguments (1982: 3). With the help of theory, the power of argument (with all the connotations of rigour, logic and clarity carried by the word) could be put to work in understanding the photographic image.

So how successful has *Thinking Photography* been in setting the intellectual and theoretical agenda of photography studies? While its radical perspective was certainly consolidated and developed during the 1980s in the work of critics such as Tagg, Martha Rosler (1989) and Abigail Solomon-Godeau (1991), not to mention Burgin himself (1986a; 1986b), the book's status today appears curiously anachronistic. It is a book quite clearly of its time, born of a particular moment in the recent history of ideas, and the relic of an era when the belief in the political power of radical cultural critique was still strong. Our sense of the book's status as a relic comes in particular from its material nature. Strikingly, neither its contents nor its design were ever updated: even the most recent printings carry the same photograph of Burgin on the back cover as the first edition and the notes on contributors freeze them in time in 1982. The insistent pastness of Burgin's portrait photo, we might say, encapsulates Barthes' discussion in 'Rhetoric of the Image' of the illogical conjunction between the here-now and the there-then with which photog-

raphy confronts us, the past persisting in the present and haunting it like a ghost (Barthes 1977a: 44).

Thinking Photography provokes a peculiar blurring of temporality and chronology in other ways as well. First, this is related to the contents of the anthology. While most of the essays were written in the few years previous to 1982, the collection opens with Walter Benjamin's essay from 1934, 'The Author as Producer'. The initial function of Benjamin's essay is undoubtedly to give some historical depth and foundation to the theoretical paradigm Burgin sets out to promote by placing it in clear alignment with a radical Marxist tradition. However, while there are chronological reasons for its location at the start of the volume, the prominence he gives it is undoubtedly also due to its content. The essay is not wholly, or even in large part, about photography *per se*, but about the social role of the artist and intellectual. Benjamin operates with an expanded concept of cultural production, in which barriers between spheres of activity that remain discrete and self-contained under capitalism are dismantled. While Benjamin foregrounds the barriers separating writers from visual artists, his comments might equally apply to the barriers between artists and critics. Burgin's contextualization of 'The Author as Producer' invites us to read it as a template for those engaged in intellectual action, be it as artists or as theorists – a template that the remaining essays in the volume seek to exemplify.

For an intellectual to be properly revolutionary, suggests Benjamin, 'consists in an attitude which transforms him, from a supplier of the production apparatus, into an engineer who sees his task in adapting that apparatus to the ends of the proletarian revolution' (Burgin 1982: 31). The role of the intellectual, argues Benjamin, is to find innovative ways to subject the dominant social order and its cultural production to critical scrutiny, and thereby help contribute to its downfall. In doing so, he lends support to Burgin's argument in the introduction that the concern of those engaged with the photographic object should be to revolutionize our understanding of it and not to contribute to its market value. The apparently easy coexistence of Benjamin's essay with those by Burgin, Tagg and others suggests that it has trans-historical relevance, and that it can transcend and travel without difficulty between different historical and cultural moments (invites us to draw comparisons, indeed, between the Thatcherite Britain of the early 1980s and the Nazi Germany of the 1930s).

Second, the presence of Roland Barthes both in and around Burgin's volume illustrates how the temporality and chronology of theoretical ideas can become warped by their passage from one academic and cultural context to another, with often complex consequences. The next part of the introduction considers in more detail the striking conjunction that sees the publication of *Thinking Photography* follow on from that of *La Chambre claire* and its English translation, and the ensuing battle for theoretical supremacy which Burgin and the other defenders of a more politically-engaged photography studies felt obliged to fight.

Burgin versus Barthes or the struggle for the soul of photography studies

While one of these two interventions on photography is more obviously designed to be a contribution to a discipline in formation, the other is a series of reflections on the medium which – despite giving itself the relatively modest status of 'notes on photography' – has become one of the sacred texts of that discipline over the past 25 years or so, and has provided it with some of its most persistent (if not unproblematic) ideas; but the conjunction of the two books is all the more striking for the way in which it brings together two rather different sides of Barthes himself. More precisely, Burgin brings to the fore, and underscores the relevance of, the work of the Barthes of the 1960s – that of the semiotician and the critic of mass visual culture – at the very moment when Barthes himself takes his leave from and criticizes 'scientific' approaches to the photographic image.

Even though Burgin does not reproduce any of Barthes' writings in *Thinking Photography* (on the basis that 'Rhetoric of the Image' in particular was by then widely known in translation), the theorist's work and ideas are a persistent presence throughout, surfacing repeatedly both in notes and references, and the 'select bibliography' Burgin proposes to his readers. At the same time, a notable absence from the bibliography, bearing in mind that it had been published in 1980 in French and in 1981 in English, is *La Chambre claire*, Barthes' most recent contribution to thinking on photography. Consequently, we find ourselves confronted by what emerge as two different, not to say competing, theoretical or interpretative paradigms. Burgin asserts the need to interpret and understand the workings of the image in its social context, to unmask the ideological and political power of images, and draws on what we can term the 'hermeneutics of suspicion' developed by Barthes and others in the 1950s and 1960s in order to do so. At precisely the same moment, Barthes himself begins to take photographs out of the realm of the social, the political and the ideological, and place them squarely in the realm of the individual, the subjective and the idiosyncratic.

In doing so, moreover, Barthes also distances himself from 'scientific' attempts to understand the nature and workings of the photographic image. When considering the position Barthes adopts in *La Chambre claire*, it is essential to place the essay in the context of his own intellectual trajectory (a reflex which a number of its commentators unfortunately fail to have). In several respects, it marks the end of a cycle for Barthes. After a long period of what he terms, in 1975, his mood of scientific 'euphoria' (Barthes 1975: 129), the opening pages of *La Chambre claire* testify to his mounting sense of disappointment and disillusion with the discourses of the human sciences (psychoanalysis, semiotics, sociology). First, he recognizes their inability to exhaust, or do justice to, the photographic object; second, he traces his frustration with them to his 'desperate resistance to any reductive system' (Barthes 1981: 8), his desire to acknowledge the irreduc-

ibility of subjectivity. Barthes concludes that the most honest, or most valid, way to proceed is to rely on and investigate the nature of his own response to the photographic image: 'I resolved to start my inquiry with no more than a few photographs, the ones I was sure existed *for me*' (1981: 8, Barthes' emphasis). The move is articulated, of course, in the notorious opposition he goes on to introduce between the *studium* of the photograph (what everyone can see) and its *punctum* (what only I can feel), and the privileging of the latter over the former. The hermeneutics of *La Chambre claire* favours the individual over the collective and in doing so encourages a mystified relationship to the photographic image (the viewer's response to the photograph ultimately lies beyond analysis; or rather, analysis of that response shows it to lie in the realms of emotion, sentiment and affect). That of *Mythologies* and 'Rhetoric of the Image', on the other hand, undertook precisely to demystify the image and encourage a collective recognition and interrogation of its phantasmagorical power.

While *Thinking Photography* carried no trace of *La Chambre claire*, Barthes' last word on photography would come to be a constant reference point in subsequent years both for Burgin and for John Tagg as they sought to assert precisely the paradigms and discourses which Barthes himself had come to see as *inadequate* to the task of engaging with the photographic image. In many ways, the diverging perspectives on photography crystallized by the publication of *Thinking Photography* and *La Chambre claire* resulted as much as anything from the processes affecting the circulation of ideas from one cultural and intellectual context to another. The paradigms for which Barthes was in large part responsible had already been reshaping the terrain of the human sciences in a French context for the previous twenty or so years; but the lag caused by translation, institutional and intellectual resistance meant that they were only just beginning to make an impact in the UK by the early 1980s. Living through their own euphoric moment of radical science, Burgin and Tagg could not fail to be troubled by Barthes' apparent abandonment of such paradigms, and to fear a betrayal of the critical cause.

How best could they respond to a text which rejects the discourse of theory in exchange for a celebration of the 'magic' of the photographic image; which endorses a 'realist' view of the photograph as inherently analogous; and which takes issue with the 'fashion' among contemporary commentators for asserting its codified nature while attempting to bracket out what Barthes sees as its ineluctable status as a trace of the real (Barthes 1981: 88)? Both Burgin and Tagg can be seen to deploy what we might term strategies of containment in relation to *La Chambre claire*. Burgin's response, the essay 'Re-reading *Camera Lucida*', was quick to appear. First published in *Creative Camera* in 1982, it was reprinted four years later in *The End of Art Theory*. Burgin is happy to recuperate Barthes' text as a 'contribution to photography theory' (Burgin 1986a: 88), in other words as part of the project he is in the process of shaping; but as one of its principal architects, he also feels able to make a critical assessment of that contribution.

Burgin takes issue in particular with the turn to phenomenology that defines *La Chambre claire* and Barthes' attempts to explore the affective nature of the photograph. The move is a problematic one for Burgin as it entails putting to one side the insights of psychoanalysis (phenomenology, as Burgin points out (1986a: 83), not recognizing the notion of the unconscious). But it is precisely in the domain of psychoanalysis, he argues, where some of the most pertinent insights for photography theory are to be found. The rejection of psychoanalysis 'has severe consequences in that it denies photography theory a body of research which, I believe, is crucial to its development' (1986a: 83). Burgin proceeds to read *La Chambre claire* against itself, by suggesting how Barthes' notion of the *punctum* can be seen to have its roots in psychoanalytic theory (1986a: 82–3). Nevertheless, Burgin's engagement with *La Chambre claire* is a respectful one. Acknowledging that it is often a 'mistake' to take Barthes' work at face value (1986a: 88), he recognizes that there might be more to the text than its contribution to photography theory – indeed, that a contribution to 'photography theory' might be the last thing on its mind.

John Tagg's response to *La Chambre claire* is rather more bullish. He devotes the opening pages of *The Burden of Representation* to a lengthy critique of Barthes' reassertion of the realist position in *La Chambre claire*, and his willingly mystical investment in photography as 'magical'. What photography needs, argues Tagg, is a history not an alchemy (1988: 3). Tagg locates Barthes' vision of photography firmly in the realm of his particular circumstances. It has more to do with Barthes' grief over the death of his mother than with a rigorous and scientific attempt to understand photography:

> The trauma of Barthes's mother's death throws Barthes back on a sense of loss which produces in him a longing for a pre-linguistic certainty and unity – a nostalgic and regressive phantasy, transcending loss, on which he founds his idea of photographic realism: to make present what is absent or, more exactly, to make it retrospectively real. (1988: 4)

Tagg's rhetorical strategy here is notable for the way in which he deploys the voice of science, in the form of psychoanalytic discourse, to gain command over Barthes' position. From the perspective of psychoanalysis, Barthes' understanding of photography emerges as a symptom of his personal grief, a product not of reason but emotion, with the implication that its validity should be called into question as a result. Naïve and emotional responses to photography, it seems, no longer have a place in a discipline which can call on an increasingly sophisticated theoretical framework, one which Barthes himself, at an earlier stage in his career, had helped to fashion.

The concerted effort made by Tagg to discredit and defuse Barthes' intervention is an indication of how seriously he takes what he clearly perceives to be a problematic, but nonetheless persuasive and powerful understanding of photography, and of the influence it was coming to have. The history of 'photography

theory' as it has taken shape since the 1980s suggests that Burgin and Tagg were right to be sensitive to the likely impact of *La Chambre claire*. Of the two competing paradigms – one which locates thinking about photography in the present and the political, and another which locates that thinking more in the realm of the memorial, the past and the personal – it is arguably the latter which has set the critical agenda most successfully and which has gained the most critical currency. Barthes' text proved to be a profoundly influential statement on photography through the way in which it allows a whole series of critical tropes to crystallize: memory, mourning, trauma, death, the familial and so on. Moreover, its focus on such themes chimed with, and undoubtedly contributed to, the broader trends shaping the critical paradigms of the humanities in the 1980s and 1990s. *La Chambre claire* entered circulation, and began to be mobilized by scholars in their analysis of photography, at a time when questions of ethics, personal identity and memory were starting to dominate the Western intellectual and academic agenda more generally. These shifts were driven by a growing interest in historical events such as the Holocaust, as well as by the changing concerns of prominent intellectual reference points such as Jacques Derrida, whose so-called 'ethical turn' led him to become increasingly preoccupied by such issues in his later work. Their legacy can be found in the essay by Louis Kaplan, among others, in the current volume. It was also a time, ironically, and in contradistinction to the mood expressed in the work of Burgin and Tagg, when the acknowledgement of one's own affective investment in the subject of one's research became increasingly acceptable, when emotional response became an entirely valid position from which to begin thinking about photography and other cultural forms (See Hirsch 1997, for example).

In the proliferation of approaches and paradigms they display, and the variety of photographies with which they engage, the essays in the current volume enjoy the status of snapshots. They bear witness to the vitality and strength demonstrated by photography studies in the twenty-five years since Burgin began the ambitious step of attempting to shape its intellectual and theoretical agenda. While photography studies might not have thrown the first brick in the revolution, it nevertheless continues to scrutinize and confront the complex ways in which the photographic image functions in our societies, and to remind us of the ethical imperative to remain vigilant to them. Thinking photography remains, more than ever, a vital intellectual and political activity.

Chapter 1

Mindless photography

John Tagg

The 2005 Durham conference 'Thinking Photography (Again)' marked, for me, a return to old ground – to a landscape of my past and to arguments of another time. Yet, in pondering this return, I found I persistently misremembered the publication date of *Thinking Photography,* pushing it back two years in my mind to 1980 (Burgin 1982). No doubt, this was partly the desire for a neater anniversary as the occasion for retrospect. Even then, I would have had to contest the date since, in its conception and its intellectual style, I have the book firmly in the late 1970s. Such is the reliability of my memory, across so many breaks that would have been all the more liveable if they had only been epistemological.

When I look at the book now, I cannot help but judge it by its cover, in that I find myself held by Victor Burgin's rather self-consciously contrived, though unattributed, photograph on the dust jacket. I see there the Leica M4, of which Victor was so proud at the time, and a pile of books, certainly brought together for the occasion, yet still pulled from the shelves of his office on Riding House Street perhaps or, more likely, from the bookcases in his apartment on the Albert Bridge Road, opposite Battersea Park. Contrived or not, the cover speaks of a moment when it seemed important and even pressing to bring these books together in this way, as if in themselves they made an important statement: a French collection of essays published by Viktor Shklovski in Russian between 1919 and 1921 (Shklovski 1973); Alan Trachtenberg's reader, *Classic Essays on Photography*, from 1980 (Trachtenberg 1980); the fourth issue of *Communications*, in which Roland Barthes's 'Elements of Semiology' and 'Rhetoric of the Image' first appeared (*Communications* 1964); Ferdinand de Saussure's *Course in General Linguistics*, though not in the English translation then available (Saussure n.d.); a slim volume on Soviet photography from 1928 to 1932, published in Munich by Hanser in 1975 (Sartorti and Rogge 1975); Walter Benjamin's *Understanding Brecht*, which included the translation of his productivist essay, 'The Author as Producer', that also appears in the book (Benjamin 1973); then, to one side, issue number 51 of *New Left Review*, containing the first English rendering of Jacques Lacan's 1949 paper, 'The Mirror-Phase as Formative of the Function of the I' (*New Left Review* 1968); next to it, volumes four and five of *The Standard Edition of the Complete Psychological Works of Sigmund Freud*, in which Strachey's

translation of *The Interpretation of Dreams* was published (Freud 1953); and, lastly, opposite and seemingly out of place, the 1978 Aperture edition of Robert Frank's *The Americans* (Frank 1978).

It is an odd collection, though you could no doubt trace these same works through the footnotes of the essays that follow, all the way to what now seems the extraordinarily narrow field of reference of the 'Select Bibliography', whose purpose, we are told, is 'to indicate a relatively small number of books and articles in English to which the reader unfamiliar with the general orientations of the foregoing essays may refer' (Burgin 1982: 217). Today, this little library is both instantly recognizable, as the reading list for an endlessly reiterated pedagogical canon, and yet, at the same time, irretrievably distant, since it is hard now to recall the unwarranted political hopes and eclectic intellectual investments that took these books in hand, waving them as warning, as the red guards once did with the thoughts of Chairman Mao. Here, on this shelf, then, is what was imagined as the space of photographic theory, a space that the introduction is at pains to distinguish from the spaces of 'criticism' and 'history' (Burgin 1982: 1, 3–4). Wedged between Frank and Freud is the narrow opening in which it was proposed to *think* photography, to theorize it as a 'material practice' – though that is not all there is to say, since there is clearly more at stake on this shelf than merely clearing a space for a discipline. These books are not just stacked up as theoretical tools or as the metonymic figures of a larger project. They are also there as a challenge to all those photographic practices that shirk the work of theory and, as the introduction suggests, do no more than reproduce the requirements of certain fixed repertoires within the vocational divisions of the culture industry that encompass the use of photography (Burgin 1982: 3).

This sense of implicit challenge on the cover, though it hardly lingers now, is a reminder that, at the time it was shaped, the confines of this little space were dreamt within a broader field of activism that was not at all constrained to the academic arena, but that staged itself in what had suddenly become a heterogeneous political field with multiple points of entry demanding inventive forms of engagement. This was the field of 'cultural politics' and 'the politics of representation' – phrases that evoke a time of uncomfortably brash and abrasive confrontations, of less than subtle polemics and raw counter-practices in which, for a time in Britain in the late 1970s, what was believed possible of theory ran beyond the competition for academic careers. It was a time when the insistent and exhilarating and, no doubt, naïve talk of 'interventions' and 'the politics of culture' coloured a wider field of action and involvement, changing the sense of possibility, even if the rigour of formulation was not always great and even if the mood was not to survive the forced marketization of the post-*Belgrano* Thatcher years, let alone the smugness of Major's Britain or the 'Socialism with a Lying Face' ushered in by Prime Minister Blair.

This shelf, then, belongs to another moment, another 'conjuncture', in which its strange little theatre of theory was not cast under the proscenium that now defines for us the frame of a discipline. The books on this shelf were put there

as a challenge – a challenge echoed in a certain sly insinuation in the over-arching title as, in the grammatical shift from participle to adjective, *Thinking Photography* conjures up not just a bridge between the theorizing of photography and a photography committed to theory, but also this photography's opposite: a thoughtless photography, an unthinking photography, a mindless photography. This veiled insult, which seemed quite subtle at the time, was certainly intended. In the late 1970s, we knew who the guilty were and could have named names. When, for example, my analysis of 'Power and Photography' was first delivered as a lecture, in a series of talks at the ICA in London, just prior to the opening of *Three Perspectives on Photography* at the Hayward Gallery, it was couched in part as a pointed rebuff to an earlier contributor whom we saw as an arch-proponent of the naïvely untheorized view that truth was to be found by the activist camera out there on the streets. I say this not to revisit such judgements here and now, but rather to mark something of the conjuncture and the discursive field in which, as it was put at the time, *Thinking Photography* made its intervention.

As the handbook of a counter-canon, *Thinking Photography* self-consciously staked out a site for photographic theory and scrupulously separated itself from what it stigmatized as the myriad forms of mindless practice. Yet, by doing this, it thereby also attached photography to thought, not only as that thought's possible object, but also as its potential tool, as an extension of the critical mind. This proffered convergence of photography and thought is borne out by the contents of the collection, in which the dominant model for thinking photography is that of language, whether this is framed in terms of a formalized semiotics, as in the contributions by Victor Burgin and Umberto Eco, or in terms of a concept of discursive practice, as in the essays by Alan Sekula and myself. Gone, then, is the conflation of photography with the immediacy and self-evidence of vision. Gone is the camera as analogue of the eye and thereby of the conscious mind and its epistemological relation to the world of experience. Yet, photography still remains a function of mind, as a site of meaning and as the site of inscription of the subject of that meaning: a lucid site, graspable as the landscape of a certain order and recognizable, at least in the imaginary, as a place of belonging, a dwelling of the human that has somehow survived the long trek through the age of Althusser.

I sense we have come to the threshold of a certain limit: the limit, perhaps, of that shelf on the cover. To try come at what that limit expels, let me hazard two anecdotes – and what could be more anecdotal than a story about the traffic in Central London?

Driving in Central London, of course, is something that has been very much under scrutiny, at least since it became clear in the mayoral campaign of 2000 that part of 'Red Ken's' plan for the inner city was that it should be filled with surveillance cameras. My concern here, however, is not to offer an opinion on the success of Livingstone's Congestion Charging Scheme in ameliorating the economic and environmental impact of excessive numbers of motor vehicles.

Nor is it to speculate on the appetite of administrations of every political stripe for the newest technologies of social regulation. What interests me is the closed circuit of the technological system itself.

The Central London Congestion Charging system was introduced on 17 February 2003 (fig. 1.1). Under its provisions, between 7:00 a.m. and 6:30 p.m. on weekdays, cars are charged £8 a day to enter an eight square mile area stretching from Tower Bridge in the east to Hyde Park in the west and bounded to the north and south by the so-called 'Inner Ring Road'. Drivers pay the charge in advance by telephone, using credit cards, by text message, by logging on to an internet site or at post offices, petrol stations and retail outlets, and at self-service machines located in car parks. Information on those who have paid is logged into a centralized database, while, on the streets of Central London, almost seven hundred analogue cameras positioned at entry points to the restricted area, at other points within it, and on a number of mobile units, record the number plates of vehicles passing through the narrow field of view of their lenses. The cameras send live video images over secure fibre-optic communications lines to a secret, central 'hub' site, operated under contract by private sector service providers. Here, automatic number plate recognition technology identifies and reads each vehicle registration mark in the image stream, compiling an evidential record for use in enforcement actions against drivers who have not paid the charge.

At midnight each day, the 'hub' site computers delete the registration numbers of the cars whose owners have paid and relay the plate numbers of those who have not to another computer and thence to the Driver and Vehicle Licensing Agency in Swansea. This government records centre has databases containing the specifications of all of Britain's twenty-eight million vehicles. The data received from the 'hub' site is then checked against these records and the names and addresses of defaulters are forwarded to a third centre in Coventry, which issues the penalty notices, doubling the original cost of the congestion charge for payments after 10:00 p.m. and imposing a £100 fine on those who have not paid by midnight.[1] All this takes place through an automated system connected to existing databases and systems of administration, while the use of analogue cameras ensures the conformity of enforcement processes with the evidential requirements of the courts.

It is not, however, the connection of camera to data storage and record retrieval systems that is new. The incorporation of record photography in nineteenth-century policing, medicine, psychiatry, engineering, social welfare and geographical surveys always depended on the deployment of a composite machine – a computer – in which the camera with its inefficient chemical information storage system was hooked up to the file cabinet with its organizational cataloguing system, constituting for the late nineteenth century a new information technology that would radically redirect the public and legislative functions of the archive. What is striking about the London traffic control system is that cameras, records, files and computers are all involved but, except where

Transport for London

London Congestion Charging Technology Trials

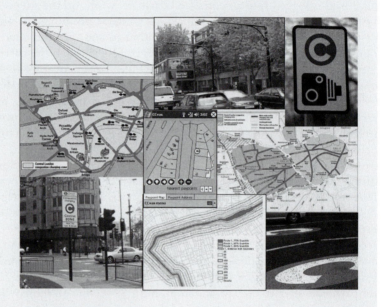

Stage 1 Report

February 2005

Figure 1.1 Cover of *London Congestion Charging Technology Trials, Stage 1 Report*, prepared by the Traffic and Technology Team within the Congestion Charging Division of Transport for London (February 2005).

enforcement proceeds to the courts, there is never a visual presentation.[2] This is simply dispensed with as irrelevant. Certainly, part of the circuit involves an imaging process, but the detour via visualization is all but entirely cut out and, whatever process of recognition occurs, it evidently does not involve anything that might be seen as entailing communication, psychic investment, a subject, or even a bodily organ.

This is interesting and disconcerting. However, let me move to my second instance, which, given my understanding of the science involved, is hardly less anecdotal. It also concerns the surveillance of space, though now of a space of rather larger dimensions than that required to park a car. The lateral space mapped by this image is approximately sixty light years across and the object under scrutiny is estimated to be at a distance of around four hundred and twenty light years from the Earth, which means that the event graphed in June 2005 took place in 1585, or thereabouts (fig. 1.2).

The data on which the image is based were gathered by a radio 'telescope' whose parabolic reflector, fourteen metres in diameter, relayed incoming waves into thirty-two feed horns and receiver systems. In order to chart molecular clouds in this part of the constellation Taurus, the reflector was tuned to the frequency of radiation emitted by carbon monoxide molecules, the measurable amount of power coming in at this frequency being proportionate to the amount of carbon monoxide present. The radio telescope used was capable of scanning a square of half a degree on the plane of the sky every two hours. Given this constraint and the limited period in which Taurus was visible above the horizon, it was possible to scan no more than four squares a day, so that this image of three hundred and fifty-seven squares took a little over eighty-nine days of telescope time to complete, not counting time lost to snow, sleet, thunderstorms and equipment failures.[3]

In principle, the data collected by the radio telescope scans could have been read in digital form by a computer programmed to calculate variations of density and mass. In practice, however, attempts to automate the reading process have met with limited success, not because they have lacked precision, but rather because, at a time when the parameters of the investigation remain open and multivalent, the visual appraisal of morphological variations in the image presentation has allowed for multiple avenues of reading and for the recognition of things that have not been anticipated or built in to the research in advance. Recourse to visualization thus responds to a pragmatics of inquiry that only works, however, when its axes and conventions are strictly defined.

For non-specialists, there is ample scope here for misunderstanding. Even as we look at it, we have to remember this is a visual rendering of non-visual phenomena. What the image represents has nothing to do with spatiality, volumetrics or figure–ground relations. It is a record not of light reflected from varied surfaces, but rather of quantity: of intensity of radiation as a measure of molecular density. It is, moreover, an image mapped in two dimensions only, containing no information along the line of sight. It would be profoundly

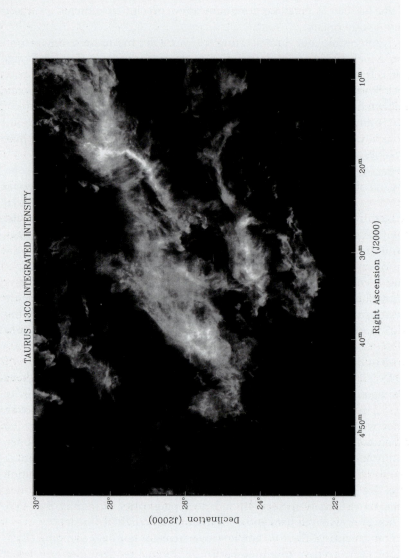

TAURUS 13CO INTEGRATED INTENSITY

Right Ascension (J2000)

Declination (J2000)

Figure 1.2 Taurus 13CO 7 June 2005. Radio telescope image of solar dust cloud radiation from the Taurus Molecular Cloud Survey, National Astronomy and Ionosphere Center, Cornell University, 2005. Courtesy of Paul Goldsmith, formerly James A. Weeks Professor of Physical Sciences at Cornell University, now at NASA's Jet Propulsion Laboratory in Pasadena.

misleading, therefore, to read into it any degree of depth or three-dimension-ality. The colour, contrast, brightness and image density, too, are not indexical, but the products of choices framed by the scales of adjustment and arbitrary colour tables written into the software through which the data on radiation was processed. The colour and tonal contrasts thus have no meaning, except in relation to the heuristic graphic conventions that calibrate signal strength in terms of preset colour variations. Historically, indeed, it was only the develop-ment of digital graphic software programs that enabled coloured image displays such as this to replace earlier astronomical maps that charted variations in density recorded by radio telescope data with 'contour lines' that were often hand drawn. In short, then, this is neither a photograph nor a visual equivalent, however much we might want to see here an apotheosis of Stieglitz or some cosmic drama on a truly Baroque scale, as if we were witnessing Tintoretto's *Origin of the Milky Way* stripped of its allegorical figures and exposed in the awesome, luminous vastness of its primal space.

What we have instead is an artefact whose value is embedded in the 'complex and sophisticated system of visual hermeneutics' in which, through instrumentation, targeted phenomena are prepared and produced as visually readable (Ihde 1998: 77).[4] Driven by what Don Ihde has termed the 'engi-neering paradigm' of 'scientific visualism' (1998: 159), proliferating technologies now routinely convert even non-visual sources into visual ones through such processes as X-rays, ultrasound, magnetic resonance imaging, positron emission scans and computer assisted tomography. Astronomy, indeed, was one of the first sciences to set off down this path, using technologies developed in the Second World War, such as radar and low noise radio receivers, to move from optical instruments, restricted to things observed in visible light, to radio astronomy and, more recently, to the exploration of spectra far beyond the wavelength range to which human eyes are sensitive. With such new instrumentation previ-ously unknown phenomena, such as pulsars, quasars, cosmic background radia-tion and the interstellar dust and dense gas clouds from which new stars are formed, have been constituted as visually graphable images, most often – as here – through conventions of fictive colouration.

In contrast to Ihde, however, I am not here concerned with the epistemo-logical claims made in a technico-scientific hermeneutics for visualization and the necessary distance it implies. It is not the truth-value of the image that engages me, or the protocols of multi-instrumental repetition and varia-tion through which this truth-value is institutionally secured, at least within a certain community of discourse. No more is it a matter of the processes of tech-nological enhancement whose results are both more and less than the sensory capacities and dynamic yet delimited processes of bodily perception. The issue is not the functionality of instrumental prostheses or the adequacy of techno-logical analogies to embodied thought – pace Lyotard (1991), embodiment is no longer the measure here. What we have is rather a kind of reverse ergonomics, as in the graphic display helmets for supersonic fighter pilots that work around

the limited bodily capacities of the human system component, prone as it is to blank out from an overload of instrumentally presented technical calculations and data. In compensation, the machinic ensemble calculates and incorporates the limited bodily capabilities of the human operator and builds them into its system in advance.

Where is this taking us? Well, in *Thinking Photography,* there was a prevailing sense that photography operated in the space between meaning, a subject and the networks of power that hold both in place. It was not that photography was thought of as an analogue of human visual perception or as a transparent tool of human inquiry; rather, photography was framed as a site of human meanings, of meanings that called the human into place. My briefly rehearsed examples undermine this confident assumption. In the one case, there is nothing corresponding to a subject or to meaning as a mental event. There is not even necessarily an engagement of a bodily organ for which the instrument can serve as a kind of prosthesis. And if, in the second case, the circuit through the body does take place, then it constitutes a kind of concession to the inadequacies of corporeal perception and reason, governed by the pragmatics of wiring the organism into a machinic process with maximum efficiency. What we have in my second example is an imaging practice in which the visual is effectively evacuated of content, and this is more than that process of evacuation Jonathan Crary (1990) would say began in the 1840s. Here, the visual is also emptied of any content of palpable sensation, of stimulus and response, of the body as a surface in touch with the world. There is nothing being imaged that can touch the inner surface of the eye. There is nothing to be seen. The process of seeing is no more than a hook-up: a means to plug an organ into a circuit.

In the first case, of course, we have gone one stage further. Here, it is not just that the visual is evacuated of content. The visual itself is evacuated, visualization is dispensed with, and the circuit is completed through a fully automated process that can only with caution be called 'recognition' and 'identification', since there is nothing here that corresponds to the activity of a subject. But what is to stop us from saying that we have arrived here at a technological threshold that, slowly but predictably, will advance to take in the second case, where the variables are multiple and the parameters less defined, so that, here too, the image to reading cycle will come to eliminate embodied sensation, subjective recognition and any sense of an event of meaning as a human event. This would not be a landscape recognizable to *Thinking Photography,* even in its reduction of vision to the workings of a code. It would rather be a landscape in which we would find ourselves propelled towards an unwelcome encounter with a photographic assemblage that is emptied of the visual but that has already captured and stripped out the body, recoding it for other purposes.

Perhaps we are getting nearer the mark. In *Thinking Photography*, photographic processes, whether technological or semiotic, are always recognizable and recognized and within them, problematically or not, the subject always finds itself at home. What my anecdotal examples suggest is a very different process that is

irreducibly external, uninhabitable and non-human. If this is the case, does it not also prompt the thought that what we are dealing with here is not just the horizon of some technological future but a shadow cast over the present and the past, in which photography loses its function as a representation of the ego and the eye and even as a pleasure machine built to excite the body. In place of those figures, photography is encountered as an utterly dead thing; mindless in a much blunter sense than imagined twenty-five years ago; indifferent to the irresolution, uncertainty and incompletion and to the leaps of faith that drive bodily thought and perception; intent not on expanding human functionality and cognitive capacity, but on absorbing, decoding and recoding them. Such a photography, far from being superseded as an inflexible model of perception and subjectivity, as Crary would have it, would have to be seen, from the very beginning, as driving in the opposite direction towards a systemic disembodiment that, accelerating in the technologies of cybernetics and informatics, has sought to prepare what has been hailed as the 'postbiological' or 'posthuman' body for its insertion into a new machinic enslavement.[5] What is expelled by the title, *Thinking Photography*, thus ceases to be a joke but returns in forbidding form as that inorganic machinic regime which has taken a grip on our bodies, that has captured them, and that has recoded them in terms of its own dead flow.

Where might this take us, as we try to engage the complex historical deployments that make up the heterogeneous field of the photographic in which *Thinking Photography* called on us to intervene?

In the 1978 essay that made up my own contribution to the collection, I tried to analyse the production of truth effects in documentary photographs not as the workings of an internal semiotic code, but as an outcome of their discursive mobilization, their channels of circulation, or their 'currency' – a concept that opened on the relation of documentary to the state and that I also sought to connect to Foucault's notion of a 'regime of truth' (Tagg 1982). Photography has no identity, as I said at the time, but the photograph may, for the photograph captures meaning even as the openness of the photographic is captured and fixed by the discursive apparatus of the frame. The workings of capture, however, clearly exceed the framing of the photograph. The photographic apparatus, as I have argued, developed as a composite device in which the bureaucratic administrative technologies of the archive were coupled to the mechanics of identificatory capture built in to the operating system of the picturing machine. This was the platform for the assemblage's utility to sovereignty and to the State: the camera and the filing cabinet – the One-Eyed Man and the One-Armed Man, as Deleuze and Guattari (1987: 424–73) describe them – conjoining magical capture with legislative subjection as the axiomatic processes of technical machinic enslavement in the modern nation-state.

I should not get diverted at this point from where I want to go, but I want to signal that what is animated here is also, more broadly, the apparatus of Culture itself, conceived in German idealism as the unfolding expression of the moral and mental essence of humanity, the very process of collective self-consciousness,

transcending the opposition between the externality of an abstract, rational civi-
lization, with its alienated structures of 'pure culture' that devalue natural being,
and the organic and in-dwelling, if unrationalized, culture of integration of the
community of faith.[6] Where this apparatus of Culture finds its seat and educa-
tive function is in its absolute unity with the State, on the basis of what was
posited as their shared interiority as organic, historical expressions of the under-
lying ethical substance of an ethno-cultural People – the source and foundation
of the nation-state. Culture's task, according to this view, is the creation of a citi-
zenry adequate to this State, not by calling them out in the name of an abstract
humanity and reason, but by raising to consciousness a rationality supposed to
be immanent within them, embodied in the continuity of indigenous custom,
tradition and belief. Conceived as a means to capture a population for moderni-
zation and predicated on the reality of German underdevelopment, the idealist
concept of Culture emerges, then, as a discursive machinery for recruitment
and mobilization that reconciles rationalization and belief and simultaneously
displaces the threat of destruction and revolution.

I said that I should not get diverted, but here is a strategy and machinery
that will take us, one hundred years later, to the threshold of documentary
and its defining relation to the social democratic nation-state. Understanding
the centrality of the relation of documentary to this State form opens the way
to re-seeing documentary photography in its strategic moment, at a moment
of crisis in the late 1920s and early 1930s in which documentary's rhetoric
of appeal took shape in a space of overlapping investments. One stratum was
certainly the State's deployment of the disciplinary technologies, information
storage systems and instrumental knowledges that made it possible to engineer
a take-off in social administration. Overlaid on this was the State's investment of
the new techniques of statistical survey and public opinion research that came
to service the management of consent. Finally, there was the State's appropria-
tion of the developing technologies and the rhetorics of mass communications
that defined the emergent field of public relations. The efforts to functionalize
this array of techniques and technologies converged in the United States in the
mid 1930s around the drive to secure the necessary conditions for the politics
and public culture of the social security State: the liberal, corporatist response
to the crisis of the 1930s; a response that allowed the State a role as economic
facilitator for Capital, even while it positioned the State in a re-secured public
culture as paternalistic mediator and guarantor of a transcendent national
interest. It was a response that would also include what I have elsewhere called
the New Deal cultural strategy – a strategy performatively enacted in the very
structure of documentary.[7]

What marks out documentary from the older regimen of the document
and the record is not only the absorption of narrative strategies from popular
media, which also modelled a system of circulation. The historical specificity
of the documentary mode is above all predicated on a new structure of address
(fig. 1.3) – a rhetoric of recruitment through which viewers fall under what

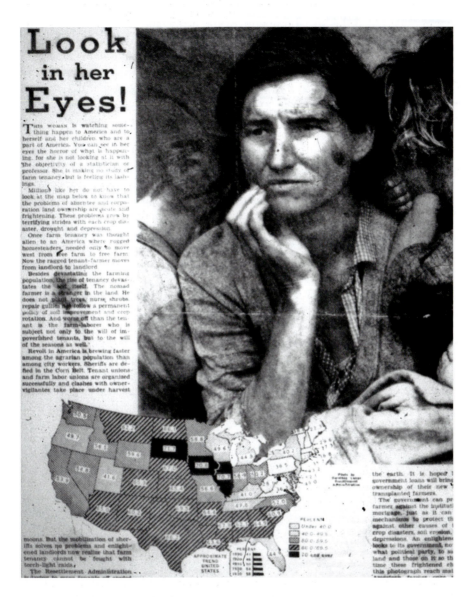

Figure 1.3 'Look In Her Eyes,' *Midweek Pictorial* (17 October 1936).

Lacan once called the 'social function' of the image and are given over to the 'gaze behind', with its 'hypnotic' institution of desire that operates the subject 'by remote control' (Lacan 1979: 113, 115; 1973: 104–6). In documentary, this 'gaze behind' is the paternalistic gaze of the New Deal State: the fulcrum of a machinery of capture that has so little to do with the poor and dispossessed – those *objects* of documentary – and so much more to do with the recruitment of *subjects* as citizens, called to witness, called to reality and coherence, precisely at a time when the established regimes of sense and sociality were profoundly threatened by a crisis that was never solely political or economic. In this conjuncture, documentary constituted a concerted attempt to forestall a crisis in the field of meaning and the field of the subject. It worked explicitly as a means of recruitment whose mobilization sought to incorporate its targeted audiences in an identification with the imaginary coherence of its system – an identification that enacted and secured a particular regime of truth, of subjectivity and of sense, closing down the openness and disputability of reality that is always dangerously prone to erupt at times of crisis. However, in documentary, the refinement of this strategy of appeal was also tied to the disciplinary reconstitution of the social field and to a strategy of governance bound up, in turn, with the history of the modern, interventionist State.

We are returned, then, to the imaginary of the New Deal State and to a cultural strategy enacted in the structure of documentary itself: in its dramatization of witness, in the very visibility it gave to crisis, and in the relations of viewing to which it recruited its subjects. To be captured by this machinery was to be captured in the imaginary of the benevolent, impartial, paternal state, but to be captured in the act of compassionate looking: an act of decency and the act of a citizen – a civic subject called to duty. To feel the moral imperative to look headlong at catastrophe and to meet the eye of the forgotten who look straight back was to bear witness to the truth of citizenship and to renew again the ethical contract between the citizen and the State as the form of our collective participation in that truth. From crisis came the renewal of the corporate community. If only it worked, at least for a time.

Such was the New Deal strategy of crisis management, enlisting identificatory realism in the service of state intervention in order to implicate the viewer in the politics of truth of the administration and in the very perspective of the paternal state – the triumph of its gaze over the eye. To be implicated here was to be caught in a particular closure of sense and in the reality and the relations of subjection it produced: its exteriority and its interiority; its setting in place of a subject for an object and an object for a subject. To be implicated here was, then, to be caught inside a closing down of the disputability of the real, as part of the displacement and incorporation of dissent. Yet, the ending of dispute and the disappearance of dissent did not apparently happen by force – beyond the force of recognition. For to be implicated here was, above all, to be caught in a delirium of transference through which desire was foreclosed and the community 'reconstituted' within what the philosopher Jean-François Lyotard has called

'the imaginary of management' (1997: 31). It was not, therefore, only a rhetoric that was at stake. It was, rather, a cultural–political strategy – a strategy of governance, a politics of representation, an instrumentalization, as always, of 'Culture' itself as what is essential to politics. This takes us a long way from notions of a progressive documentary tradition or of the democratization of visual culture. If documentary documents anything, it is only a certain strategy of power and desire. If documentary captures anything, it is only a certain subject – subject to that strategy of power and to that strategy of desire: the subject of documentary, hit at the midriff, as John Grierson demanded, and yanked up to 'the plane of decent seeing' (Grierson 1981: 39).[8]

We may seem to have come a long way from machinic enslavement and the hard-wiring of the body into the circuits of a mindless assemblage through a machinery of visualization. Yet the mechanism that plugs the viewer into 'the plane of decent seeing' is a political technology that effectively has nothing to do with corporeal vision but merely works through visual recruitment to hold the viewer in place: to capture the viewer as a function of the State. I have said so much about the weight of the years that separate us from *Thinking Photography*, but here is something that has not changed: the indictment of the State as a machinery of technical enslavement; the indictment of the State as a mechanics of disembodiment; the indictment of the State as the Culture of dead things. That is why I look back with lingering regret to a time in the late 1970s when, in the euphoria of political delusion, we half believed that this State could be smashed and that the first brick could be thrown by photographic theory.

Notes

1 See *Your Guide to the Central London Congestion Charge* (2004) and *London Congestion Charging Technology Trials Stage 1 Report,* prepared by the Traffic and Technology Team within the Congestion Charging Division of Transport for London (February 2005). See also, 'Chaos Hits London Traffic Charge Plan' (anon 2002) and Monaghan (2004).

2 Images that are unclear and that might lead to questioning of the evidential record compiled by the automatic number plate recognition technology are also, as the technical report puts it, somewhat enigmatically, reviewed 'manually'. *London Congestion Charging Technology Trials, Stage 1 Report*, p. 25.

3 For the little I understand of the science here, I am entirely indebted to Paul Goldsmith, the James A. Weeks Professor of Physical Sciences at Cornell University. The Taurus Molecular Cloud Survey is a joint venture of Cornell University and the University of Massachusetts at Amherst, funded in part by the National Science Foundation.

4 See also Ihde (1991).

5 The term 'postbiological' comes from Moravec (1988). 'Posthuman' is the term preferred in N. Katherine Hayles's discussion of disembodiment in cybernetics and informational theory (Hayles 1998). 'The new machinic enslavement' is discussed by Gilles Deleuze and Félix Guattari (1987: 456–9). Hayles, I should add, would want to stress the counter-argument, that, by participating in systems whose cognitive capacity exceeds individual human knowledge, human capability is expanded as the parameters of the cognitive system it inhabits expand. The difference here is largely a matter of how one assesses the political technology into which the machinic assemblage is articulated. But it is also a

question whether the body can be said to 'inhabit' an apparatus in whose grasp it can only find itself 'at home' in so far as it suppresses its own corporeal processes and submits to a machinic recoding.

6 The antithesis between the reified rational structures of *Bildung* and the organic community of belief is found in Hegel's *Phenomenology of Spirit,* written in Jena in 1807. This antithesis is transcended in Hegel's later conception, developed in lectures on the philosophy of history delivered at the University of Berlin between 1822–3 and 1830–1, of the essential unity of Culture and the State as manifestations of the underlying Spirit of a specific ethno-cultural People. See Hegel (1977 and 1956).

7 See 'The Plane of Decent Seeing', chapter 3 of Tagg, forthcoming.

8 Part of this essay, originally published in the *New Clarion* (11 June 1932), was included in earlier editions of *Grierson on Documentary*, in 'The Role of the Critic', Forsyth Hardy's introduction to the section 'Background to Documentary'. See Grierson (1946).

Chapter 2

Thinking photography beyond the visual?

Elizabeth Edwards

The sensory photograph

In this photograph by Roslyn Poignant, taken in Arnhem Land, Australia, in 1992, Frank Gurrmanamana sings one of a series of Jambich manikay songs, which are best glossed as sacred history songs. This he does in response to a series of Axel Poignant's photographs of the rom ceremony, holding one of the images in his hand, and matching the appropriate verse in the series to the image.[1] In this way, he engages with and reinforces his relationship with his lineage and ancestors. The verbal imagery of the songs mirrors the visual imagery of the indexical trace of the rom pole motifs, blurring the distinction between the two (Poignant 1996: 23). But the embodied interaction with the photograph is extended beyond the visual as Frank Gurrmanamana uses the photographs themselves as clapping sticks to accompany his singing, holding them in his hands, beating them rhythmically with his fingers, recalling the sound of the clapping stick and its significance.[2]

This photograph, and the use of the photograph within it, encapsulate the multi-sensory and intersensory nature of photographs which I am going to discuss in this chapter. I want to consider ways in which we might extend our understanding of photographs beyond the visual itself, and thus extend our theory of photography beyond the dominant semiotic, linguistic and instrumental models to a more strongly phenomenological approach, in which materiality and the sensual play a central role in how photographs are understood. Throughout this chapter my concern is with the sensory engagement with the physical photograph as a material object. Digital environments and technologies have, of course, radically impacted on much that I discuss. However, the argument is not only historical. While the means of creating and accessing images may have shifted from analogue to digital, and ways of storage shifted from shoe boxes to CDs, there still remains a cultural desire for the material object to fulfil specific social functions. Further, the image on the computer screen still demands levels of sensory and embodied engagement: the slight flicker of the screen, the tap of the keyboard, the physical movement of operating the mouse and the social networks of image exchange (see for example

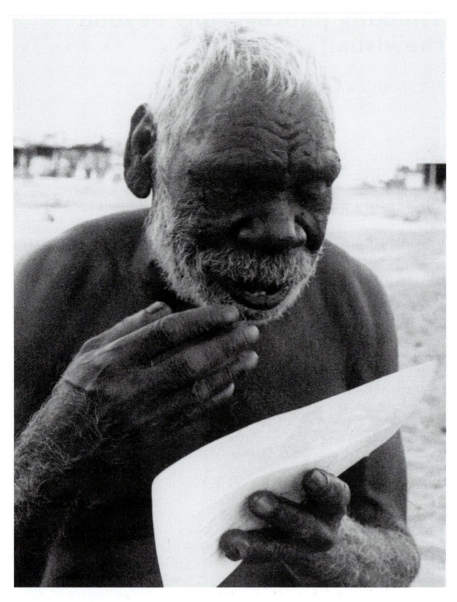

Figure 2.1 Roslyn Poignant, 'Frank Gurrmanamana sings one of a series of Jambich manikay songs'.

Cubitt 1998: 88–90). Whilst they are different in their manifestations, they are also ultimately of the same order.

My chapter concentrates on the role of photographs in the cultural systems that phenomenologists have called 'lifeworlds': 'that domain of everyday, immediate social existence and practical activity, with all its habituality, its crises, its vernacular and idiomatic character, its biographical peculiarities, its decisive events and indecisive strategies' (Jackson 1996: 7–8). This involves a broader sensory apprehension of photographs that is determined through material mediation and questions regarding how the sensory saturates the links between people and people, and people and things, in the social uses of photographs. This position clearly requires thinking beyond the visual. Materiality is of key importance here because materiality precisely emphasizes the relational qualities of photographs in a social context. However, it is not simply the material forms of the image-object that concern me, but the performative strategies which link the body of the viewer with specific sensory formations, in relation to a thing. Sensory and embodied apprehensions, of course, embed, and are embedded by, social relations. Recent work on the photographic object as material culture has stressed the social dynamics of photographs in specific cultural environments, as photographs are handled, caressed, stroked, kissed, torn, wept over, lamented over, talked to, talked about and sung to in ways that blur the distinction between person, index and thing.[3] Furthermore, the performative material culture of photographs stresses their physical presence in the social world. They are written on, exchanged, displayed and performed in a multitude of ways in that they are placed in albums, wallets, frames or lockets, stuck on walls, hidden in shoes, or buried in biscuit tins away from the eyes of the secret police. Clearly, of course, it is the image itself that motivates these actions and embodied responses; but as Barthes (1981: 6) has argued, there is an inseparable 'lamination' of signifier and signified, so materiality and image are likewise inseparable.[4]

A shift towards the oral, the tactile and the embodied as 'the existential ground of culture and self' (Csordas 1994: 6) not only provides new ways of thinking through photographs, it also responds to broader concerns about the way in which the senses have been marginalized in cultural analysis, rather than considered integral to 'being-in-the-world', which is saturated with intentionality, inter-subjectivity, and existential immediacy.[5] The possibility of sensory knowledge is, then, a concern that is emerging in a wide range of disciplines, from archaeology, through anthropology, art history, cultural theory and psychology to neurophysiology.

An extended 'reading', however, can only emerge from a substantially extended and refigured theoretical base, which mediates between the sensual and the analytical (Stoller 1997: xiv). Recent ethnographies of photographic practices that have come out of anthropology have pointed to the necessity of such a theory.[6] A considerable amount of writing on photography within anthropology has, of course, also emerged from semiotic and post-structuralist

approaches to culture. But the more recent work of Edwards, Pinney, Wright and others has shown that a visual semiotics founded on linguistic models provides an inadequate account of the way in which photographs acquire meaning in lived experience. The semiotic model seems to limit our understanding of how images are actually made to have meaning, and there is thus a pressing need to extend this theoretical base by 'prioritizing the knowledge with which people live rather than the knowledge with which Western intellectuals make sense of life' (Jackson 1996: 4). Such a project contributes to a 'corrective anthropology', which attempts to explain the actual lived experience of people through the making of everyday knowledge. As such, it approaches photographs through an ethnographically-grounded consideration of the functions and expectations that make photographs meaningful, rather than a theory that constructs photography as a form of ontological or analytical abstraction (see Elkins 2007). This is not to divorce photography from its meta-levels or to de-politicize it, for its instrumental qualities embedded in power structures remain active over a wide range of visualizing and photographic practices. Rather, this approach attempts to reclaim at least part of the territory where knowledge is not merely about dominant structures of 'how to know' but integrally related to, and negotiated through, multiple social processes and experiences (Jackson 1996: 4).

In many writings on the subject, photographs and photography have become paradigmatic of the privileged relationship between vision and modernity and the latter's disciplinary apparatus.[7] However, if a growing body of recent work within photography theory is beginning to destabilize this position, there have been wider formative murmurings for some time. The broad flow of postmodern influences opened the way for a shift from an emphasis on explanatory causes to one of creative effects (Jackson 1996: 4), in that they destabilized presumed authorities in general and the privilege of European intellectual canons. This had the potential to disperse photographic meaning over a wide variety of sites and practices, including the sensory. Of particular weight, for instance, has been the work of Alfred Gell (1998: 6), whose notion of the social agency of objects calls for a more 'action-centred' approach to things and the way in which they play a 'practical mediating role [...] in the social processes'. At a broad level, recent research in anthropology, but also in art history and cultural history, has taken what one might describe, following W. J. T. Mitchell (2005), as both a material and sensory turn.[8] Linked to this, as I have suggested, is a further-reaching 'turn', the phenomenological turn, which, Jackson (1996: 12) argues, 'prepares the ground for detailed descriptions of how people immediately experience space and time, and the world in which they live', a domain of knowledge inseparable from the world in which people actually live and act.[9] More specifically, the presence – or absence – of the sensory as an inseparable component of the photograph's materiality, has resonated through theoretical writing on photography; if, that is, we care to look for it. Susan Buck-Morss (1992), for instance, has argued that Walter Benjamin's famous essay on the work of art in the age of mechanical (largely photographic) reproduction, represented a move

away from the sensory: from aesthetics (in the original sense of the domain of the sensory) to anaesthetics, a numbing of the sensorium. For Roland Barthes (1981: 80–1), indexicality is a radiation from the real body which touches him and is 'a sort of umbilical cord [that] links the body of the photographed thing to my gaze', becoming redolent with an implied tactile quality of shared skin. Meanwhile, Victor Burgin (1986b) in his essay 'Seeing Senses', writes within a psychoanalytical framework of the way in which language and mental images range across the sensory order. And where Barbara Stafford (1997: 5) has drawn attention to the way in which the Saussurean 'linguistic turn' of textualism, which has impacted on so much photographic theory, has 'emptied the mind of its body, obliterating the interdependence of physiological functions and thinking', Michael Taussig (1993) has argued for the necessity of rethinking the term 'vision' in relation to other sensory modalities.

The inseparable entanglement of the visual in other sensory modes has recently received increasing critical attention within visual culture studies itself. For instance, Mitchell describes this phenomenon as 'braided', in that 'one sensory channel or semiotic function is woven together with another more or less seamlessly' (2005: 262). Whereas Mieke Bal has argued for the 'impurity' of the visual, pointing out the absurdity of an essentialized form of 'the visual':

> The act of looking is profoundly 'impure' … this impure quality is also … applicable to other sense-based activities: listening, reading, tasting, smelling. This impurity makes such activities mutually permeable, so that listening and reading can also have visuality to them.
>
> (Bal 2003: 9)[10]

A similar position has been argued by anthropologist Webb Keene who describes the 'bundling' of sensory and material affects in which an object is defined through the co-presence of the visual with other qualities – such as texture, weight, size (2005: 188).

In art history, this position has been articulated most recently in the work of Hans Belting (2005: 302), who, as part of his broader *Bild-Anthropologie* project, reconfigures Mitchell's emphasis on the trio of image, text and ideology as set out in the 1986 *Iconology*, to posit a matrix of image, medium, and body as a way 'to grasp images in their rich spectrum of meanings and purposes'. That is to say, this matrix becomes the agent through which meaning is transmitted, which, in the case of the photograph, turns on its status as a social object and the body as the perceiving body, on which meaning ultimately depends. A further reworking of the boundaries between people and things, vision and the haptic, is to be found in neurophysiology, where there is a corpus of work in cognition theory that posits that skin is an arbitrary boundary and that things are, in fact, part of the mind. In this formulation, the mind is not so much a series of language-like data structures and symbol manipulations; rather, echoing Jackson's anthropological phenomenology, it is 'the tuning of basic responses to a real world that

enables an embodied organism to sense, act, and survive in a coupling of organisms and the world which is at the root of daily action' (Clark 1997: 4). In this understanding of the human mind as 'wild cognition', people are 'hard-wired' as environmentally embedded and embodied agents: 'beings that move and that act upon and thus within their worlds', in an ongoing engagement with the sensorially-perceived world (7). Or, as Clark provocatively puts it: 'Mind is a leaky organ: forever escaping its "natural" confines and mingling shamelessly with body and with world' (53).

In anthropology, in particular, there is a rich seam of work which, in recent years, has approached the sensory not only as a possible route to richer and denser ethnographic data, but as an area of investigation that will force a rethinking of theoretical and methodological issues in a way that is congruent with the arguments I am making for photography (see e.g. Erlmann 2004: 2). As early as 1986, James Clifford, in the introduction to the seminal volume *Writing Culture* – which largely presented a textual/inscriptive model of culture – implied a sensory argument in that the dominant metaphors of ethnography might 'shift away from the observing eye towards expressive speech [and] gesture' (1986: 12). The sensory has resonated throughout writing on the visual in anthropology for some time and, as I have suggested, can be said to have its roots in the poetics of postmodernist decentrings and destabilizations which emerged in the 1980s. One element in this shift was away from, or at least a profound self-consciousness of, the visualism of anthropology. This manifested itself in a change in emphasis from the observing eye to the expressiveness of speech and gesture, as exemplified by the work of Erlmann (2004).[11] A concern with the performative embodiment within the everyday usage of images has led Christopher Pinney (2001: 158) to develop the term 'corpothetics' by which he means 'the sensory embrace of images, the bodily engagement that most people [...] have with artworks'. He sees this as 'a critique of conventional approaches to aesthetics' and argues for 'a notion of corpothetics – embodied corporeal aesthetics – as opposed to "disinterested" representation which over-cerebralizes and textualizes the image' (2004: 8).

This position is paralleled by recent concerns about the 'decarnalization' of objects and the way in which the analysis of material objects is often premised solely on the visual and its linguistic translation.[12] This is particularly pertinent in relation to the analysis of photographs, where there has been a predominant tendency to see what the photograph is of, but not what the photograph is. Or, as Pinney (2003: 182) has argued, echoing Stafford, 'the stress on the cultural inscription of objects and images has erased any engagement with materiality except in linguistic terms'. This position reflects the values attached to Western understandings of the hierarchy of the senses, in which seeing and hearing stand for the production of rational knowledge, whereas touch, smell and taste represent the lower, 'irrational' sensory realms. Most recently, David MacDougall (2006: 7) has explored the relationship between filmic images and sensory apprehension, arguing that 'we tend to forget how cursory looking can be. To

look carefully requires strength, calmness, and affection. The affection cannot be in the abstract: it must be an affection of the senses'. All these positions suggest that a significant critical trend is emerging from within anthropology and indeed beyond, which locates the ambiguities of visual experience – here looking at photographs – within a broader sensory domain.

What emerges, then, is a fertile ground from which to consider the way in which photographs are made to mean in relation to social actions across the range of sensory experience, in which different perceptual situations demand perhaps different sensual configurations (Burgin 1986b: 58). So, one might argue, my approach in part is engaged in a larger reading of photographic and image theory 'against the grain' (to turn the metaphor back on itself). The aim is not to deny the effectiveness of photographs and photographic theory; rather it is to understand them in transformative ways. In particular, I bring together two key strands – the material and the sensory – in order to explore the way in which they mediate the understanding of photographs in everyday social practices. Within these practices, the photographs themselves become highly charged 'social objects' which, in turn, mediate and are entangled in human relationships. In this way, photography is looked at and makes meanings within a broader 'context of communal sensory orders' (Howes 2005: 5).

But what are these sensory configurations and how do we move beyond mere acknowledgement of their existence? My remarks so far have served to set out a position and, therefore, operate only as a macro-level description, in that they are concerned with the perceiving body as a whole. However, if we are to begin to develop a sensory theory of photography it is necessary to consider the micro-levels of sensory experience in which visual objects are enmeshed. For as Jean Arnaud (2005: 7) has argued in a discussion of the work of artist Michael Snow, 'seeing means activating the image in ways other than through looking'.

Oralities

I am now going to consider the blurred boundary between the visual and the oral, although, as I shall discuss later, the visual and the oral entangle themselves with equal energy with other sensory forms. This is, of necessity, a broad-brush methodological approach – the micro-levels that concern me notwithstanding – because, of course, questions of sensory perception are 'blurred by a host of factors such as class position, ethnicity, and geographical location' (Erlmann 2004: 17). Language has saturated the discourse of photography to the extent that Kracauer saw language as oral tradition as necessary to making photography historically sufficient: 'were it not for the oral tradition, the image alone would not have sufficed' to reconstruct the historical moment (1995a: 48).[13] And, as Burgin (1986b: 51) has argued, the photograph is 'invaded by language in the very moment it is looked at: in memory, in association, snatches of words and images continually intermingle and exchange for one another'. Whilst the

visual and language have been seen as related, theorists such as Burgin and Mitchell have tended to focus on the relationship of similarities and differences between the two signifying systems. My concern here, however, is to move beyond the conceptualization of language as an abstract, symbolic and signi-fying system, to an understanding of language as something heard and integral to the acoustic landscape, in which a series of sonic iterations carries not only the sign, but also emotion. It is this acoustic landscape, moreover, that frames the social interaction of the photograph. Csordas has pointed to the tensions between 'representation', which has so dominated debates on photography, and 'being-in-the-world': semiotics and phenomenology and the parallel concerns with 'language' and 'experience' which emerge from a dominant representa-tionalist theory of language. Rather than rehearsing the common critique that experience is mediated by language, he argues that 'language gives access to the world of experience in so far as experience comes to, or is brought to, language' and, further, that language itself is a modality of 'being-in-the-world'. (Csordas 1994: 10–11) Indeed, there have been periods in history, even in the Western world, when speech itself was considered one of the senses (Classen 1993: 2–4).

Bearing these considerations in mind, I wish to explore the role of the photograph within a specific form of meaning-making, namely, the telling of histories, for this is possibly the major use of photographs and one in which photographs are made to fulfil specific social functions for their users (Jackson 1996: 6). Most photographs exist not in contexts of 'art' or formal expression, but in the everyday: as postcards and in family albums, newspapers or maga-zines. It is these images that shoulder the greatest weight of social meaning. At the same time, they exist in multiple sensory domains.[14] Crucially in this context, such photographs are not only looked at in silent contemplation, but as Erlmann (2004: 17) notes, they are spoken about and spoken to.[15] Their emotional impact is articulated through forms of vocalization as people relate to one another. Photographs are enmeshed in oral stories – personal, family and community histories – as the narrated world is vocally articulated. They are performed through the spoken or sung human voice, telling stories to an audi-ence – formal or informal – and framing social interaction.

Martha Langford (2001) has explored orality in relation to Canadian photo-graphic albums, arguing for the centrality of language and narrative in the understanding of albums as self-conscious historical forms.[16] Langford's analysis does not, however, engage with the material and sensory aspects of photog-raphy that concern me here, making it necessary to extend her notion of the oral dimension of the photograph by exploring the active sensory, experiential reiterations of photographic history-telling. These, in turn, are linked to the social body as a living medium, and thus to the social embeddedness of photo-graphs. As material objects, photographs are 'passageways into those experiential fragments, deferred emotions and lost objects' that are 'integral to the tangible force of […] historical passage' (Seremetakis 1993: 2). We could say that the oral

penetrates all levels of historical relations with photographs to the extent that the spoken and the seen cease to be separate modalities; instead they are bound together in and through the human body.

The oral is, however, not simply the verbalizing of content: 'this is how the street looked when I was a child'; 'I remember that dress: my aunt gave it to me'. Rather photographs both focus and extend verbalization, as they have dynamic and shifting stories woven around and through them, imprinting themselves in and being played back repeatedly through different tellings. They connect people to people. Kracauer (1995b: 5) famously asserted that both history and photography were forms of alienation, distancing and disembodiment, an assertion that resonates with Csordas's (1994) argument concerning the disappearance of the body in accounts of human experience. By contrast, a sensory approach suggests precisely the reverse, as a merging of indexical, iconographical, material and sensory elements reconnects people, history and image. Photographs and voice are performatively intertwined, connecting, extending and integrating the social function of images. Orality is ultimately situational and grounded in physical speech rather than abstract language; it is close to the human lifeworld (Ong 1982: 49). As the spoken word, orality has a viscerality, a greater 'bodily force' (Erlmann 2004: 17). Because of its physical constitution as sound, the spoken word 'proceeds from the human interior [deep in the body] and manifests human beings to one another as conscious interiors, as persons, the spoken word forms humans into close-knit groups' (Ong 1982: 74). So, if language becomes something visceral, emanating from within the body, photographs must be understood as operating within the larger sonic and auditory ecology, which in turn exists in broader soundscapes that themselves sensorially inform the act of telling.[17]

Vocalization and performance, however, must not be thought of simply in terms of 'writable' words or indeed in terms of the linguistic notion of discourse. As I have suggested, we need to think about the way in which photographs exist within sound, the medium of language. It is the sound of the voice that makes language and happening something embodied and experienced. Thus we need to see the oral expressions that envelop photographs in a more extended acoustical form, which takes account not only of the sound of voices, spoken or sung, in rising and falling rhythms, tones and volumes as sound yields up language (Ingold 2000: 248). We must also consider paralinguistic vocalizations such as sobbing, laughing or the production of melody, which has the potential not only to reinforce language but to break its spell and discursive reason' (Howes 2005: 2). Weeping and song, for instance, which so often surround photographs, are about shared emotional states, expressive codes linking people to actual words, images and happenings (Feld 1990: 222). As such, they might be seen as extending and doubling the indexical trace of the image, emotionally and haptically embedding memory practices.[18]

Sound, then, creates an ongoing and dynamic environment in which to view photographs, constituting a social act in that it reinforces both the sociality of

objects, the relations in which they are enmeshed and the sense of the social self. Feld (1996: 130) has described the flow of sound as 'The flow of poetic song paths [which] is emotionally and physically linked to the sensual flow of the singing voice', and 'a fusion of space and time that joins lives and events as embodied memories'. These create the affective tone through which photographs are apprehended. As Ruth Finnegan has argued:

> Here is a subtle intermingling of individually-sounded and -heard creations, of specific context, and of patterns which are more or less enduring and agreed with others. In its own capacity to draw on auditory resources in this versatile mix of ways, human vocal interaction makes up a remarkable, highly flexible and enormously far-ranging human-created tool for sonic communication.
>
> (Finnegan 2002: 80)

Sound creates relational knowledge in the social sense (Erlmann 2004: 5). 'Sound and hearing have a special relationship to our sense of presence. When we speak of a presence in its fullest sense, the presence which we experience in case of another human being, which another person exercises on us and which no object or living being less than human [or we might add "ancestor"] can exercise – we speak of something that surrounds us, in which we are situated: "I am in his presence."' (Ong 1970: 130). This response to photographs is made clear by Gordon Machbirrbirr from Maningrida, Australia, when talking to anthropologist Roslyn Poignant:

> It's like a life coming to you. Like you have your life coming back … I have never seen my ancestor, but I would like to see them in the photo you know and say 'Ah yeah, this is my grandfather'… and when you look at the photo and say 'Aah' and you think that the spirit of that person came to life, and lived.
>
> (quoted in Poignant 1992: 75)[19]

The nature of the photograph doubles this phenomenon. As a surrogate presence of the image content (the dead ancestor) is experienced through its merged visual and bodily apprehension, it suggests the possibility of sensorially-saturated historical experience.

Sound is, of course, inseparable from the embodied experience of hearing. Following McLuhan and Ong, Tim Ingold has pointed out that sound communicates directly and immediately through hearing. Hearing forms a porous boundary between the external and the internal, which appeals directly to 'the "inwardness" of life' (Ingold 2000: 247). But hearing implies listening, that is, engaged, intentional hearing, an alert responsiveness to sound (Connor 2004: 163). Like looking at photographs of the ancestors, 'its social equivalent in the visual sphere is the experience of the eyes meeting and the sense that this

or marginalize the sensory dispositions of the cultural periphery (Seremetakis 1996: x).

Oral expression demands the interaction of a specific audience at a specific time, that is, it is lodged in relationships, creating the contexts for the transmission of stories, remembering of course, that the subject of the photograph itself can be the interlocutor. The narrated story allows the audience to respond as stories are woven around photographs, which are held, passed from hand to hand, and caressed. These are not single voices of linear narrative, for photography itself, with its infinite re-codability, militates against linear narratives. Photographs exist in a world of fragments and discontinuities, triggering a series of associations of conscious and unconscious thoughts (Burgin 1986b: 69). But at the same time, photographs allow histories or stories to emerge in socially interactive ways that would not have emerged in that particular figuration if the photograph had not existed. In this context, Lucy Lippard (1992: 20) has agued, in relation to Native American readings of photographs, that in many ways, 'understanding [...] photographs is a process of reaching out for what is finally absent, rather than grasping the presence of new "truths"'. Photographs become active voices. Again, this is more than a question of simply a triggering of memory; rather, as Daston (2004: 9) has argued, it is things, in this case photographs, that enable people to talk: 'we would stop talking [...] we would become as mute as things are alleged to be. If things are "speechless" it is because they are drowned out by all the talk about them'.

It is the sensory approach, I would argue, that allows photographs the space to be heard. Verbalized, histories and photographs become polyphonic, dialogic narrations in which the narrator shifts from point to point, adopting appropriate modes, effecting responses from his or her audience (Brown and Peers 2005: 230–1). In this, sound, or acoustic patterns, are socially organized and follow a recognized cultural logic to modulate 'special categories of sentiment and action' (Feld 1990: 79, 99). The rhythms shift from straight narration, song, lamentation, laughter, all of which demand different sets of responses from listeners. But responses are not necessarily ordered; instead they are multi-layered and dynamic, mirroring the disorder of photographs themselves. Photographs literally unlock memories and emerge in multiple soundscapes, allowing the sounds to be heard and thus enabling knowledge to be passed down, validated, absorbed and refigured in the present. In this way, the oral entanglements of photographs render them truly multi-vocal. As such, photographs can be seen as emotional, interactive and relational, giving the chance to 'open horizons beyond the micro-analytical to a way in which wider social organization [such as telling history] might be understood' (Csordas 1994: 15). In this, the sensory order around photographs is refigured towards a less concentrated, but more immediate, mode of apprehension.

What we see emerging is a more complex arena in which to understand the mutability of the photographic, in which meaning resides not only in the endlessly recodable signifier, but in the embodied apprehensions of the photo-

produces a communicational contract' (Carter 2004: 43). To extend this para-
digm then, the heard sound of the oral, listened to, draws the visual, the photo-
graph, deeper into the world of the perceiver and his or her social relations. In
this way it reinforces and moulds the apprehension of the photograph.
It extends the photograph from the enclosed pictorial space of the image itself
to something 'dynamic, always in flux, creating its own dimensions moment by
moment' (Carpenter in Ingold 2000: 249).

However, silence, the absence of voice or sound, is an equally important form
of performance and communication (Tacchi 1998: 28). This might, of course,
be the intentionally silent contemplation of photographs, a specific moment
that involves specific social desire surrounding photographs: one can imagine
Barthes' (1981: 67–71) contemplation of the photograph of his mother in the
Winter Garden as such a silent moment. However, one can argue that forget-
ting and loss are not merely about a Barthesian 'that-has-been', but that silences
represent a non-functioning of the oral, a lack of sociability, around photo-
graphs. Such silences may not be intentional, but enforced by the history of
power relations and regimes of visibility. Yet they contain that which Burgin
(1986b: 58) has described as the 'faint auditory images of words' which here
might constitute possible histories. The power of this suggestion is demon-
strated in the way in which photographs are often described through oral meta-
phors. For example, an exhibition Lost Identities: A Journey of Rediscovery
(1999) curated by members of the Peigan Nation, Canada, proclaimed on its
website that 'photographs can speak, they can whisper or shout'; but they are
also described as voiceless: 'Many photographs ... are silent. When individuals,
events or other details are not known, photographs do not have voices'. People
were asked to 'find voices and stories buried in the pictures'.[20]

Oral articulation, the naming of names, invests tellers with a dynamic power
over their own history, breaking the silence, articulating the interaction of
photographs and people in historical relations. Hence the importance of photo-
graphs in telling genealogies, for photographs return or reinforce the power to
speak of one's history, to name names (MacDonald 2003: 235–6), for the named
can no longer be erased from history.[21] There is a strong sense in which such
histories, mediated by photographs, are inscribed in the flesh which, evoked by
sensory modalities, incorporates cultural memory and history (Stoller 1997: 45).
The photographic moment intervenes in the sensory structures of everyday life,
which become marked and recalled; it intervenes in the zones of amnesia for
'the senses as the bearers or record-keepers of involuntary and pervasive mate-
rial experience, and therefore as potential sources for alternative memory and
temporality are precisely that which is frequently subjected to social forgetful-
ness and thereby constitute the sphere of hidden history' (Seremetakis 1996: 20).
This, of course, becomes important in histories of fracture and dispossession,
such as Native American or Australian Aboriginal histories, but it is equally so
in other forms of submerged or alternative historical narrative, where it can
be argued that the imposition of Western-style visualism has been able to hide

graphic object itself. Indeed, as if to extend this argument, Erlmann (2004: 5) has suggested that 'hearing and associated sonic practices' cannot be contained in their own domain; rather they have worked 'in complicity with the panopticon, perspectivism, commodity aesthetics, and all the other key visual practices of the modern era we know so much about', taking us back again perhaps to received theories of photography.

Tactilities

Orality does not exist, however, outside the broader patterns and practices of embodiment. Indeed, as we have seen, the very act of making sound comes from within the body. It is an active not passive process that is also linked to hearing (Erlmann 2004: 10).[22] There is a strong tactile or haptic component in the oral expression of photographs, as people must be in the presence of one another to communicate as photographs are viewed in groups in close proximity, passed from hand to hand, displayed, discussed and handled within everyday practice.[23]

Touch is in many ways the most intimate of the senses, and as Barthes (1973: 90) argues, it is 'demystifying', for it registers the body to the outside world. Touch draws attention to the perception of one's own bodily state, as the outside is absorbed and registered through sensitive parts of the body, especially hands (Stewart 1993: 31, 33). This not only pertains to the way in which Barthes (1981: 80–1) talks about the touch of the indexical; as the finger is run over the image, touch gives solidity to the impressions of the other senses: it connects people to things. It is the act of touching the photograph that accentuates a sense of the presence of the ancestor, confirming vision, as touch and sight come together to define the real (Ong 1982: 168–9; see also Rose 2004). Photographs are held, caressed, stroked and kissed. In family photographs, for instance, perhaps touch transfigures the indexical into the real for a moment, as fingers trace the image of the referent, a sensory accumulation which materializes historical consciousness. Seremetakis terms this 'commensality', which she defines as 'the exchange of sensory memories and emotions and of substances and objects incarnating remembrance and feeling'. In this type of exchange, she continues, 'history, knowledge, feeling and the senses become embedded in the material culture and its components: specific artefacts, places and performances' (Seremetakis 1993: 14).[24] As photographs become active sensory interfaces between referent and viewer, there is a perpetual movement between touching to see and seeing to touch, to the extent that touch enables seeing, in this way bringing about a blurring of the iconic, indexical and material aspects of the photograph. In this context, the integral relationships between seeing photographs and touching the referent are played out at the surface of the image. Indeed, the indexical trace is sometimes removed by constant touch: it is worn away. This, however, does not necessarily invalidate photographs as social objects. As Chris Wright (2005: 263) found in the Solomon Islands, photographs were still 'seen' as being

'of' someone and treasured as such, long after the material decay of the photo-graph had rendered the image illegible in terms of Western thinking.

The relationship between touch and sound is what Conner (2004: 154–6) terms a form of 'sonic tactility', which is connected to the telling of history. In this, he echoes Finnegan's (2002: 213–14) argument that 'Human memory is extended and embodied through our tactile as well as our visual or audi-tory experience. Something of a commemorative function can be performed through the handling of familiar objects (such as photographs) [...]. [S]ymbolic tactile contact between humans through external artefacts is yet another way in which human beings extend their experience beyond the here and now into the longer ranges of the past'.[25] The tactile qualities of photographs, with their smooth surfaces and delicate paper bases may be secondary to the visual, but they are nonetheless highly significant in the transmission of shared values. And indeed, it is often the case that touch is necessary in order to see and thus to construct a stable and apprehensible visual field.[26]

However, in this, not only are photographs touched, but they are also enmeshed in a fluid continuum of touch and gesture by means of which groups of interlocutors are made to cohere. As I mentioned earlier, in the context of my discussion of materiality, photographs are viewed in groups: bodies touching, a proximate sense of an interpreting community.[27] For as Classen (2005: 1) has pointed out, touch is not just a private act, but a 'fundamental medium for the expression, experience and contestation of social values and hierarchies'. A number of anthropologists have noted how photographs are viewed, passed around and commented upon, according to local kin and political hierarchies, and in this way, the photographs are made to perform the appropriate histories within age and gender groups. Poignant (1992: 73), for instance, reports how photographs were passed back away from the women and taken to the other side of the yard for viewing by the young men of the family, in accordance with the community's complex avoidance rules. Similarly, Bell (2003: 115), working in the Purari Delta region of Papua New Guinea, describes how at Koiriki he handed photographs first to male elders as protocol demanded, after which they were passed down through the hierarchy.

Proximity brings into play non-verbal channels of communication – facial expression, gesture, even smell – all of which contribute to photographic meaning, in that they create environments for the affective experience of images. Following McNeill (1992: 1), gesture in this context might be described as the 'spontaneous creations of individual speakers' and is marked here only as the articulation of touch and embodied responses to photographs. Touching is one of the most expressive gestures, which both links the personal, idio-syncratic, and context-specific to socially regulated aspects of experience, and frames the pragmatic content of the oral image, marking the story. Gesture coexists with speech, in that we should 'regard the gesture and the spoken utter-ance as different sides of a single underlying mental process' (McNeill 1992: 1). Even small movements reinforce both voice and image and thus narration.

For gestures themselves are visual in that they are seen in conjunction with, for instance, sound. They make narrative more vivid and reveal the speaker's conception of the discourse, extending language/speech beyond the production of sound to an embodied sensory experience.

Obviously, gesture, like other sensory forms and bodily behaviours, is profoundly cultural and so generalization is largely meaningless. Nevertheless, it is essential that photographs are understood as embedded in gesture just as they are in oral expression. For words, and thus related images, have meanings not only linguistically but, as I have suggested, through the nuances of gesture, inflection and facial expression, that is, 'the entire human existential setting in which the real spoken word always occurs' (Ong 1982: 47). This link between body, gesture and telling histories has, of course, been widely recognized by oral historians as an integral part of the performance.[28] It is, therefore, equally important to recognize that the presence of the photograph will elicit specific gestural and haptic forms, which shape the communication of memories. The fact that touch and gesture become so important in the unspoken relations with photographs can be linked back to the indexical quality of the photograph.

A tentative conclusion

Touch and gesture return us to relationships because, as Finnegan observes (2002: 212), they operate in the 'immediate bodily presence of interacting participants' and thus they bring us, finally, back to the photograph of Frank Gurrmanamana, singing 'stingray' to the photograph, and at the same time using it as a clapping stick. I have perhaps strayed far from the visual dynamics of photographs, but while photographs might be predominantly visual, they are what Mitchell (2005: 262) describes as 'braided' in that 'one sensory channel or semiotic function is woven together with another more or less seamlessly'. Likewise, one sensation is often followed by, and closely related to, another, to form continuous patterns of experience, representing a dense social embedding (Howes 2005: 9; Erlmann 2004: 9). For the experience of photographs, their meaning and impact, cannot be reduced merely to a visual response. Rather, they must be understood as corpothetic, and sensory, as bearers of stories, and of meanings, in which sight, sound and touch merge.[29] This position responds to the inherent reflexivity in photographs, the shifting relations between referent, image and viewer which have marked thinking about photography almost since its inception. It is therefore necessary to recognize that we 'see with our whole bodies', as shifting attention, physical movements and visceral responses mark our relations with the image in a broader economy of the senses (MacDougall 2006: 3). Interpretation of, and through, the senses becomes a mode of recovering of truth as a collective, material experience revealed through gesture, experience, and performance (Seremetakis 1993: 6). If touch and sound are defining characteristics of vision in relation to the social use of photographs, then, methodologically, there is no way in which we can elide the material,

and thus the sensory, in thinking about photographs. Bodies literally perform images.

Kracauer (1995a: 52) wrote of photography that in order for history to present itself, its mere surface coherence must be broken, because the 'likeness' of the photographic image might refer to the look of the subject, but does not immediately reveal itself to understanding. One could understand this as a challenge to the visual surface of the photograph: that its full apprehension lies within and beyond the visual. If photography produces a set of objects, meanings and social relationships – what we might gloss as 'histories' – we need to look for more diverse ways to understand the apprehension of photographs, to break their reduction to the visual alone. Paul Stoller (1997: 89), in his book *Sensuous Scholarship* has argued that 'fully sensuous scholarship encompasses reality, imagination and reason, difference and commonality fused and celebrated in both rigorous and imaginative practices as well as in expository and evocative expression'. Of course, such an approach requires specific, ethnographically grounded studies of embodied apprehensions of photography and photographs in order to be meaningful. As Mitchell (2005: 257) rightly points out, 'all so-called visual media turn out to involve the other senses', and thus we have to understand the precise role of the visual in this wider domain. However, the sensory should not be seen merely as a way of extending our understanding of vision, but of fundamentally refiguring our understanding of not only the social functions of photography – although this is perhaps the most obvious of areas – but also in arenas of aesthetic practice: from the privileging of certain forms of sensory and material response in traditional connoisseurship (Willumson 2004: 47–76), to the engagement with the multi-sensory character of images by contemporary artists (Schneider and Wright 2006). While I have only been able to map out the contours of a territory of where and how we might take these ideas further, my overall aim has been to contemplate whether it is time to extend our thinking about photographs beyond the visual and beyond the simply material existence of photographs, and to position the apprehension of photographs across the complex exchanges of sensory experience (Burgin 1986b: 58), to move them from the objectifying tendencies of vision, to the connectedness of sound and touch (Ingold 2000: 246). Such an approach moves photographs beyond the dichotomy of the oral and the visual, to a broader sensory apprehension of the world. An anthropological approach points to different modes of consciousness from which emerge differently figured ways of knowing, and so (who knows?) we might eventually arrive at a reconfigured theory of photography: a theory that emerges from what people actually do with photographs.

Notes

1 Personal communication, Roslyn Poignant, 2003.
2 For an extended analysis of these issues in a specifically Australian context, see Edwards (2005).
3 For work on photographs and materiality, see Edwards (1999); Edwards and Hart (2004); Pinney (2004); Wright (2004); Batchen (2004). For a debate on the nature of materiality, persons and things, see Rowlands (2005).
4 On the inseparability of the photographic image and its material base, see Edwards (1999). This also applies to digital environments.
5 Whilst Batchen's (2004) recent work on 'vernacular' photographies has rightly stressed the need for a more visceral reading of photographs that encompasses touch, sound and smell, it fails to engage analytically with the cultural nature of that sensory experience and viscerality.
6 See, for example, Edwards (2005); Pinney (2004); Wright (2004).
7 See, for example, Crary (1990); Jay (1993); Lalvani (1996); McQuire (1998); Tagg (1988).
8 Stoller (1989: 38) uses the term 'sensual turn' to escape from 'the sediment of certainties of cultural empiricism'.
9 A broader phenomenological analysis is beyond the scope of this chapter, but the connections between my discussion and Merleau-Ponty's notion of 'being-in-the-world' and Husserl's concept of *Lebenswelt*, for instance, are clear.
10 For responses to this position see various contributors, *Journal of Visual Culture*, 2003, 2(2).
11 Of course, similar critiques of visualism emerged at the same time in other disciplines. See, for example, Jay (1993); Crary (1990).
12 For a discussion of material culture and the senses more generally, see the essays collected in Edwards, Gosden and Phillips (2006).
13 For an extended discussion of language and photography, see, for example, Scott (1999).
14 Throughout this chapter I am using the term 'everyday' to mean photographs that exist in what James Elkins has described as the domain of 'non-art images'. These photographs make up the vast bulk of photographs ever taken, used and displayed. For this reason, I am resistant to the concept of 'vernacular photography/photographies' because the term implies a minority norm from which the majority depart and in relation to which they are found wanting in some way. Elkins's (1999) concept of 'non-art image' in my mind similarly reproduces the category norms.
15 In silent contemplation photographs might, of course, be entangled within inner speech, which links disconnected and incomplete, yet saturated language to images (Burgin 1986b: 57).
16 Langford's (2001: 122–23) stress on the orality of photographs, the specificity of oral consciousness, and the way in which 'an album's oral structure and interpretive performance will bring us closer to understanding the photographic work' is instructive here. However, her analysis draws heavily on the more formalistic qualities of the work of Walter Ong (1970) and Jan Vansina (1965 and 1985), reproducing their characterizations of oral culture as a-historical, undynamic, totalized and technically determined.
17 There is, of course, a substantial philosophical and theoretical literature devoted to language, speech and writing that stretches back to the classical period in which, for example, Aristotle argues that only the spoken word represents mental experience. For a useful summary see Ingold (2000: 247–9).
18 There is an extensive literature on the anthropology of emotion which is beyond the scope of this chapter, but it should be noted that Harkin (2003), for instance, has argued the importance of recognizing emotion as a modality in historical narrative.

19 Gordon Machbirrbirr is Burarra photographer at the Maningrida Bilingual Literature Production Centre, Arnhem Land in Australia, see Poignant (1992). For similar sentiments in a British context, see Rose (2003, 2004).

20 *Lost Identities: A journey of rediscovery*, 1999, <http://www.head-smashed-in.com/frimidentity.html> accessed 19 April 2006).

21 For a discussion of the importance of naming and photographs, see Brown and Peers (2005). In relation to their project with the Kainai Nation, Canada, they discuss the embodied processes through which 'named' photographs shifted from being 'anthropological types' to 'named ancestors' embedded in local historical practices.

22 This is not unlike Merleau-Ponty's (1962: 93) description of the double sensation of touching one's own skin.

23 The viewing of photographs in digital or camera-phone environments is rapidly shifting the embodied practices of image viewing and sharing. See Cubitt (1998); Sutton (2005).

24 As Stewart (1993: 31) has pointed out, 'touch' is strongly linked with emotion (at least in English): 'I am touched' means 'I am emotionally moved'.

25 Batchen's (2004) analysis of 'vernacular' photography has also stressed the importance of the tactile but does not explore the nature of the tactile.

26 Mitchell (2005: 263) summarizes theories of vision from Descartes to Oliver Sacks, which have emphasized the centrality of touch in vision. See also Lindberg (1976).

27 An extended consideration of this topic might explore the kinaesthetics of photographic engagement, drawing on a wide range of material from the anthropology of movement. For an overview of the field, see Farnell (1999).

28 See, for example, Finnegan (1970); Tonkin (1992: 51–2); Ong (1982).

29 There are ways in which one could extend this analysis to smell and perhaps even taste. Carolyn Steedman (2001: 70) has written, in a way that might be extended to photographs, of the 'feel' of the archive and the smell of past paper, the dust from decaying paper and leather that coats the hands making them dry, stains the clothes, and catches one at the back of the throat. Régis DeBray (1996: 153–4) has also connected photographs with smell: 'Is not a photograph as affecting as an odour, unexpected and poignant? We might even think of it as an odour for the eye, set down and made perennially fresh by the material […] that has received the graphic image of a person long since fled: an odour that remains.'

On snapshot photography

Rethinking photographic power in public and private spheres

Catherine Zuromskis

I

In May of 2004, the late cultural critic Susan Sontag made her final pronouncement on the moral destitution of photography in an excoriating article for the *New York Times Magazine* entitled, 'Regarding the Torture of Others: Notes on What Has Been Done – and Why – to Prisoners, by Americans'. Her subject was the then recently discovered photographs of prisoner torture at Abu Ghraib prison in Iraq. One of the most egregious of these images (fig. 3.1) depicts two smiling American soldiers, Army Specialists Charles Graner, Jr. and Sabrina Harman, posing behind a pile of naked, hooded prisoners. Echoing her positions in *On Photography* and *Regarding the Pain of Others*, Sontag regarded these photographs as evidence of an increasing complacency toward violence in American visual culture. Citing conservative justifications for the photographed acts of torture – that the prisoners were hardly innocent and that it was all in fun[1] – and evasions that address not the volatile content of the photographs but the very fact of their existence as a threat to the safety of American soldiers, Sontag posits a numbing of American sensitivity and morality towards images of suffering. As more and more photographs are taken and consumed, Sontag argues, the world is atomized into a series of disconnected images and anecdotes. By embracing these isolating images, she charges, we have abandoned political agency, cultural intimacy, and moral accountability in favour of an anaesthetizing flow of visual content. Thus, regarding the images of prisoner torture at Abu Ghraib, she concludes, 'the photographs are us', the grim ethical legacy of our unbridled fascination with photography (Sontag 2004: 26).

Within a week of its publication, Sontag's position was, not surprisingly, echoed by *Times* op-ed columnist Frank Rich and savaged as a 'freewheeling, incoherent, anti-American diatribe' by *The National Review* (Goldblatt 2004). The article, in my view, drew much-needed attention not to the acts portrayed in the Abu Ghraib photos *per se*, but to the photographs themselves and the very fact of their existence in our image-saturated culture. Sontag's article raised important questions about why such photographs

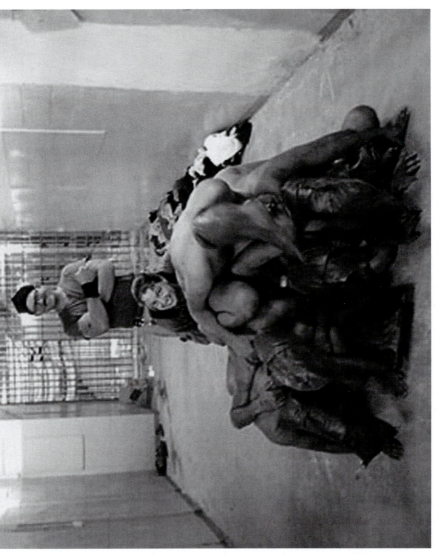

Figure 3.1 Army Specialists Charles Graner, Jr. and Sabrina Harman posing with prisoners at Abu Ghraib prison.

were taken and for whom. At the same time, however, something about the article made me bristle. It was not that I disagreed with Sontag's political stance – far from it. Like Sontag, I was and continue to be appalled by the unjustified onslaught of American imperialist violence in Iraq. And I too was disturbed by the pleasurable ease with which the perpetrators of 'prisoner abuse' posed alongside their victims, and the quickness of the conservative administration to rationalize away such concrete evidence of gross military misconduct. But I felt that underlying this justified political rant, in her own circuitous way, Sontag was really pointing the accusatory finger *at photography*, suggesting that the medium itself was complicit in the creation of a culture that could produce, and in certain tacit ways support, images like this one.

This position was not a new one for Sontag; she always had a somewhat contentious relationship with photography. From her earliest writings on the subject, Sontag has struggled to reconcile her deep fascination with photographs with an insistent sense of the specious morality of the medium. While she is quick to acknowledge the way that photography enthrals its viewers, offering beauty, fantasy, knowledge, and a democratic aesthetic on a scale unparalleled in other visual media, she also states in no uncertain terms that 'there is an aggression implicit in every use of the camera' (1977: 7). As a machine of distance (whether physical, psychological, or aesthetic) the photographic apparatus is also a tool of domination. By taking up the camera, she argues, one chooses voyeuristic detachment over immersive experience. Aesthetically speaking, Sontag views this as an essentially surrealist enterprise: automated, alienating, and trespassing on alternate realities. But she also reads this voyeuristic act as inherently violent: photographs 'appropriate' and 'incriminate'; they 'turn people into objects to be symbolically possessed' and are 'a potent means of gaining control over' another. In one passage, she likens the camera to a gun and photography to 'sublimated murder'. In another, she cites the plight of the wartime photojournalist who must choose between capturing an image and saving a life (1977: 4–18).

Photographs like the one reproduced here seem tailor-made to illustrate Sontag's position. The scopophilic domination of the helpless prisoner/subject by the cruel and unflappable soldier/photographer fits perfectly into Sontag's binary model of photographic power. The photographs taken at Abu Ghraib were integral to the acts of torture being carried out. Particularly in tortures like simulated sex acts, the presence of the camera was designed to heighten the prisoners' humiliation and degradation. Moreover, by documenting these acts on film, prison guards underscored their control over the prisoners both in the moment and into the indefinite future.[2] And thus, Sontag suggests, however instrumental they may have been in exposing military misconduct, these images are always already implicated in the acts they depict: 'The horror of what is shown in the photographs cannot be separated from the horror that the photographs were taken' (2004: 26).

But is it really that simple? To be sure, this image constitutes an act of aggression, but it is also distinct from many of the public modes in which photographs of atrocity are often disseminated – the artistic and journalistic war photographs, for example, that form the basis for Sontag's investigation in *Regarding the Pain of Others*. What struck me immediately upon seeing the Abu Ghraib photographs in general, and the above image in particular, was that despite the overt violence of the subject, the visual style of the photograph most resembled that of a common snapshot. It was clearly made by an amateur with a digital snapshot camera, presumably (if the soldiers' expressions are any indication) for pleasure. In its central composition, its carefully orchestrated pose, and the clichéd 'thumbs up' gesture, the image recalls candid photographs from a family vacation or an outing with friends – except that instead of posing alongside a sand castle or the fishing trip's catch of the day, these snapshooters pose alongside debased and humiliated prisoners. And it is for me the snapshot quality of this image that makes the scene all the more horrifying: by combining the unmitigated violence of the actions depicted with this unsettlingly familiar photographic rhetoric of the snapshot, the image seems to posit torture as the norm, a banal and unremarkable part of everyday life.

I call attention to this fact because the snapshot genre has always seemed a pregnant omission in Sontag's writings on photography. While her approach to the photographic medium is deliberately wide-ranging – considering both vernacular and aesthetic examples – Sontag devotes only a few pages in the entirety of her writing on photography to the lowly, ubiquitous snapshot. This is perhaps because the unique characteristics of the genre pose something of a challenge to Sontag's rigid, binary formulation of photographic power. How, then, might the codification of this image as a 'snapshot', alter Sontag's interpretation? Reading every photographic act as one of aggression and detachment, Sontag not only essentializes the medium, ignoring the mutability of power in different genres and individual photographic instances, but she also disregards social constructions of power that organize photographic meaning on a grand scale. My aim, then, is not to contradict Sontag's assertion that power is always embedded in the rhetoric of the photograph, but to articulate that power differently, as a struggle between discrete and private photographic acts and the publicly constructed ideology of photographic norms. In so doing, I seek not to redeem images like the one above, but to open them up to closer scrutiny. Indeed, it is precisely because these photographs are so awful, and so politically loaded, that I think they deserve a more careful exploration than Sontag's justified but limiting moral outrage allows. In what follows, then, I will explore the genre of snapshot photography in more detail in the hope of complicating Sontag's essentialist (and essentially moral) reading not only of the Abu Ghraib photographs but also of the medium as a whole.

II

Let me begin by looking at a very different image: the man pictured here is my father and the child in striped trousers is me, circa 1973 (fig. 3.2). While genre distinctions can be slippery, I think my readers will generally agree that this image qualifies as a 'typical snapshot'. I use the term 'snapshot' to describe an amateur form of image-making, requiring little or no photographic skill on the part of the photographer. Theorists of the genre have characterized the snapshot in terms of its intimate social function and its simple and straightforward visual style.[3] The subject (here the familiar parent and child pairing) generally has considerable personal or emotional significance for the photographer (in this case my mother), and the photographer maintains this emotional emphasis on the subject by circulating the image within a distinctly private, often familial sphere of consumption. Whether placed in a silver frame, pasted in an album, or tucked away in a shoebox, photographs like these constitute emotional touch-stones, personal totems, and conduits to happier, simpler times within their particular networks of consumption. I am particularly drawn to this photograph because of its framing. My mother shoots from slightly below eye level with my father, emphasizing the thrilling vertigo of my position atop his shoulders. But such aesthetic concerns are ultimately secondary, as long as the snapshot fulfils its basic indexical function. Indeed, snapshots often seem designed to be as stylistically unremarkable as possible. The identifiable visual rhetoric of the genre is one of utterly banal visual conventions: frontal posing, central framing, demonstrative gestures of affection, and the all-important smile. But what these conventions lack in originality they more than make up for in affective func-tion; in combination with the emotionally significant subject and a sphere of eager and intimate consumption, these conventions above all others testify to the intimacy and complicity of the familial bond.

In her brief treatment of the subject, Sontag attempts to fit the snapshot (or, as she more broadly defines it, 'popular photography') into her larger analysis of the medium by focusing on the public face of the genre: its ritual conven-tions. Popular photography, she says, is primarily 'a social rite, a defence against anxiety, and a tool of power' (1977: 8). In a somewhat circular argument she suggests that we take pictures because not to do so would be unthinkable. The photographic act dispels anxieties of unbelonging by providing a socially acceptable and minimally intrusive form of engaging with others and claiming life experience. The tourist who snaps pictures everywhere she goes allevi-ates fears of being in an unfamiliar place by colonizing new spaces through her lens. And the nuclear family maintains superficial bonds to an increasingly distant extended family through a cluster of mute faces staring from frames on the mantelpiece. In either case, Sontag's reasoning suggests, the photographer or the photographic consumer maintains a symbolic connection through the photograph but one that is precisely only symbolic, supplanting real interaction and experience.

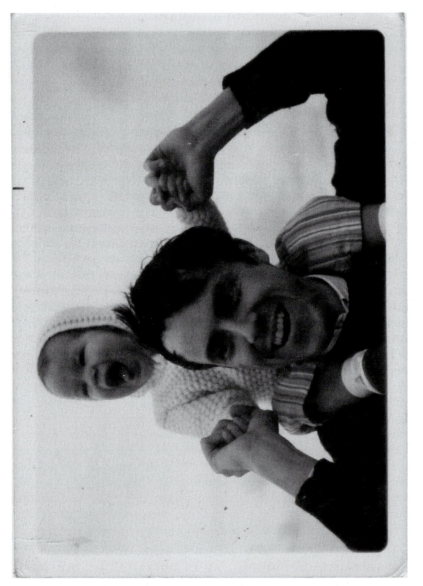

Figure 3.2 The author and her father, c. 1973. Collection of the author.

While the picture of my father and me provides a good example of the affective function of the snapshot described above, it also fits well into Sontag's mechanics of distance and aggression. The photograph is, by all accounts, a 'good snapshot'. Both subjects are fully visible and smiling. The pose is significantly carefree (signifying spontaneity) as well as one of affection (denoting familial intimacy); and of course, since it captures the child at a young age it fulfils the all-important role of preserving the fleeting moments of youth. The image is then designed to fulfil the social imperative of documenting familial closeness. By snapping this picture, having it developed, sending prints to relatives and archiving it in an album, my mother arrests any anxieties she might have about being a good parent. Yet in order to do so, Sontag might suggest, my mother had to extricate herself from the familial interaction itself. As iconic as the image might become once it is memorialized in a frame or the pages of an album, my mother can only ever enjoy this moment voyeuristically. Thus, she chooses distance and the opportunity to possess a trace of the past over the chance to live in the present.

This kind of analysis is convincing but, I think, incomplete. By focusing on the ritual of snapshooting, Sontag accounts for one of the most striking aspects of snapshot photography: the way that, from one individual to the next, private snapshots look remarkably the same. This is why I can show a personal photograph in the public context of this book and feel confident that my readers will understand its rhetorical meaning even if they do not recognize the subjects. Sontag also perceptively notes that photography gives a form of agency to the individual with the camera, a means of signifying a connection to people, places, or events (even if that connection ultimately distances as well). Where I think she missteps, however, is in collapsing the ritual conformity and the individual agency of snapshot production and consumption into one impulse, as if to imply that popular photography coalesces organically into ritual practice. In contrast, what strikes me as interesting about the snapshot, and that which makes it such a provocative object of study, are the instances where these two agendas refuse one another, playing out the struggle between cultural norms and individual desires through the rhetoric of the image.

III

Here is another typical snapshot: a boy and girl (brother and sister perhaps?) strolling happily down the beach (fig. 3.3). Or at least this appears to be a typical snapshot but for the fact that it is in a 1952 advertisement for a Kodak camera (having been used for another campgain two years previously. Sontag emphasizes the ritual function of the snapshot in certifying familial bonds, but because of her ontological approach, she is far more interested in the qualities she can locate in the medium itself than in the social, cultural, and political influences that construct its use. But images like this testify to the way that ritual photographic culture is *externally* constructed. Historical evidence suggests that many of the

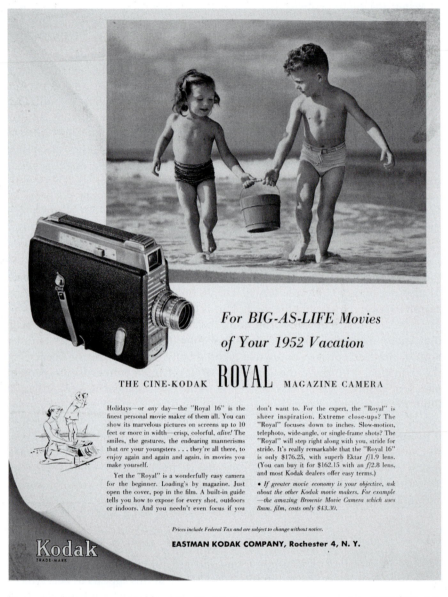

Figure 3.3 Advertisement for the Cine-Kodak Royal Magazine Camera. July, 1952. © Kodak. Image courtesy of George Eastman Collection, George Eastman House.

aspects of snapshot culture we consider natural or inherent are, in fact, socially and commercially manufactured. Nancy Martha West has shown, for example, that snapshooting was first associated with outdoor leisure activities like biking, skiing, and picnicking (West 2000). Only after Kodak began to advertise snapshot cameras as a means of documenting family life and emotional relations in the domestic sphere did snapshot photography gain such a poignant and important role in the chronicling of sentimental family histories. As an example of just such a promotional image, what is interesting about the photograph in this advertisement is that despite its conventional appearance, the image is simply too good to be a real snapshot. The subject is candid, but the children are too perfectly framed, shot in close-up and at eye level. Despite their proximity to the photographer they seem oblivious to his presence. In addition, their (fully visible) expressions and gestures are highly demonstrative of a kind of accord and mutual generosity that may be something of a rarity in real-life sibling interaction. This photograph, then, like any number of images circulated publicly through Kodak and Polaroid promotional material, popular photography manuals, print advertising, and even the photos filling empty picture frames at the store, presents a carefully constructed visual ideal, designed to direct and normalize our individual notions of what can and should be considered a 'good snapshot'.

This visual ideal is at once unattainable and, in a way, invisible. On the one hand, the ideal snapshot is deliberately distinct from the prevalence of 'real' imperfect images, so often marred by frowns, blinks, blurry turns of the head, and accidental thumbs across the lens. It sets the bar intentionally high, ensuring that snapshooters will take lots of pictures, buy lots of cameras and film, and invest more emotional energy in the image when it comes out well. However, as dominant as this ideal is, it is also internalized, hegemonic. Emphasizing visual simplicity and the fundamental emotional bonds between photographer and subject, snapshot photography is a mode of image-making that is constructed precisely to seem unconstructed, manufactured to be read as spontaneous. The naturalization of this ideal is central to the importance of the snapshot in American culture. Snapshots are proof positive of domestic and social harmony, potent symbols of the American Dream accessible to (almost) any member of the general public. With their firm footing in traditional values, to borrow an idea from Lauren Berlant, snapshots produce normative cultural citizenship through private actions.[4] The more we 'impulsively' strive for this photographic ideal, the more such symbolic conventions are cemented into American culture. What I want to posit then, in contrast to Sontag's model of the photographer driven by a compulsive need to appropriate ritualistically and colonize the world around her through her lens, is an external, regulating discourse of snapshot meaning, one that advances commercial and moral–political agendas, but also one that conceals itself within the notion of a naïve, unstudied, and instinctual mode of photographic production. Furthermore, insofar as she reads these conventions of photographic practice as essential to the medium itself, Sontag not only ignores the hegemonic forces invested in photographic meaning, she also reinforces them.

IV

As I have suggested, however, the hegemonic conventions of snapshooting are only half of the story. While snapshot photography operates within a highly normative structure, this structure is inhabited by a collection of singular, disparate photographic acts. These acts – polymorphous, individual, and rooted in personal, even clandestine desires – contradict the social and cultural conventions of snapshooting in subtle but important ways. Challenging the notion that snapshot photography can 'mean only culturally', photography scholars have argued that snapshots are vital tools in the preservation and creation of individual histories and memories (Kuhn 1995). Paramount to this function is the memorialization of things at their best. Thus, while snapshots draw much of their emotional cachet from being photographic – and therefore, it is assumed, unfailingly truthful – traces of the past, the image itself often offers a distinctly rosier and inaccurate version of the events portrayed. A week-long family car trip marred by arguments and tears can still produce the perfect portrait of the entire family, harmonious and smiling, in front of the Grand Canyon. Or there is this photograph (fig. 3.4): me again on the far left, a few years ago, with some fellow graduate students who, like me, were attending a six-week summer program at Cornell University. While the impressive Taughannock Falls, off camera right, provided the impetus for general picture snapping, the real focus was on the making of memories and connections between the participants. Insofar as this photograph signifies that the five of us were there in front of the waterfall on that day this photograph is an accurate representation of reality. But there is more going on here. At the time this image was taken, we did not know each other well, but by picturing us together this photograph signifies a mutual affinity between the sitters: we are posing as friends despite the fact that we are not, yet, and may never be. As such we have internalized the rhetoric and conventions of the snapshot, and are fulfilling our social duty, preemptively even, by posing for a picture together. This image then represents a fantasy of substantive bonds between the subjects and a speculative claim on possible future intimacies.

This speculative claim is particularly loaded in the case of the man I am seated next to, Daniel, who is now my husband. At the time this photograph was taken, we had engaged in a brief flirtation at a few social events, but neither of us had yet articulated our feelings to one another. As people milled about at the base of the waterfall, someone, I can't remember who, waved me into this group to pose for a picture. Motivated by my accidental but photographically symbolic proximity to Daniel, I passed my camera to the photographer for my own version of the image. Given that no significant intimacy had yet occurred between Daniel and me, the gesture had multiple functions. First, by posing for this photograph and by asking the photographer to take the picture again with my camera I am signifying my attraction to Daniel, my desire for future closeness. Daniel, by doing the same, is reciprocating that gesture, but since the future of our relationship is as yet uncertain there is also an element of fantasy here; if

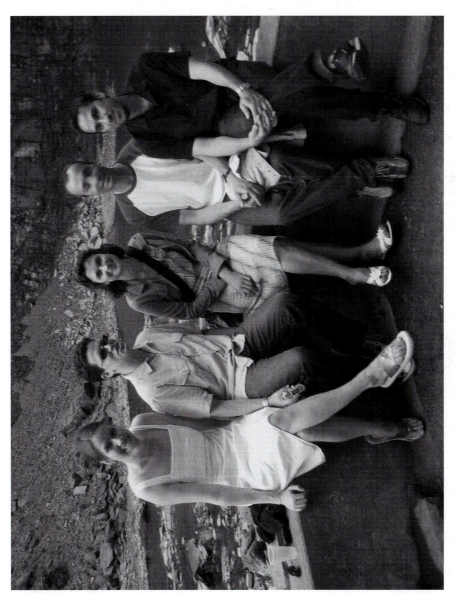

Figure 3.4 The author with friends at Taughannock Falls, near Ithaca, NY, summer 2004. Collection of the author.

my flirtation with Daniel goes nowhere, a trace of our mutual desire will still be available for me to return to through the image.

I want to suggest that the individual dynamics of this photograph pose a challenge to Sontag's model of photographic power. First, the most persuasive counter-example to Sontag's posited 'act of aggression in every use of the camera' is the snapshot's emphasis on emotional relations. Snapshot photography is constructed as a private mode of interaction between individuals; to pose for a photograph, to pose with someone in a photograph, or to solicit a pose in order to take a photograph, are all, within the realm of snapshooting, conscious gestures of intimacy. If one of us had resisted the photographic act, demonstrably refusing to be included in the image by scowling or turning away, the snapshot moment would have been ruined. There is, then, a power dynamic at work here, but it is not quite as simple as Sontag would suggest. The snapshot depends upon the sharing of photographic power, a collaboration between the photographer who knows how to frame the image and trip the shutter, and the sitter who knows how to pose, smile, and hold still so that her image will deserve revisiting later. In some cases, this subjective agency eclipses the photographer's power entirely, as when the tourist relies on a passing stranger or a self-timer and a well placed rock to document her vacation memories.

On the individual level, then, the snapshot radically decentres the simple binary of photographer/self *versus* subject/other, resituating the photographic act as a connective or dialogic gesture that manifests agency on both sides of the lens. On one level this mutual agency serves to reinforce the hegemony of snapshot convention by establishing real-life intimacies through photography. However, I would argue, as well, that snapshot photography offers individual opportunities for non-conformity, for subtly challenging the dominant ideology of snapshot practice through private photographic acts. Poised at the cusp of cultural normalcy and individual anomaly, the snapshot is engaged in both repressing and revealing the truth of the latter. As I have noted, even if a closeness had never developed between Daniel and me, I would still have a photographic fiction of that closeness; and while snapshot culture dictates otherwise, I would have had the power to enjoy that fiction as private visual fantasy. Popular culture is full of cautions against the fantasy misuse of such potent images. From the iconic scene in *Mommie Dearest* (Frank Perry 1981) in which a hysterical Joan Crawford violently eliminates an ex-lover from her past by cutting his face out of every one of her photographs, to tales of child pornographers turned in to the authorities by photomat technicians, to the protagonist of *One Hour Photo* (Mark Romanek 2002) who constructs a fantasy family through stolen snapshots, popular culture seems to offer almost as many negative examples of snapshot practice as positive ideals. These examples are presented as dangerous, perversions of photographic decency, but as such they are also sites of political possibility. Indeed, I suggest that the close regulation of this private culture of photographic production through hegemonic conventions speaks to the very volatility of a form that is so personal, so tied to individual desires.

V

So which is the case with the Abu Ghraib photograph? Are Graner and Harman's photographic instincts in some way guided by the hegemonic force of snapshot culture or do their snapshot memories of torture in an Iraqi prison constitute an aberration of this most banal mode of image-making, revealing perversion and moral decrepitude? In my analysis of the genre as a whole I have tried to resituate Sontag's formulation of photographic power from the domination and objectification of the subject by the photographer or viewer, to a struggle between monolithic photographic conventions and swarming individual practices.[5] And I think this model nicely illuminates if not the meaning of the Abu Ghraib photographs, then at least the cultural struggle to interpret them. On one side there is Sontag (and many others), who ignore the cultural associations of the snapshot genre in order to indict these images and the conservative spin machine that has worked so hard to neutralize them. While she refers to the photographs as 'snapshots' in passing, Sontag is far more invested in comparing these images to public and commercial photographic modes: photojournalism, pornography, and notably, the souvenir lynching photographs of the late nineteenth- and early twentieth-century American South.[6] Because the Abu Ghraib photos were 'meant to be circulated and seen by many people', she says, they indicate a public audience for and acceptance of the atrocities they depict (2004: 28). On the other side of this interpretive struggle are the members of the Bush administration who emphasize precisely the private nature of the snapshot image. If we take the conventions of snapshot photography at face value, the amateur look of the image and the grotesque 'thumbs up' point not to a systemic problem, but rather to the deviant dealings of a few morally deficient individuals acting purely on their own impetus.

Perhaps, then, the truth of this image lies somewhere in between – drawing together public sentiment and private desires, official protocol and unauthorized actions. While we can be quite certain that this image was not meant to appear, as it did, on the front page of the *New York Times*, it also did not occur in a void. And the fact that images such as these follow the rhetoric of snapshot photography speaks not only to the disregard for human life and dignity on the part of the proud soldiers posing and smiling alongside debased Iraqi prisoners, but also to a military and political culture in which such images are seen as 'normal', 'all in fun'. Ultimately, I do agree with Sontag, but only in part. And I suggest, in contrast to Sontag's claim that the events at Abu Ghraib were 'designed to be photographed' (2004: 29), that photography is not so much culpable of the atrocities it represents as a window onto pervasive ideologies (in this case of racism and violence) that emanate unconsciously from intimate acts. As such, the revelatory nature of the medium is equally capable of aiding and undermining such ideologies. Which of these is the case with the Abu Ghraib photographs, I leave open for debate.

Notes

1 Sontag illustrates this point with a quote from conservative radio talk show host Rush Limbaugh, who, during a radio broadcast in May 2004, stated: 'This is no different than what happens at the skull and bones initiation and we're going to ruin people's lives over it and we're going to hamper our military effort, and then we are going to really hammer them because they had a good time. You know, these people are being fired at every day. I'm talking about people having a good time, these people. You ever heard of emotional release?' As quoted in Sontag (2004: 28–9).

2 Indeed, as Seymour Hersh has reported, some government officials understood the purpose of these images to be blackmail: 'It was thought that some prisoners would do anything – including spying on their associates – to avoid dissemination of the shameful photos to family and friends. [An unnamed government consultant] said, "I was told that the purpose of the photographs was to create an army of informants, people you could insert back in the population". The idea was that they would be motivated by fear of exposure, and gather information about pending insurgency action, the consultant said' (2004: 38).

3 See, in this regard, Julia Hirsch (1981); Marianne Hirsch (1997); Marianne Hirsch (1999); Kuhn (1995); Spence and Holland (1991).

4 In *The Queen of America Goes to Washington City*, Berlant challenges notions of an embodied public sphere with the assertion that American cultural citizenship is today, 'a condition of social membership produced by personal acts and values, especially acts originating in or directed toward the family sphere' (Berlant 1997: 5).

5 In this notion of swarming individual practices I am much influenced by Michel de Certeau's *The Practice of Everyday Life* (1984), in which he posits a dynamic relation between the established structures and institutions of power and the heterogeneous, fragmentary, and invisible practices of individuals.

6 On the parallels between the Abu Ghraib photographs and lynching photographs, see Apel (2005).

Chapter 4

Family photography and the global drama of human rights

Andrea Noble

> Most of us addressed or implicated by these forms of performance protest are not victims, survivors or perpetrators, but this is not to say we have no role to play in the global drama of human rights violations.
>
> Diana Taylor, *The Archive and the Repertoire*

> What *makes for a grievable life*? Despite our differences in location and history, my guess is that it is possible to appeal to a 'we', for all of us have some notion of what it is to have lost somebody. Loss has made a tenuous 'we' of us all.
>
> Judith Butler, *Precarious Life*

On 24 August 2004, the digital edition of the Argentine daily *Clarín* featured a colour photograph of a smartly dressed man in his mid forties holding up two black-and-white family snapshots for the camera (fig. 4.1). Like most family photographs, those on display in this image are in many ways unremarkable: a man and woman smile warmly at the viewer. Numerous details within each image accentuate the homely, relaxed intimacy of these family scenarios: the man's pipe; the bisected figure of the child who leans back into the embrace of the person we assume to be his father to get into the viewfinder's field of vision; and the arm that affectionately rests across the woman's shoulder. Although this couple is unknown to us, their pose is more than familiar in its everyday informality and predictability that is the hallmark of family photography as a genre. Displayed in their current context, however, these family snaps, whilst sadly familiar, are anything but ordinary. As the accompanying caption and text reveal, the man who proffers the photographs to the camera is Daniel Tarnopolsky, the only surviving child of Hugo Tarnopolsky and Blanca Edelberg, whose disappearance, along with two of their three children, in July 1976 was linked to agents of the military dictatorship. Their still images here bear eloquent testimony in the context of a photo opportunity staged to mark the compensation that ex-admiral Emilio Massera, a key perpetrator in the regime of state terror (1976–83), has been ordered to pay Tarnopolsky. To the right of the frame, completing this politically charged family scenario, sits Estela

Figure 4.1 Tarnopolsky, with the leader of the Abuelas, Estela Carlotto, shows photographs of his parents.

Carlotto, the leader of the Abuelas de Plaza de Mayo (Grandmothers of May Square), a civic association whose aim is to locate and return to their rightful families those children kidnapped during the dictatorship.[1]

If these intimate, private snapshots of Hugo Tarnopolsky and Blanca Edelberg are, through their repetition of the conventions of family photography, in themselves instantly familiar, so too is the public display of this photographic genre in images such as this one. Alongside formal portraits and ID photographs, the family snapshot has acquired emblematic status in the context of human rights activism in Argentina and indeed across a range of Latin American countries. In response to the violence, repression and impunity that have been a recurrent feature of the region's political life with particular force between the 1960s and 1980s, photography has emerged as a centrally important element in the material culture of protest and struggles for justice. The political uses to which photographs have been put are multiple in those countries of the subcontinent in which state repression and its favoured modus operandi, forced disappearance, are prevalent. From Argentina, Chile, through Peru, Honduras, Guatemala to Mexico, photographic images have wide currency in the political arena of human rights struggles, with the potential to engage a community of viewers outside the national sphere in which the disappearance took place (fig. 4.2). As a mode of photographic performance and endlessly repeated gesture staged precisely for the camera, such images have achieved iconic status.[2] Instantly recognizable by a broad transnational viewing public, they loudly proclaim, 'these are our children, our partners, our siblings; they are missing; where are they? We want them back'. Or, in the case of the Tarnopolsky photo opportunity, 'these were my parents, my siblings: all the money in the world cannot bring them back'.

In fact, what makes the Tarnopolsky photo opportunity such a compelling image, in part, is its intensely self-referential nod to an established iconography of human rights activism in Argentina and beyond, in which the photograph within the photograph has become a poignant symbol of forced disappearance. Despite the charged, emotive freight of these photographs, there is, however, a tendency to overlook them, to view them as mere props in human rights activism, rather than endowed with their own specifically photographic agency in the struggles for justice, truth and memory across the subcontinent. So, for example, there is by now an abundant literature on Latin American state terrorism and resistance to it; with regard to the material culture of protest, with a few notable exceptions detailed below, inquiry has been scant and is long overdue.

In the opening line of an essay that persuasively argues that we have an ethical and political responsibility to attend to image production and management in the context of war crimes, military operations and paramilitary atrocities, Thomas Keenan (2004: 435) poses the following simple question: 'What difference would it make for human rights discourse to take the photo opportunity seriously?' Although Keenan is explicitly concerned with perpetrator images, or as he puts it, 'Not the photo ops on behalf of human rights, but the ones

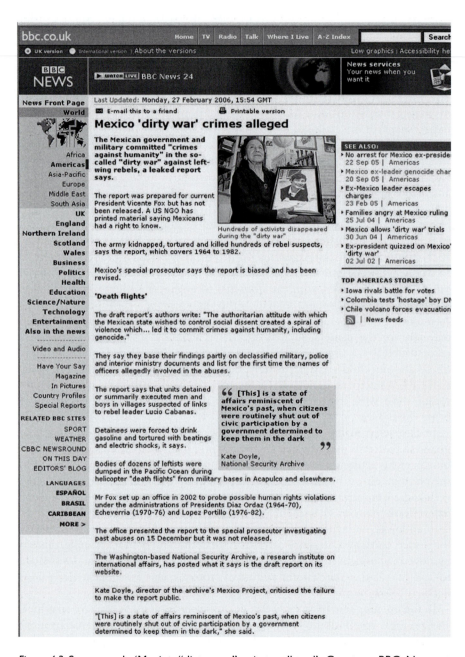

BBC NEWS

▶ WATCH LIVE BBC News 24

News services
Your news when you
want it

News Front Page

Last Updated: Monday, 27 February 2006, 15:54 GMT

World

✉ E-mail this to a friend 🖨 Printable version

Mexico 'dirty war' crimes alleged

Africa
Americas
Asia-Pacific
Europe
Middle East
South Asia
UK
England
Northern Ireland
Scotland
Wales
Business
Politics
Health
Education
Science/Nature
Technology
Entertainment
Also in the news

Video and Audio

Have Your Say
Magazine
In Pictures
Country Profiles
Special Reports

RELATED BBC SITES
SPORT
WEATHER
CBBC NEWSROUND
ON THIS DAY
EDITORS' BLOG

LANGUAGES
ESPAÑOL
BRASIL
CARIBBEAN
MORE >

The Mexican government and military committed "crimes against humanity" in the so-called "dirty war" against left-wing rebels, a leaked report says.

The report was prepared for current President Vicente Fox but has not been released. A US NGO has printed material saying Mexicans had a right to know.

Hundreds of activists disappeared during the "dirty war"

The army kidnapped, tortured and killed hundreds of rebel suspects, says the report, which covers 1964 to 1982.

Mexico's special prosecutor says the report is biased and has been revised.

'Death flights'

The draft report's authors write: "The authoritarian attitude with which the Mexican state wished to control social dissent created a spiral of violence which... led it to commit crimes against humanity, including genocide."

They say they base their findings partly on declassified military, police and interior ministry documents and list for the first time the names of officers allegedly involved in the abuses.

The report says that units detained or summarily executed men and boys in villages suspected of links to rebel leader Lucio Cabanas.

Detainees were forced to drink gasoline and tortured with beatings and electric shocks, it says.

Bodies of dozens of leftists were dumped in the Pacific Ocean during helicopter "death flights" from military bases in Acapulco and elsewhere.

> 66 **[This] is a state of affairs reminiscent of Mexico's past, when citizens were routinely shut out of civic participation by a government determined to keep them in the dark** 99
>
> Kate Doyle,
> National Security Archive

Mr Fox set up an office in 2002 to probe possible human rights violations under the administrations of Presidents Diaz Ordaz (1964-70), Echeverria (1970-76) and Lopez Portillo (1976-82).

The office presented the report to the special prosecutor investigating past abuses on 15 December but it was not released.

The Washington-based National Security Archive, a research institute on international affairs, has posted what it says is the draft report on its website.

Kate Doyle, director of the archive's Mexico Project, criticised the failure to make the report public.

"[This] is a state of affairs reminiscent of Mexico's past, when citizens were routinely shut out of civic participation by a government determined to keep them in the dark," she said.

SEE ALSO:
▸ No arrest for Mexico ex-preside
 22 Sep 05 | Americas
▸ Mexico ex-leader genocide char
 20 Sep 05 | Americas
▸ Ex-Mexico leader escapes
 charges
 23 Feb 05 | Americas
▸ Families angry at Mexico ruling
 25 Jul 04 | Americas
▸ Mexico allows 'dirty war' trials
 30 Jun 04 | Americas
▸ Ex-president quizzed on Mexico'
 'dirty war'
 02 Jul 02 | Americas

TOP AMERICAS STORIES
▸ Iowa rivals battle for votes
▸ Colombia tests 'hostage' boy DN
▸ Chile volcano forces evacuation

📶 | News feeds

Figure 4.2 Screen grab, 'Mexico "dirty war" crimes alleged'. Courtesy BBC News at
<http://www.bbc.co.uk/news>

coming from the other side, the other sides' (435), this chapter is set in motion by the flip-side of Keenan's question. That is, in the first of two inversions, I am interested precisely in 'the photo ops on behalf of human rights'. If, as Diana Taylor asserts in the epigram that frames this chapter, we have a role to play as onlookers in the global drama of human rights violations, through an exploration of the photo op on behalf of human rights in the context of Argentina and Latin America more widely, my aim is to explore the terms and conditions of this role. Taking the Tarnopolsky photo opportunity as emblematic of what we might term the photography of disappearance, this chapter raises a series of questions regarding the political and emotional work that is done by this mode of photographic display. Where does the political effectivity – and affect – of such photographs lie? What is the photography of disappearance's mode of appeal, whom does it address and on what terms? Is this a peculiarly Latin American phenomenon or does it have wider significance beyond this particular geo-political location? At the same time, however, this chapter's concerns are equally methodological. In my discussion of the material culture of protest in Latin America, with its emphasis on the family that is dramatically crystallized in the Tarnopolsky photo opportunity, I reformulate Keenan's question. I also ask: what difference would it make for photography studies – particularly that branch of photography studies concerned with the politics of family looking – to take human rights discourse seriously?

The transnational tactics of political protest

Violence is deeply rooted in the social fabric of both Central and South American countries. Or as Edelberto Torres-Rivas (1999: 285) puts it in sobering perspective: 'It may be stated that more than half of Latin American societies (forming 75 per cent of its overall population) have experienced various forms and degrees of political terror'. It is the method of the 'disappearance' of persons which has become one of the most notorious hallmarks of Latin American political regimes. In the face of such repression, powerful grassroots movements emerged, convened by relatives of the missing who took to the streets and plazas to protest against the abductions and to demand their relatives' return. Of these groups, the Argentine Madres de Plaza de Mayo is, without doubt, the most prominent, formed when relatives of the disappeared started to make enquiries at courts, police stations, army barracks, prisons and the like, in the process gradually beginning to recognize each other. Their first formal protest march took place in April 1977, when fourteen mothers gathered in the Plaza de Mayo, the main square in Buenos Aires and the heart of Argentine civic life, to draw attention to their plight. The group, composed mostly of housewives, with little or no experience of political activism, rapidly began to organize into an important form of resistance to the military government.[3]

The influence of the Madres has not, however, been confined to the sphere of Argentine politics; as Diana Taylor (1997: 184) contends, the work of the Madres

also inspired numerous other political groups across Latin America. In the information age, solidarity networks and sharing of tactics have become even more evident, with links to a range of similar organizations a common feature of the websites of most groups. Indeed, a revealing example of the transnational flow of practices of political activism, in Mexico the first *escrache* was carried out on 15 August 2004 by representatives of the Comité Eureka and the Mexican affiliation of the human rights organization composed of children of the disappeared, Hijos por la Identidad y la Justicia contra el Olvido y el Silencio (H.I.J.O.S.: Sons and Daughters for Identity and Justice Against Forgetting and Silence). Derived from the Argentine slang meaning 'to uncover', *escraches* have their origin in Buenos Aires, where protesters gather publicly in front of the home or place of work of a known perpetrator of state terrorism. The Mexican protesters assembled outside the home of ex-president Luis Echeverría, who is widely believed to have been deeply implicated in the 1968 Tlatelolco massacre and ensuing 'dirty war'.[4] Thanks to transformations in the global communications media, modes of engagement in political activism now travel in ways that were barely imaginable when the Madres first started to organize in the 1970s. This is nowhere more evident than in the prominence accorded to the photographic image as a travelling icon of disappearance par excellence.

Of the academic commentators to have addressed human rights activism in Latin America, including the role of photography, the work of Diana Taylor stands out for its lucidity and is worthy of comment here, not least because it precisely pays close attention to the performative dimension of such activism that is played out in the domain of the visual. In *Disappearing Acts* (1997) and the 1994 essay 'Performing Gender: Las Madres de Plaza de Mayo', Taylor focuses on the Argentine 'dirty war' in light of its theatrical qualities and the self-presentation of its key protagonists, the military and the Madres de Plaza de Mayo. More recently, in *The Archive and the Repertoire* (2003), she has also drawn comparisons with connected performances in other locations, including Mexico, Peru and the United States. What though, does Taylor have to say about questions of photographs and performance?

Pointing to the Madres' method of pinning photographs and copies of photographs to their clothes, Taylor emphasizes the women's display of themselves as 'walking billboards' (1994: 287). The physical deployment of images, particularly identity photographs, is central to the representation of absent bodies of the missing, defying the junta authorities which destroyed records, withheld information and denied the waiting families a proper burial. At the same time, the display of photographs of the disappeared, which were inscribed with the name and date of their subject's abduction, insisted that these were people with names and faces. In recent years, the Madres have not featured images of their children as prominently in their public protests as was once the case, but this does not mean that the role of photography in the material culture of protest has diminished. Rather H.I.J.O.S., which like the Madres and Abuelas are an association that politicizes affiliative bonds in their activism, have inherited

many of the values and practices of their maternal forebears, whom they 'quote' in their use of photographs, but their performance is not identical (Taylor 2003: 187). Where the Madres, under dictatorship, concentrated on the fate of their children, the children of the *desaparecidos* have their sights 'clearly set on the repressors' (2003: 180). As well as the photographs of their parents, they take and parade images of torturers and military leaders, visual acts of exposure carried out outside the dwellings of the perpetrators of atrocities.[5]

If Taylor is primarily, although not exclusively, concerned with Argentina, it is instructive to turn now to cultural theorist Nelly Richard, whose work, with its focus on Chile, offers further evidence of the wider, transnational currency of the photography of disappearance. Her work also presents a different approach to the material culture of protest that is more tightly focused on the photographic object itself as an artefact that enjoys a special relationship with the past of which it is an indexical inscription. In the essay 'Imagen-recuerdo y borraduras' ('Image-memory and erasures'), Richard (2000a) examines the way in which visual artists Luz Donoso and Carlos Altamirano reference photographs of the disappeared as they were deployed by relatives in work that seeks to engage with the 'problemática del recordar y del olvidar' (problematic of remembering and forgetting) that courses through post-dictatorship Chilean society. Before exploring the work of these artists, however, Richard sets up the theoretical paradigms that frame her analysis. She does so through careful attention to the ontological affinities between the photographic act and the practice of forced disappearance that endows the photographic object with uncanny potency in the discourses of memory that are the subject of her essay.

Alluding to theorists of photography, including Roland Barthes, Susan Sontag and Jacques Derrida, and particularly their emphasis on the medium's spectral qualities and its ability to materialize its absent referent in the present, the thrust of Richard's argument is oriented towards establishing a structural relationship between photography and disappearance. In a nutshell, in the display of images of the disappeared as forms of political protest, the photograph's metaphoric abduction of its subject from the flow of time powerfully evokes the real practice of disappearance whereby human subjects are violently abducted from the flow of life. Furthermore, Richard notes that the photographs on display in these protests tend to fall into two categories, namely identity and family photographs:

> In the first case [...] the subject is regulated by the law which individualizes that subject, isolating his/her identity, separating him/her from his/her context in everyday relationships to place this identity at the disposal of social control under the sign of the impersonal. In the case of the photo album, the subject is linked to the biographical plot of a family group whose personal ties are ritualized in the photographic ceremony of being-together.
>
> (Richard 2000a: 166)[6]

Whilst identity photographs belong to the public sphere of surveillance and state control, and family photographs to the private, domestic sphere, both sets of images work in the service of the archive and, as Richard (166) explains, provide visual information about people or circumstances, according to a classificatory order: typological, in the case of the identity photograph or chronological in the case of the family album photograph. In the case of the identity photograph, the public documents that exemplify the disciplinary gaze of the state and its institutions are turned back upon this gaze when the family re-appropriates the image to testify at once to the missing person's presence – he/she *was* here – and his/her absence.[7] In the case of the family photograph, this private document is conversely taken out of the private album and inserted into the public sphere. In both instances, for Richard, the political charge of such photographic performances by relatives of the disappeared resides in the structural parallel between the photograph, its referent and the practice of disappearance.

To be sure, the work of both critics is persuasive. Taylor's highly effective analyses are concerned with both performers and onlookers in the complex discourse of memory and trauma in Argentina. Yet, as Catherine Grant (2003: 69) has argued, although Taylor discusses the deployment of photographic images in some detail, 'she does not make such mediated "records" her object, preferring instead to offer her own and others' verbal evocations of the period as primary evidence'. Meanwhile, Richard precisely makes 'such mediated "records"' her object, focusing in particular, on the ontological and archival status of such photographic records; nevertheless, she does not address the relationship between the performance of these objects and their target audiences. In short, where Taylor privileges the performance over the photograph, Richard privileges the photograph over the performance.

Whilst these accounts have much to recommend them, I would argue that there is a tendency in both to emphasize what *is done* to photographs (paraded by relatives or deployed by artists), over what photographs *do*.[8] Taking my cue from the work of Elizabeth Edwards (2001) and Edwards and Janice Hart (2004) on photography, anthropology and material culture, I suggest that the photographs on display in human rights arenas in Latin America are 'not just stage settings for human actions and meanings, but integral to them' (2004: 4). That is, in my focus on photographic display as a form of travelling tactic in the transnational human rights arena, I shift the emphasis somewhat, to argue that it is time to acknowledge their role as social actors, 'impressing, articulating and constructing fields of social actions in ways that would not have occurred if they did not exist' (Edwards 2001: 17). If we are indeed to engage with these photographs as actors (or, in the case under scrutiny here, we might say activists), it is essential to attend to their relationship with the overlapping, if potentially conflictive, spheres of human rights discourse and family photography, where the axis of conflict turns on questions of the global versus the local, the public versus the private, and the collective versus the individual.

Activist photographs

If photography has a prominent role to play in relatives' protests against state terrorism at a subcontinental level, it does so not only in the form of the images of the disappeared people themselves, paraded as a material trace of the existence of their absent subjects, but also in the staging of protests as fundamentally made-for-camera events. For the demonstrations to achieve an impact beyond the localized public spaces in which they take place, they depend on the presence of photographers and film crews to create a widely disseminated spectacle of protest. In short, their political agency is predicated on their ability to travel across media and space, thereby appealing to a broader national and international community of viewers. What is more, by staging made-for-camera events, relatives of the disappeared resort to what, in the field of human rights discourse, has come to be known as the 'mobilization of shame'. In a discussion of this tactic, in the essay cited in the introduction, Keenan provides the following definition:

> It is now an unstated but I think pervasive axiom of the human rights movement that those agents whose behavior it wishes to affect – governments, armies, business, and militias – are exposed in some significant way to the force of public opinion, and that *they are (psychically or emotionally) structured like individuals in a strong social or cultural context that renders them vulnerable to feelings of dishonor, embarrassment, disgrace or ignominy.* Shame is thought of as a primordial force that articulates or links knowledge with action, a feeling or a sensation brought on not by physical contact but by knowledge or consciousness alone. And it signifies involvement in a social network, exposure to others and susceptibility to their gaze.
>
> (Keenan 2004: 436, emphasis added)

I have quoted Keenan at length because his definition of the mobilization of shame at once sheds light on the photographic performances that are the subject of this article and, at the same time, requires further development.[9]

Following Keenan's formulation, in the visual economy of human rights, shame involves a multi-tiered relay of looks that not only shuttles across time, space and media, but also entails different registers of affective response.[10] In this transcultural arena, the perpetrators are the primary target audience. They are, however, hailed indirectly via an appeal to national and international communities of viewers, whose opprobrium is sought, and who then figuratively turn their gaze to the perpetrators. These are viewers 'with a conscience [and] have no need of shame; they feel self-imposed guilt, not embarrassment that comes from others' (436). Guilt, it should be added, comes from a sense of pity derived from regarding the pain of others, where the representational politics of pity are overtly gendered.[11] In this scenario, the collective bodies that are addressed – from the onlookers present at the scene of protest witnessing it first hand,

through those who experience it in its mediated form, to the perpetrators – all are appealed to as individuals embedded within social structures. In the spectacles of protest at issue here, however, these collective bodies are not addressed simply as *any* individuals embedded within *any* social structures. Rather, the social structures at stake are specifically family structures and political affect is intricately bound up with the medium of representation. In the conflation of the personal and the political, the mode of address invites the viewer to participate in the complex relations of what, in the field of photography studies, has come to be known as familial looking.

The emergence of photography studies as a discrete field of enquiry that has taken place over the past thirty years, outlined in the introduction to this volume, has concomitantly brought with it an interest in family photography and the family album. From Julia Hirsch's *Family Photographs: Content, Meaning and Effect* (1981), through Jo Spence and Patricia Holland's edited volume *Family Snaps: The Meanings of Domestic Photography* (1991), and Annette Kuhn's *Family Secrets: Acts of Memory and Imagination* (1995), to Marianne Hirsch's *Family Frames: Photography, Narrative and Postmemory* (1997) and her edited volume *The Familial Gaze* (1999), academic studies of family photography have proliferated.[12] The interest that surrounds this genre can, in turn, be linked to broader transformations that have occurred in the human sciences, particularly in the wake of feminist theory and the boom in memory studies. The latter are academic endeavours that have worked to dislodge grand narratives, shifting the focus instead on to the personal, the subjective and the micro. And, as Marianne Hirsch and Valerie Smith (2002: 12) note in the introduction to the special issue of *Signs* devoted to feminism and cultural memory: 'Both fields emphasize the situatedness of the individual in his or her social and historical context and are thus suspicious of universal categories of experience.'[13] I will return to the hermeneutics of suspicion that both fields display towards 'universal categories of experience' later in my discussion. For now, I simply note that it is the work of Hirsch and especially *Family Frames* – a text that is rapidly acquiring seminal status in both memory and photography studies – that is perhaps most representative of the confluence of memory, feminist and family photography studies.

Following in the footsteps of earlier commentators, Hirsch observes in *Family Frames* that the camera, the photograph and its material support, the album, have a special affinity with the preservation and perpetuation of family memory. In the age of mechanical reproduction: 'The family photo both displays the cohesion of the family and is an instrument of its togetherness; it both chronicles family rituals and constitutes a prime objective of those rituals. [...] As photography immobilizes the flow of family life into a series of snapshots, it perpetuates family myths while seeming merely to record actual moments in family history' (Hirsch 1997: 7). For Hirsch, as for many scholars of this genre of image, family photography is embedded in the fabric of everyday life and is deeply implicated in the reproduction of hegemonic ideological structures

founded on the myth of the nuclear bourgeois family. This being the case, what is required then is 'a language that will allow us to see the coded and conventional nature of family pictures – to bring the conventions to the foreground and thus to contest their ideological power' (10). Where Hirsch's study takes debate regarding family photography forward, it is in its anatomization of the looks that are exchanged around family photographs and the album:

> It is my argument that the family is in itself traversed and constituted by a series of 'familial' looks that place different individuals into familial relation within a field of vision. When I visually engage with others familially, when I look through my family's albums, I enter a network of looks that dictate affiliative feelings, positive or negative feelings of recognition that can span miles and generations.
>
> (Hirsch 1997: 53)

Highly coded and conventionalized artefacts, family photographs promote looking that is affiliatory and identificatory; at the same time, localized, private instances of family looking are problematically implicated in broader structures of power. And as Hirsch, amongst many others, has argued, nowhere is the imbrication of private and public familial looking more clearly manifest than in the totemic 1955 cold-war era exhibition, *The Family of Man*.

As is well known, *The Family of Man* was curated by Edward Steichen, then Director of Photography at MoMA, and consisted of 503 photographs from 68 countries featuring the family as a timeless and universal entity united by common themes – birth, childhood, courtship, marriage, labour, death, etc. – and toured some 37 countries over the span of a decade. I do not wish to rehearse in detail the significant debate that has accrued around Steichen's self-pronounced 'blockbuster'; it is arguably one of the most written-about exhibitions in the history of photography.[14] For now, I simply wish to note that the main thrust of this critique sets out to expose the way in which the exhibition was predicated on an understanding of photography as an apparently transparent, universal language which perpetuated the mythology of the family 'as stable and united, static and monolithic' (Hirsch 1997: 51). Through the affiliative and identificatory acts involved in the transcultural museum experience, it naturalized a Westernized model of the bourgeois, nuclear family as the inevitable telos of human progress. Let me be clear: with an emphasis on the exhibition's dubious gender politics, its US imperialistic designs – it was, after all, sponsored by Coca Cola – this line of critique is without doubt well founded and one with which I hold. To the degree that it has become one of the most debated exhibitions in the history of the medium, however, it has cast a long shadow over critical reflections on the representation of the family in photography studies. Thus, just as for Hirsch, citing Alan Sekula, *The Family of Man* is '"a guidebook for the collapse of the political into the familial" [...] [and] the camera, the family picture and the family album are effective instruments of this collapse' (69), so

too this exhibition has become a blueprint for approaches to family photography and family looking. Indeed, what unites most writing on family photography is its articulation of the need to set up sites of resistance to the myth of the coherent nuclear family, to find alternative 'points of view' that challenge and contest the universalism and humanism inherent in the dominant familial gaze, which in a multitude of scholarly work is cast as a force of reaction.

How, though, might an understanding of the affiliatory and identificatory looks that circulate around family photography help us to grasp what is at stake in the photography of disappearance and the transcultural modalities of its mobilization of shame? How might insights from family looking allow us to shift the focus, to offer an account of photography as integral to human rights activism, 'impressing, articulating and constructing fields of social actions in ways that would not have occurred if they did not exist' (Edwards 2001: 17)? What place, finally, is there for the hermeneutics of suspicion that pervades so much work on family looking in approaches to the material culture of human rights? Before sketching out answers to these questions, let me be clear once more. In what follows, I am not advocating a return to a Family-of-Man style of transcultural looking that would collapse difference in the name of a universal human family. Rather, I want to argue for a reconsideration of the possibility of intersubjective and transcultural looking through photography by bringing into consideration what feminist philosopher Judith Butler terms 'the relational ties that have implications for theorizing fundamental dependency and ethical responsibility' (Butler 2004: 22).

Writing in the aftermath of the 9/11 attacks on the World Trade Center and the Pentagon, and drawing on psychoanalytic concepts of mourning and melancholia, in the second essay of *Precarious Life*, titled 'Violence, Mourning, Politics', Butler reflects on the possibility of international community founded on the experience of vulnerability and loss. She acknowledges that human vulnerability to violence is distributed unevenly at a global level and that, under current political conditions, lives lost are grieved differentially. In a global hierarchy of 'grievability', some lives are rendered worthy of grief in public discourse (e.g. those who perished in the attacks on 9/11); meanwhile, there are others – for example, the countless Iraqis or Afghans annihilated in the subsequent 'war on terror' – who remain nameless and implicitly unworthy of grief. In short, these are victims, not considered fully human in life, and 'if violence is done against those who are unreal, then, from the perspective of violence, it fails to injure or negate those lives since those lives are already negated' (33). The visual media, it should be added, have had a crucial role to play in establishing the hierarchy of grief in the public sphere.[15]

The primary question motivating Butler's meditations is what, in the aftermath of recent global violence, might be made of grief other than a cry for war. To this end, Butler argues for making: 'grief itself into a resource for politics' which, she states, 'may be understood as the slow process by which we develop a point of identification with suffering itself' (30). Such a process would involve

recognizing the fundamental interconnections between human beings, without, however, collapsing the differences between them. Further, this process would engage an ethics of cultural translation, and in the final analysis, would require the rethinking of 'the meaning of the tie, the bond, the alliance, the relation, as they are imagined and lived in the horizon of a counterimperialist egalitarianism' (41). The implications of grief as a resource for politics and the attendant 'relational ties' can be explored further with regard to the intensely self-referential and, explicitly familial, photo opportunity featuring Daniel Tarnopolsky.[16]

For Tarnopolsky, the display of photographs of his parents – that is to say, subjects derealized by agents of the regime – on one level, is a mode of rematerializing and re-humanizing them. Speaking of the decision to exhibit his family snaps in the context of the photo opportunity, Daniel Tarnopolsky explained to his audience that it was: 'para que vean que los desaparecidos son gente, no fantasmas' (so you see that the disappeared are people, not ghosts) (Ginzberg 2004). At the same time, there is something inevitably spectre-like about the display of these photographs, for the overwhelming power of this image is derived from photography's ability to register simultaneously the presence and absence of Hugo Tarnopolsky and Blanca Edelberg. As such, it belongs to a long iconographic tradition in the history of photography, in which, as Geoffrey Batchen (2004: 12) has noted, early daguerreotypes frequently featured people staring pensively at other photographs, where 'holding a photograph within a photograph answers to the need to include the virtual presence of those who are otherwise absent'. In the daguerreotypes Batchen examines, absence often referred to absence through death of a loved one. Relatives of the disappeared, however, can entertain no such certainties. With no body to bury, the photograph within the photograph in the human rights photo opportunity melancholically materializes the ontological uncertainty of the absent presence of the disappeared. In the Tarnopolsky image, the poignancy of this is even more acute. The passage of time is marked in the disjuncture between the black–and–white snaps of Hugo and Blanca framed within the colour image that is the principal photograph. Now, in 2004, Daniel Tarnopolsky looks to be approximately the same age as his parents, who remain forever frozen on that threshold between life and death, in the photographic time-space of 1976.

In fact, the photographs within the photograph are pivotal to the meaning of this image, defining the relationships between those depicted within the frame and, importantly, between those within it and, significantly, those located outside. True, Daniel Tarnopolsky is holding up the images of his parents – he is doing something to them; at the same time, as material objects they have a determining role to play in the human transactions that are at stake in this image: they, the snaps, do things in their own right. It is the photographs of Hugo and Blanca that define Daniel relationally as a son. In turn, Daniel is defined via his absent parents in relation to Estela Carlotto, who sits to his left as the representative of the Abuelas, that is to say, an association that precisely politicizes affiliative bonds.

But this is a photo opportunity. As an image event, its meaning and wider political burden are predicated on the promotion of intersubjective and, potentially, transcultural looking relationships that play out beyond the confines of the offices of the Abuelas de Plaza de Mayo in which it was staged. Drawing on the paradigms of family photography studies, it can be said that 'I visually engage with others familially, when I look through my family's albums [and the "albums" of others], I enter a network of looks that dictate affiliative feelings, positive or negative that can span miles and generations' (Hirsch 1997: 53). To engage empathetically with the Tarnopolsky photograph, I recognize myself in relation to this family through the structure of my own family album, in which I am positioned as somebody's daughter. Through these identificatory looking structures, I try to imagine myself in the other's place and so understand his affective state. Ultimately, I cannot put myself in his place: his experience is beyond the realm of my own. Ethically, I should not put myself into his place; or as Butler puts it, drawing on the ideas of Adriana Cavarero 'we are exposed to one another, requiring a recognition that does not substitute the recognizer for the recognized' (48). At the same time, the politics of this image hinge on an understanding of the way in which this family has been ripped apart by the eruption of repressive agents of state into the private domain of the family home. Again, there is poignancy to the visual composition of the photo opportunity. With a family snap in each hand, the son, Daniel is positioned between his mother and father, symbolically performing an act of photographic reconstitution of the family tie. In other words, that which is publically performed here is private grief for the lost family bond, where grief here is rendered public and a resource for politics.

In its staging of the disintegration and longed-for but impossible reunification of the family, the Daniel Tarnopolsky photo opportunity calls forth a network of relational ties that in turn invite affiliative feelings. In so doing, the photograph also mobilizes shame. To return to Keenan (2004: 436), shame 'signifies involvement in a social network, exposure to others and susceptibility to their gaze'. I look at the image of Tarnolpolsky's family, seeing my own (imperfect) family scenario reflected back to me through an act of transcultural identification. In this way, I recognize myself and feel empathy – however problematic this might be. These were Tarnopolsky's parents, his siblings, all the money in the world cannot bring about reparation – this should not be allowed to happen again. Meanwhile, at the other end of this chain of looking are those agents whose behaviours must be affected – Emilio Massera as chief perpetrator; the contemporary Argentine government as the guardian of civil society – who are similarly structured like individuals by this photo opportunity. They too are parents, grandparents, siblings. As such, the photo opportunity renders them vulnerable to feelings of dishonour, embarrassment, disgrace or ignominy which is intensified by the knowledge that they are exposed to others, are susceptible to their gaze. This, I would argue, is how such images work; whether they *work* – whether they prompt action – is open to dispute: for

affect is of course one thing, effect is another matter altogether. Nevertheless, as Keenan (2002: 114) states in a second essay, suggestively titled 'Publicity and Indifference', 'the only thing more unwise than attributing the power of causation or of paralysis to images is to ignore them altogether'.

Thinking family photography again

This chapter has pursued a double-line of enquiry. On the one hand, it has examined the agency and affect of a photographic phenomenon that has transcultural currency in the arena of struggles for human rights across Latin America. On the other, homing in on the Tarnopolsky image as emblematic of this phenomenon, it has explored the methodological efficacy of photography studies, particularly family photography studies, for engaging issues of agency and affect at play in these images. To be sure, the methodological paradigms that have emerged in family photography studies certainly go a long way to illuminate the relationship between the image and beholder that is so crucial for an understanding of how the photographic image works in the global human rights arena. To reformulate Hirsch (1997: 10), family photography studies provide us with 'a language that will allow us to see the coded and conventional nature of [the human rights image-event] – to bring the conventions to the foreground and thus to [*grasp* rather than] *contest* their ideological power', where that power derives from their emotive instantiation of affiliative networks of looking. Such image-events coordinate patterns of identification, where their affective force lies precisely in the *convergence* of the familial and political (rather than, as Sekula would have it, 'the *collapse* of the political into the familial').

However, is the photography of disappearance a uniquely Latin American phenomenon or does it have wider transnational currency? Taylor (2003: 174) has convincingly argued that it almost certainly originated in Argentina, where the Madres movement '"caught on": members of human rights movements throughout Latin America, the Middle East, the former Soviet Union, and other areas have started carrying photographs of their disappeared'. The iconic gesture of the photograph within the photograph has travelled and now circulates in and across a diverse range of geo-political contexts in which, by definition, the 'family' as social construct exists in myriad forms. That this is the case is borne out by a glance at some of the photographs themselves. One need look no further than Latin America itself to find significant variations in the modalities of this image-event – from the middle-class family unit staged in the Tarnopolsky photo opportunity, to the tiny ID-style photographs displayed in the Andean-region photography of disappearance, where indigenous peasants are more likely to own an ID portrait than a family snap (Poole 1997). Despite differences of race, class, location and history, however, their mode of appeal tends towards consistency and turns on an engagement with the meaning of the familial bond as an affective construct, with the potential to appeal to viewers across cultures, with all the attendant problems that this undoubtedly entails. I/

we may not be able to put myself/ourselves in the place of the relatives of the disappeared; but perhaps I/we can imagine that place relationally. It is, to invoke Butler, in our affiliation with the meaning of the tie, the bond, the alliance – an act of recognition that takes place *without* the collapse of difference between us and them – that we have a role to play in the global drama of human rights violations.

Acknowledgements

I am grateful to David Campbell, Claire Lindsay, Jason Wilson and Ed Welch for commenting on versions of this essay. I would especially like to thank Alexia Richardson for bringing the Tarnopolsky photograph to my attention.

Notes

1 Taken in the offices of the Abuelas de Plaza de Mayo, the photo opportunity took place to mark the successful culmination of a seven-year legal battle in which Tarnopolsky sought moral and economic damages from Massera for the suffering caused by the forced disappearance and murder of his family members. As the accompanying text reports, Tarnopolsky donated the 210 thousand pesos of restitution money to the Abuelas de Plaza de Mayo. See O'Connell (2005) for a discussion of such legal actions in the sphere of human rights activism. The image can be viewed in colour in its original context at: http://www.clarin.com/diario/2004/08/24/elpais/p-01401.htm (accessed 3 October 2007).

2 For an extended discussion of photographic icons in US public culture, see Hariman and Lucaites (2007: 27, italics in the original), where they define photo-journalistic icons as 'those *photographic images appearing in print, electronic, or digital media that are widely recognized and remembered, are understood to be representations of historically significant events, activate strong emotional identification or response, and are reproduced across a range of media, genres, or topics*'. The photographs discussed by Hariman and Lucaites are single images such as Dorothea Lange's 'Migrant Mother' and their concern is with US liberal democracy. The images that are the subject of this essay are of a different order that I would define as iconic gestures and they arise in contexts in which there is precisely a democratic deficit. Nevertheless, Hariman and Lucaites's approach to photographic icons, with its emphasis on the performative power of iconic photographs, their high level of recognizability and their activation of strong emotional response, is equally relevant for a consideration of the iconic photographic gesture.

3 The literature on Argentine state terrorism and the Madres is vast. See, for example, Arditti (1999); Feitlowitz (1998); Guzmán Bouvard (1994); Robben (2005). See also the Madres' official website: <http://www.madres.org/>.

4 See Avilés (2004) for a report on the Mexican *escrache*. For more on the *escrache* as an Argentine phenomenon, see Kaiser (2002). Mexico, for so long characterized by political stability and quiescence engendered by the 71-year rule of the single party of state, the Partido Revolucionario Institucional (PRI), more recently initiated investigations into what, after its Southern Cone counterparts, has come to be termed its own *guerra sucia* or 'dirty war'. See Scherer and Monsiváis (2002, 2004).

5 I am indebted to Richardson (2008) for material in this section.

6 'En el primer caso [...] se trata de un sujeto normado por la ley que lo individualiza aislando su identidad, separándola de su contexto de relaciones cotidianas para colocar

esa identidad a disposición del control social bajo el registro de lo impersonal. En el otro caso, el de la foto de álbum, se trata de un sujeto vinculado a la trama biográfica de una composición familiar que ritualiza sus lazos personales en la ceremonia fotográfica de estar-juntos.' My translation.

7 Taylor (2003: 177) focuses exclusively on the ID photo, which in Argentina 'has played a central role both in the tactics of the Armed Forces and in the protests of relatives of the disappeared. When a whole class of individuals classified as criminals and subversives was swept off the streets, their images in the archives disappeared with them.'

8 In this respect, it is indicative to look at Taylor's use of language in *The Archive and the Repertoire* when referring to photographs, in which she talks of 'the strategy of *using* photographs' (2003: 175); photographs '*are* presented and viewed' (176); 'photo IDs tend *to be* organized' (176) (emphasis added).

9 Keenan draws his examples from war as media spectacle, focusing specifically on the televisual mediation of the US 'Operation Restore Hope' in Somalia (1992), and the human-rights motivated war in Kosovo (1999). The thrust of his argument is oriented towards what he terms the 'dark side of revelation', namely overexposure whereby, 'If shame is about the revelation of what is or ought to be covered, then the absence or failure of shaming is not only traceable to the success of perpetrators at remaining clothed or hidden in the dark. Today, all too often, there is more than enough light, and yet its subjects exhibit themselves shamelessly, brazenly, and openly' (438). I turn briefly to the effectiveness of the mobilization of shame in the cases under discussion here in the conclusion. For more on the concept of the mobilization of shame within human rights discourse, see Drinan (2001).

10 Here, following Poole (1997), I use the term 'visual economy' precisely to indicate the transnational flows of images in the human rights arena and the uneven power dimensions that are inevitably involved in such flows.

11 Writing of the Madres in Argentina, Taylor (1997: 200) states: 'They seemingly adhered to the tradition of women's lamentations that dates back more than twenty-five hundred years to Greek drama, in which women express protest through public demonstrations of pain and sorrow. In Argentina's tragic scenario, the Madres embodied "pity" while the military males staged "terror."'

12 This list could easily be expanded. It might also include Bourdieu *et al.* (1990) and Barthes (1981), which, whilst not explicitly about family photography, nevertheless, enshrines at its centre the relationship between Barthes, his mother and the ekphrastic 'Winter Garden' photograph which, as Shawn Michelle Smith's essay in this volume attests, now has a totemic status in photography studies. For a study that meshes theoretical consideration of family photography with empirical research, see Rose (2003).

13 Although as Hirsch and Smith also note, whilst feminism and memory studies share many overlapping concerns, they have tended to develop along parallel tracks.

14 See, for example, Barthes (1973); Sekula (1981); Sandeen (1995); Hirsch (1997) and Stimson (2006).

15 As has been widely noted, photography played a significant role in the response to 9/11, not least in what Butler (2004: 34) terms 'the obituary as an act of nation-building' (see, for example, Sturken (2007)). The global communications media equally have a role to play in the dehumanizing discourses that derealize Iraqi and Afghan victims of US and European military action (see, for example, Mirzoeff (2005)).

16 We might note, albeit briefly, that there is nevertheless something troubling about the fact that it took an act of violence against the US and the concomitant recognition of 'our own brief and devastating exposure' (Butler 2004: 29) to corporeal vulnerability to provoke such an otherwise admirable meditation on community and international relations.

Chapter 5

Dreams of ordinary life
Cartes-de-visite and the bourgeois imagination

Geoffrey Batchen

A little thing; a man standing by a fluted column, full length, the head about twice the size of the head of a pin. I laughed at that, little thinking I should at a day not far distant be making them at the rate of a thousand a day.

Abraham Bogardus, 1884, remembering his first sight of a carte-de-visite[1]

The typical carte-de-visite photograph, with its self-consciously bourgeois subject leaning on a fake column or pretending to read at a small table, is habitually regarded as being entirely without imagination. Repetitive and predictable, popular and unabashedly commercial, these small pictures have been denigrated as 'mechanical and routine' by photography's historians. Beaumont Newhall, for example, says they have 'little aesthetic value' even if, 'as documents of an era, they are often of great charm and interest' (Newhall 1982: 64–6). Mary Warner Marien's 2001 survey history devotes barely a column to the carte-de-visite as a genre, claiming not to be able to understand its appeal or success (2002: 84–5). Faced with what another scholar has called their 'conformist tyranny' (Sagne 1998: 114), Naomi Rosenblum, in her *World History*, concludes that 'carte portraits offered little compass for an imaginative approach to pose and lighting as a means of evoking character' (1997: 63). It is certainly true that cartes were made in their homogenized millions by a multitude of hack photographers. But they were also made by many of the more prominently creative names in the history of photography, including Hippolyte Bayard, Antoine Claudet, Southworth and Hawes, Gustave Le Gray, Camille Silvy, Samuel Bourne, Marc Ferrez, Etienne Carjat, Nadar, Mathew Brady, Alexander Gardner, Carleton Watkins, Oscar Rejlander, Charles Dodgson, Clementina Hawarden, Julia Margaret Cameron and Henry Peach Robinson. Are we to assume that the aesthetic limitations of the format were such that none of these canonical photographers were able to overcome them and produce imaginative images? Or could it be that the search for imagination in the carte-de-visite must be directed elsewhere, away from the usual focus on photographer and subject, and instead onto the mind's eye of their viewers?

Condemned to the netherworld of charm and social history, not much of substance has been written about cartes-de-visite as photographs. When referred to at all, words like 'bland', 'banal' and 'formulaic' are frequently employed to describe their pictorial qualities.[2] In offering such judgements, contemporary scholars happily repeat the condemnations of their nineteenth-century predecessors. Nadar, for example, poured scorn on the cartes-de-visite 'portrait factories' of Mayer et Pierson and Disdéri, even though his own studio churned out thousands of these same cartes.[3] In both cases, this derogatory assessment has a whiff of surrogacy about it. In accordance with avant-garde dogma and art historical prejudice, cartes-de-visite are disparaged, not because they are without aesthetic merit, but because they too obediently embody the sensibilities, economic ambitions, and political self-understandings of the middle class. The 'little thing' that enslaved Bogardus therefore turns out to be no laughing matter, for it represents capitalism incarnate. The question to be canvassed here, then, is whether the carte-de-visite as a form of photographic practice also embodies capitalism's inherent contradictions, whether in fact these modest pictures might allow us to imagine a different mode of life than the one they actually depict.

The backstory of the carte-de-visite is well known. Manufactured according to a system patented by Frenchman André Adolphe-Eugène Disdéri in November 1854 (and described by him as 'fine, perfect and beautiful'), the carte-de-visite was a truly global phenomenon, being produced in huge numbers on every continent from the 1850s through to the early decades of the twentieth century. Although he was not the first to canvass the idea, Disdéri adopted the carte-de-visite format as a kind of promotional gimmick. In doing so he sought to capitalize on collodion photography's intrinsic technical capabilities, abandoning any attempt to imitate the scale of established art forms like painting and stressing instead the photograph's detail, inexpensiveness, reproducibility, and flexibility as a representational medium. He and his many competitors offered their customers albumen paper prints from collodion glass negatives, mounted on a card of about 11.4 × 6.4 cm, the size of a formal printed visiting card of this period (hence the name). Exposure times for such photographs were about two seconds or less, resulting in precise and detailed pictures even at this small scale. But the real innovation in carte-de-visite photography was the use of a special multi-lens camera and a moving plate holder that allowed eight images to be made at one sitting. It meant that a photography studio could take the time and expense needed to make one portrait and divide it by many prints, reducing the cost of each unit. Further savings were made since retouching was not needed, most defects being unnoticeable at this small scale. In a large and efficient studio, as many as 200 sittings a day were possible.[4]

By 1859 cartes-de-visite were a huge success, driven by their relative cheapness and clarity as photographs, by the prevailing fashion for democratic rhetoric and conspicuous consumption, by Disdéri's own insatiable appetite for publicity and flamboyance, and by an era in which the representation of one's

self and family was regarded as a sign of financial and social success and of moral and intellectual character. The more successful studios ran over two floors and included reception areas (in which previous work was displayed) as well as the actual shooting room, offices, and rooms for the production and mounting of the photographs. The public rooms tended to be exotically decorated and offered a variety of painted backdrops and props for customers to choose from. All this paraphernalia made having one's picture taken an event that was out of the ordinary. Suitably inspired, a customer could act out, within a standard format, a number of different poses (usually full-length body) and then choose the one he or she preferred. Compared to earlier processes such as the daguerreotype, this vastly increased the degree of theatricality and control that the customer had over his or her final image. Thus mobilized, this customer could appear as eight different people, or as eight different versions of themselves, all during the one sitting. As a consequence, the power of creation was transferred from the photographer, who was often no more than an operator behind a fixed camera, to the subject, who got to make all sorts of choices about how they wished to appear.

More accurately, the authorship of carte portraits came to be a fluid affair in which both photographer and subject had an active part. The subject was able to 'choose an attitude beforehand', as one contemporary put it, but these choices were in large part limited to a system of established conventions and constraints – some technical, some cultural, and some social – which were firmly conveyed to the client by the actions and advice of the photographer.[5] That clients didn't always take this advice is evidenced by the sign that hung in the studio of London-based photographer John Edwin Mayall: 'sitters are requested to place themselves as much as possible in the hands of the artist' (Wichard and Wichard 1999: 26). Given the relatively perfunctory time dedicated to the sitting, the taking of a serviceable portrait represented a particular challenge for this artist. According to Disdéri, 'one must be able to deduce who the subject is, to deduce spontaneously his character, his intimate life, his habits; the photographer must do more than photograph, he must "biographe"'. Disdéri's various self-promotional publications stressed the need for the photographer to capture 'the language of the physiognomy, the expression of the look', encouraging the subject to take on the contradictory challenge of a 'natural pose'.[6] Cornelius Jabez Hughes defined his own priorities more narrowly in an 1859 book, *The Principles and Practice of Photography*. 'The primary object should be to produce a characteristic likeness, and the second one to render it as pleasing as possible by judicious selection of the view of the face and the pose of the figure, so as, without sacrificing character, to bring out the good points and conceal the less favorable ones.'[7]

Let us look at one or two of these portraits more closely. A man dressed in white trousers and a handsome frock coat stands in a shallow space, eyes and body turned slightly away from the camera. His left hand rests on the back of an ornate chair while his right holds a black top hat to his side. A sumptuously-

patterned curtain cascades down the left side of the picture, gathering behind the man's feet in a billow of excessive folds (perhaps in order to hide the base of a metal stand designed to keep his head steady). The man, who is unnamed, has placed his well-shod feet at right angles to each other, giving this otherwise static pose some sense of dynamic torque. This subject's whole body is shown, and the camera-operator – Bingham of Paris, according to the printing on the front and back of the card – has positioned him in the dead centre of the picture plane. The photographer has also given this man about five times as much space over his head as under his feet, so that he appears properly grounded in the frame. Although only 8.9 × 5.6 cm in size, the tones of the photograph are rich, with the light carefully calibrated to ensure the man's face is fully and evenly lit while the upper reaches of the picture are cast in suggestive darkness. Looking at once self-assured and prosperous, this man presents himself as an ideal citizen, as enjoying a suitably elevated social and financial status.

His appearance is in almost every detail identical to that seen in a portrait of Napoléon III, Emperor of France, made by Disdéri in 1858. Napoléon stands directly facing the camera, with his body slightly turned and his feet again placed at right angles to each other. Dressed in a long frock coat, rather than in royal regalia, he has hooked the thumb of his left hand into his buttoned waist coat, from where a watch chain decoratively loops across his torso. This chain declares him to be a slave to time, just like any other modern businessman. He is accompanied by some common studio props – a high-backed chair, a table with two books resting on its surface, and, behind him, a stream of light-dappled curtain flowing from the upper left corner down onto the carpeted floor. If you did not know any better, you would think this was just one more prosperous French citizen having his picture taken. In fact, as Anne McCauley has suggested, this carte was deliberately organized to leave this impression. 'The nature and style of imperial carte portraiture may also reflect a conscious effort by Napoléon III to portray himself and his family as unaffected middle-class citizens who just happened to be monarchs' (McCauley 1985: 83). Like Queen Victoria, who arranged for herself to be portrayed in cartes as an ordinary wife and mother, Napoléon flattered his middle-class subjects by pretending to be one of them. Collapsing the distinction between ruler and ruled, such pictures propose a synthesis of national and popular sovereignty; beneath their subterfuge of apparent pandering, these images actually signify the political victory of the bourgeoisie (see Hardt and Negri 2000: 105).

These two images may look very much the same but they mean quite different things. One is a personal portrait, taken primarily for distribution to friends and family. The other is a calculated piece of propaganda, intended for large-scale public distribution in the interests of fostering celebrity and preserving political power. For us today, one of these subjects has a name and the other does not, but it is the unnamed man who has now taken on the greater power – representing a generic bourgeois subject, he is the one who induces fear and loathing in photography's historians. Part of that power derives

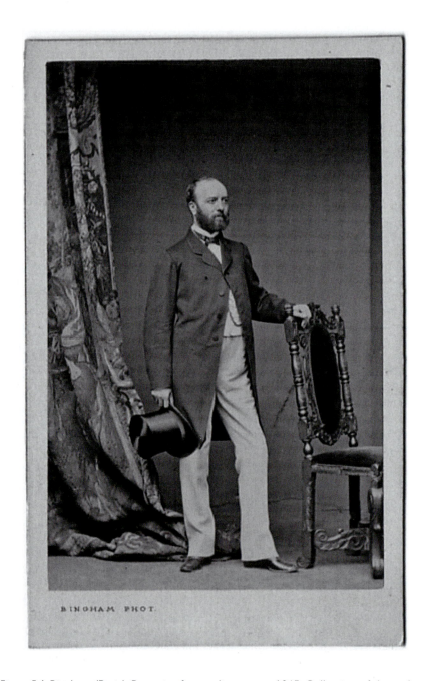

Figure 5.1 Bingham (Paris), Portrait of a standing man, c. 1865. Collection of the author.

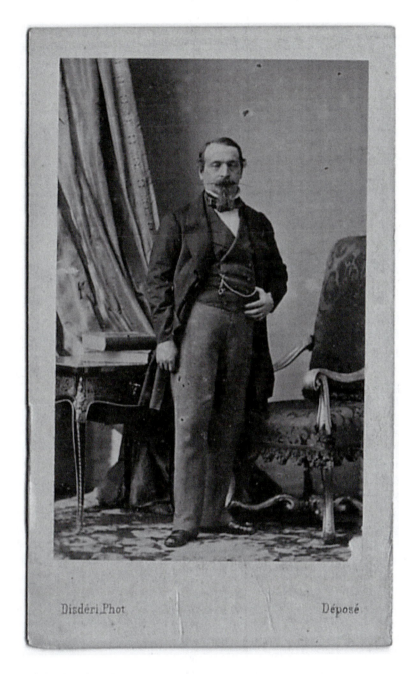

Figure 5.2 Disdéri (Paris), Portrait of Emperor Napoléon III, c. 1860. Collection of the author.

from his blank indifference to the singularity that most of these historians hold so dear; he steadfastly refuses to comply with their monotonous art historical discourse on meaning, origin and the intending constituent subject, themes which, as Michel Foucault puts it, 'guarantee in history the inexhaustible presence of a Logos, the sovereignty of a pure subject' (Foucault 1991: 64). This man is instead content to look just like everyone else, impure, a copy of what is already a copy and nothing more. He is all surface and no depth.

Not for him the Romantic pretence of individuality and intimacy found in Nadar's salt print portraits of bohemian literati (a pose as conformist in its way as that demonstrated by all these men leaning obediently on their fake columns).[8] In this sense, the carte-de-visite portrait is a rejection of Nadar's liberalism just as much as it is a refutation of sovereign power. This is a politics of a kind, even if its lack of conscious intention makes it a difficult politics to describe. There is certainly no sign in carte pictures of the strategies of opposition, negation, or denunciation we associate with avant-garde art and political subversion (unless a refusal to denounce is itself taken as a critical strategy).[9] Notice how the man in the Bingham photograph pretends the camera isn't present, gazing off into space over our heads as if into infinity. The pose is impudently borrowed from a century of aristocratic paintings, signalling yet again that, having been superseded, such codes were now available for the plundering. Many cartes-de-visite similarly repeat the iconography of high art (the tumbling curtain, the classical column, the receding landscape) but always as emptied signs, hollow signifiers of a cultural economy now dead and gone, or at least safely commodified. In both subject matter and form, then, the carte-de-visite embodies the ascendancy of the bourgeoisie and its systems of social and economic life. The question still to be resolved is whether it also represents a complete lack of imagination.

Marx has left us with perhaps the most tenacious description of the imaginary life of the bourgeoisie. Indeed almost all the basic characteristics that he identifies with capitalism could equally be drawn from a study of the carte-de-visite: the emergence of a global economy in which both production and consumption become increasingly international, the displacement of individual artisans by mass production, the accentuation of class consciousness, the constant revolutionizing of the means of production, the subjugation of all social conditions and relationships to the needs of capital. Marx's description of the processes of commodification seems especially pertinent to the carte-de-visite. A commodity is a product made by a person that is exchanged for money so that another person can use or consume it. As a consequence of this system, the social relations embodied in the process of production are subsumed to the logic of the market, resulting in a kind of commodity fetishism: 'a definite social relation between men … assumes, in their eyes, the fantastic form of a relation between things'.[10] This form is 'fantastic' because the commodity comes to be invested with unearthly powers beyond its capacity to deliver. As Paul Wood explains the process: 'the commodity becomes a power in society. Rather than a use value *for* people it assumes a power *over* people, becoming a kind of god

to be worshipped, sought after, and possessed. And in a reverse movement, as the commodity, the thing, becomes personified, so relations between people become objectified and thinglike' (Wood 1996: 263–4).

The carte-de-visite is a particularly distinctive commodity form because what is being exchanged is pictures of people. The person being photographed is turned into a thing, a picture, and then this thing is sold, exchanged, and consumed. As American scholar Oliver Wendell Holmes observed in 1862, 'card portraits have become the social currency, the "green-backs" of civilisation'.[11] One of Queen Victoria's ladies-in-waiting, the Honourable Eleanor Stanley, confirmed this equation with her disrespectful remark of 1860: 'I have been writing to all the fine ladies in London for their husband's photographs, for the Queen. I believe the Queen could be bought and sold, for a photograph'.[12] An object of desire within the economy of cartomania, Victoria was apparently also subject to this neurosis herself. Within the self-perpetuating logic of commodity fetishism, consumption, as we all know, offers a comforting, if short-lived, experience of power and control. But it also provides an anchor against the disturbing loss of anything else sacred or stable, of any fixed standard within contemporary life. In this context, the predictable conformity of the carte-de-visite portrait made it all the more alluring.

Getting back to my two portraits for a moment: what both of these cartes take for granted is that class is a look that can be codified and imitated – it's a mode of performance rather than an inherent quality. Like the subjects of most cartes-de-visite, these two men adopted stock roles drawn from a narrow repertoire of options. It would be easy to point to examples of exceptional carte portraits, featuring unusual poses and settings that deliberately subvert or mock the established conventions of the genre. There are, for instance examples where the subject of the photograph knowingly plays with carte-de-visite conventions by hiding behind the ubiquitous curtain or posing with their back to the camera or where the subject appears to be peering out through a tear in the surface of the carte-de-visite itself.[13] These exceptions merely underline the prevalence of the conventions they mock. But they also remind us of the degree to which humor and inventive play were an important aspect of the carte-de-visite experience. Numerous examples show people surrounded by obvious sets, such as elaborate window frames, or clutching standard props supplied by the studio, such as books or bottles. Other cartes have their subjects pretending to row a boat on a painted pond (this is a conceit one is as likely to find being represented in Denmark as in the USA) or sitting atop a mast on board a faked tall ship. The realism of photography does nothing to hide the inauthenticity of these scenes; in fact, it reinforces and exploits it.

But if we are going to provide a history of the carte-de-visite, there is little to be gained by examining just one or two exceptional examples; we have to engage with the genre as a whole and that means focusing on typical cartes-de-visite. As caricaturists of the time pointed out, certain 'types' of carte-de-visite image recur over and over again, with only minor variations.[14] A man stands

in front of a high-backed chair with his arm resting on a square column; a boy rests his arm on a balustrade that seems to disappear into the floor; a woman in her bonnet stands next to a table with an open book on its top; a man sits in a tussled chair with his elbow on the table beside him; two women enjoy a moment of comfortable silence as they pose, one seated and one standing, around a plush couch; a man sits at a table with pen in hand, as if caught in mid-thought; another man stands with legs crossed, one elbow on a broken column and the other holding his top hat – these and similar poses were endlessly repeated in photograph after photograph, as predictable as the rectangular format itself. In every case, the subjects of these photographs adopt a look that is familiar to them, probably from viewing other cartes-de-visite. Familiar, but also new and not yet quite natural – hence the 'stiff and studied' quality of the poses that result.[15] These are portraits of people still learning how to look like themselves.

In taking on that look, in subsuming their individual selves to it, these subjects performed a ritual of class declaration and belonging. In other words, cartes-de-visite were meant to function as a social device as much as a portrait. Having your carte-de-visite portrait taken constituted an effort to join the equivalent of what Benedict Anderson once called 'an imagined political community', but in this case it was a global community based on common class interests rather than nationalist ones.[16] To search for the 'real' subject, the inner man or woman, or to lament the absence of self-expression or overt individuality, is therefore to misunderstand the nature of carte-de-visite photography, which is all about the semiotics of typology and the sublimation of the individual to the mass. This doesn't sit well with the way art historians usually evaluate portrait photographs. But if we are going to find a way to incorporate the carte-de-visite's distinguishing features into an expanded history of photography, we must transform the logic by which that history is organized; we must, as Foucault says, 'eliminate certain ill-considered oppositions [...] the opposition between average forms of knowledge (representing its everyday mediocrity) and deviant forms (which manifest the singularity or solitude of genius)' (1991: 62).

Although signs of economic change are absented from the range of theatrical settings available to sitters, cartes-de-visite represented a revolution in photographic practice. To produce cartes rapidly and in large numbers, the owner of a studio had to break the act of photography down into discrete tasks and assign each of them to a separate worker. This in turn required a division of labour to be instituted within the studio, which, as Nadar suggested, had been turned into the equivalent of a factory. Much of the actual processing, such as developing, printing, cutting and mounting the finished prints, could be performed by relatively unskilled (and therefore cheap) labour. Disdéri's business empire was rumoured to include 62 employees, while Nadar's studio had 26. With this system in place, a designated 'operative' could then concentrate on the portrait taking itself. By adopting mass production as its model, the carte-de-visite transformed photography from a craft into an industry. This industrial

outlook was translated into aesthetic terms through the standardization of pose, format and print quality that characterized the typical carte-de-visite portrait. It is this standardization – the very aspect of these photographs denigrated by art historians – that marks the carte-de-visite's radical modernity as a visual agent of capitalism.

The industrialization of the carte-de-visite had a number of further effects. The notion of photographic 'authorship' was, for example, significantly complicated by the division of labour described above, and with it any simple understanding of ownership, property and propriety. Take the case of the Mayer and Pierson studio. In 1855 Pierre-Louis Pierson entered into a partnership with Léopold Ernest and Louis Frédéric Mayer, who, like Pierson, had previously run a daguerreotype studio. Although the studios remained at separate addresses, Pierson and the Mayers began to distribute their images under the joint title 'Mayer et Pierson', and together they became the leading society photographers in Paris. Pierson and Léopold Mayer soon opened another studio in Brussels, Belgium, and began photographing European royalty. After Mayer's retirement in 1878, Pierson went into business with his son-in-law Gaston Braun.[17] 'Mayer et Pierson' therefore signifies several studios and many different photographers, as well as a host of supplementary workers.

The name 'Nadar' represents an equally complex identity. A carte might have that name printed in red on its back in a suitably florid script, but this didn't necessarily mean that Nadar himself took the photograph or was even present in the studio that day. In fact, Nadar was forced to advertise that he ran his carte-de-visite establishment in Paris on a 'personal and daily' basis, precisely because of the constant complaints that he did not (Hambourg *et al.* 1995: 81). Within the economy of the carte, the names of photographers had become trademarks rather than embodied presences, and these trademarks could be bought and sold like any other commodity. For example, the studio known as Sociedad Fotográfica Maunoruy y Ca, operated in Lima, Peru, by Eugenio Maunoury, advertised that it enjoyed a special 'correspondency' with Nadar, first mentioning their association on 30 December 1862, and prominently displaying the famous red initial and signature on both sides of the firm's cartes, alongside Maunoury's own name and address. This deal also included the exchange of photographs, so that one finds the same image published under different studio imprints (see McElroy 1977: 545–50). Later cartes from Nadar's Paris studio listed a number of similar correspondents, including studios in Vienna, Liège, Rome, Florence, Turin, and Jersey. A history organized around proper names and great individual photographers is obviously going to have trouble coping with the divided and multiplied identities of carte-de-visite studios.

A history focused on singular images is going to have even more trouble, for cartes-de-visite represent the first major eruption of mass reproduction within the practice of photography. The aesthetic of the carte-de-visite portrait was caught up in an economy of repetition and difference, demonstrating a serial mode of production at the level of the image itself that suited the prevailing

capitalist consumer society.[18] This repetition of quasi-identical but slightly different images was matched by the proliferation of images that were in fact physically identical.[19] With cartes-de-visite (unlike the daguerreotype it super-seded), any one image could potentially be printed in the thousands (it is said that 70,000 copies of a Mayall portrait of Prince Albert were sold in the weeks after Albert's death). But even the most humble carte-de-visite was printed a number of times (reproducibility was, after all, its primary selling-point as a form of photography). All cartes-de-visite are therefore multiples; the very genre declares the photograph to be a copy for which there is no original. As Walter Benjamin (1969: 224) wrote, 'to ask for the authentic print makes no sense' (and one could equally say that to show only one print of any given carte-de-visite is equally nonsensical).

For Benjamin, reproduction is capitalism's most potent self-contradiction, a poison on which it is nevertheless totally dependent. Reproduction represents 'the basic conditions underlying capitalistic production' but an art based on its procedures might, Benjamin argued, enable one to 'brush aside a number of outmoded concepts, such as creativity and genius, eternal value and mystery' (1969: 217, 218). By doing away with uniqueness, such an art – obviously I'm thinking here of the carte-de-visite – also puts authenticity, and the unspoken authority that comes with it, at risk. What happens when a photograph of Queen Victoria is distributed in thousands of identical copies, finding its way into the homes and hands of her subjects in the form of a cheap picture? It simultaneously distances her (by turning her into a reproduction) and brings her closer (by dislodging her former 'cult value').[20] Such a photograph certifies that everyone is now equally susceptible to reproducibility, everyone can be reproduced to the same scale and in the same format. The image is no longer 'authentic' (is no longer a unique thing) but then neither is the Queen, who has become visually equivalent to her subjects (who owned cartes of themselves in the same basic pose and studio setting). Like the endlessly reproduced *Mona Lisa*, Victoria becomes more, rather than less, revered by these subjects but at the price of her own commodification. No longer having a unique existence in time and space, she is only valued as and through reproduction. She becomes image, an imitation of herself, a ghostly ideological construct.

Benjamin argued that 'the instant the criterion of authenticity ceases to be applicable to artistic production, the total function of art is reversed. Instead of being based on ritual, it begins to be based on another practice – politics' (1969: 224). In an earlier essay, Benjamin referred to the accessories used in cartes-de-visite portraits as 'junk', but perhaps it is precisely in this junking, in the banal detritus generated by the reproduction process, that photography's political efficacy is best sought (1980: 206). In this sense, although placid in appear-ance, the carte-de-visite represents a fissure within capitalism's facade of self-assurance. On the one hand, the carte-de-visite confirmed the existing political order by conforming to its visual prescriptions. On the other, by eschewing any claims to individuality, creativity, genius, eternal value or mystery, and by overtly

presenting itself as a reproducible commodity form, the carte-de-visite under-mined the ideological illusions of that same order – it might be said to have embraced capitalism to fatal excess. According to Marx, when that embrace squeezes too tight, 'men are at last forced to face with sober senses the real conditions of their lives and their relations with their fellow men'.[21] It might even be argued that the vapid repetitions inherent to the carte-de-visite make the debilitating effects of capitalism visible, stripping it of any utopian claims and making 'habitual consumption reverberate with destruction and death'.[22]

The reproducibility of the carte-de-visite had a number of other impor-tant effects. It resulted, for example, in the uncontrolled distribution of images that might otherwise have remained private. This in turn led to public scandals and contentious litigation over who 'owned' an image, the photographer or its subject. The situation was exacerbated by the fact that some photographers paid certain celebrities either a fee or a percentage of the profits for the right to take and distribute their image (the ex-slave Sojourner Truth lived on the proceeds: 'I'll sell the Shadow to support the Substance', she announced) (see Goldberg 1991: 103–112). An image, independent of its manifestation as a physical photo-graph, had become a recognized commodity, a thing in itself (as far as capitalism was concerned, shadow and substance were, in fact, no longer distinguishable). The pirating of popular images also became common, so that a portrait taken by Mayall or Brady might turn up under the name of several other studios, further complicating the question of their authorship. But the commercial distribution of cartes-de-visite also meant that images from many different sources – family, friends, the theatre, politics, from home and from abroad – might all be brought together in one place, allowing strange conjunctions that confused all accepted distinctions.

Cartes were not only bought and exchanged; they were also consumed in other ways. Celebrity portraits from the political or entertainment world were collected in albums just like, or even interspersed among, cartes of family members, to be shared and flaunted, perused and discussed at gatherings. Albums of cartes allowed one to recreate kinship structures in visual terms, and to form imaginary worlds that overcame time and space, class and gender. As image, an otherwise ordinary person could consort with royalty or with a notorious actress, or they could maintain an emotional connection with a distant loved one. 'Photography is a marvelous thing … it is very pleasing to have one's relatives and acquaintances reunited in an album. You open the book and flip through it: you see your brother who is in the army in Syria or China, your sister who is fifty leagues from Paris. You converse with them, it seems as if they were there beside you.'[23] Sometimes this conversation had tragic overtones, as in the case of an image of a seated woman in mourning clothes shown glancing up from an open album featuring a carte-de-visite of her deceased husband (or so it would seem). But, as an oil painting from 1884 demonstrates, the carte-de-visite was not always experienced alone or in silence. The painting, by British artist Solomon Joseph Solomon, shows a typical upper-middle-class interior,

complete with servants, ornate furnishings, statuettes, framed photographs, a piano and four figures gathered after dinner for music and conversation. The scene focuses on a man and woman sitting in the foreground, she gazing up at him with an open album in her lap as he concentrates on a carte-de-visite in his hand that has been taken from it.[24] The carte is the social tissue that connects them, an excuse for flirtation, argument, narrative, recollection and invention. In other words, cartes were not just objects; they were also excuses for flights of fancy and expressions of sentiment.

Sentiment is an aspect of the carte-de-visite experience that tends to be overlooked. Roland Barthes' *Camera Lucida*, on the other hand, opens with his own sentimental response to a photographic image that may well have been taken by Disdéri. 'One day, quite some time ago, I happened on a photograph of Napoleon's youngest brother, Jerome, taken in 1852. And I realized then, with an amazement I have not been able to lessen since: "I am looking at eyes that looked at the Emperor"' (Barthes 1981: 3). It is a reminder that this amazement can be induced by even the most ordinary and predictable of photographs, precisely because of the distinctively physical nature of photography's indexical connection to its subject. 'The photograph is literally an emanation of the referent. From a real body, which was there, proceed radiations which ultimately touch me, who am here [...] a sort of umbilical cord links the body of the photographed thing to my gaze' (80–81). Barthes' emotive account of the photographic experience is in accord with that offered by American philosopher Charles Sanders Peirce. An index is, Peirce says, 'in dynamical (including spatial) connection both with the individual object, on the one hand, and with the senses of memory of the person for whom it serves as a sign, on the other [...]. Psychologically, the action of indices depends upon association by contiguity' (Peirce 1985: 8, 13).

Cartes-de-visite are often about their own reception, as if to underline the psychological or emotional experience that their viewing entails. Many pictures show people holding open photograph albums or simply feature people looking at another carte. It is a reminder that cartes were scaled to be viewed in the hand rather than on a wall; they were meant to be touched as well as seen. In a cabinet card from the 1880s, a woman taken by a Canadian photographer named Reeves looks straight out at us, one hand against her cheek and the other clutching a carte-de-visite portrait of a man. She doesn't seem to see us staring back, as if she is looking only inwards, eyes open but mind elsewhere, recalling her missing lover. She poses for the camera to make visible an otherwise abstract experience, the pang of longing, the act of remembrance, the stretching of the imagination. It is as though she wants to draw our attention, not just to the particular image she holds, but to the comforting solidity of photography's contiguous memorial function. In touching her photograph she recalls that it too was touched, by that umbilical cord of light that once caressed her loved one and then this image in her hand. In touching it now, she returns the photographic experience to the realm of the body and to the intimacy of reverie.

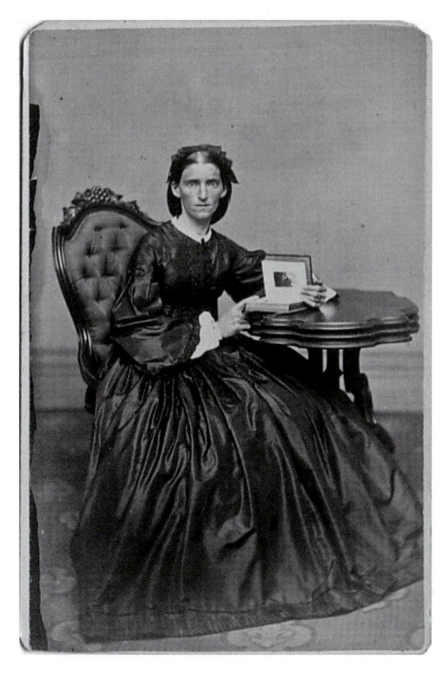

Figure 5.3 J.C. Moutton (Fitchburg, MA, USA), Portrait of a seated woman holding an open carte-de-visite album, c. 1865. Collection of the author.

94 Geoffrey Batchen

An examination of such pictures initiates a history of the carte-de-visite that concentrates on their reception as much as their production. Such a history will necessarily displace the emphasis given to innovation, masterpieces, and individual acts of creativity in most prevailing accounts, acknowledging instead the creative role played by the *viewer* of photographs. After all, anyone looking at a carte-de-visite photograph in the 1860s or 1870s would have known what we know now – that these figures are posing for a camera, pretending to be somewhere they are not, standing next to a studio prop in front of a painted backdrop. In cartes, you can often see the edges of the painted backdrop and the base of the head stand, as if revealing the means of production will make no difference to the viewing experience. Photography's realism is thereby openly declared to be an artifice, a matter of conventions. For an emotional connection to be established with the subject, a viewer is forced to look beyond these conventions, beyond the surface of the picture and the world it represents. To put it another way, the very banality of the carte-de-visite portrait, the lack of imagination evidenced in the actual picture, is precisely what shifts the burden of imaginative thought from the artist to the viewer. It is an open invitation to see more than meets the eye. This might lead us to the following paradoxical proposition: the more banal the photograph, the greater its capacity to induce us to exercise our imaginations.[25]

A study of the carte-de-visite photograph is a sounding of the collective imagination within capitalism, an acknowledgement of the creative effort required to appear as yourself while looking as much as possible like everyone else. Any comprehensive examination of the carte-de-visite, in effect a tribute to the small dreams and anxieties of ordinary life, would also have to incorporate a host of similar (and similarly neglected) studio practices that continue to be the bread and butter work of commercial photographers, from commissioned portraits of babies to formulaic wedding pictures. To take such images seriously, we must develop a critical history of both the bourgeois imagination and the processes and effects of photographic reproduction. In short, if cartes are ever to be properly encompassed within the history of photography, that history will itself have to be completely re-imagined.

Acknowledgements

This essay is a slightly revised version of a paper that first appeared as 'Dreams of Ordinary Life: Cartes-de-visite and the Bourgeois Imagination', in Martha Langford (ed.), *Image and Imagination* (Montreal: McGill-Queen's University Press & Le Mois de la Photo, 2005), 63–74, 266–268.

Notes

1 Abraham Bogardus, from *Anthony's Photographic Bulletin* (1884), quoted in Newhall (1982. 64).
2 For example, Sylvie Aubenas (2002: 48) talks about the 'banality' of this kind of photography. 'The carte-de-visite certainly represented everything with which Le Gray did not wish to compromise himself, everything that was detrimental to the new art he defended.' Ulrich Keller is similarly unflattering in his assessment of what he calls 'the bland conventionality of Nadar's cartes de visite of the 1860s': 'Nadar's embrace of the carte de visite fashion spelled aesthetic decline [...] a bland, stereotyped portrait approach emerges which relies on conventional dress and body language, flat lighting, and traditional studio props' (1995: 80, 86, 90).
3 See Rouillé (1995: 113). In fact Nadar himself built a large new establishment devoted to carte-de-visite photography on the fashionable Boulevard des Capucines in the summer of 1860, taking 15 months and spending 230,000 francs, all borrowed.
4 The most detailed account of the carte-de-visite remains McCauley (1985). For other surveys of the genre, see Gernsheim (1988: 189–203); Younger (1987); and Wichard and Wichard (1999). My essay concentrates entirely on the typical carte-de-visite portrait. However it is well to remember that the carte format was adapted to almost every conceivable genre of photography, including head-shots, occupationals, celebrities, ethnographic types, criminals, freaks, landscape, urban scenes, architecture, reproductions of paintings and sculptures, novelty scenes, genre scenes, animals, nudes, pornography, scientific studies, and so on. High art was the only genre not readily adaptable to the carte-de-visite – and even here there are exceptions; Cameron issued fully one-fifth of her images in a reduced-size carte-de-visite or cabinet card format (see Wright 2003: 83). This kind of photography is therefore hardly marginal; on the contrary, it is at the very centre of photographic production in the later nineteenth century.
5 'The majority of photographers have two or three different positions to which they submit all their models, whether tall, short, long, or small. Moreover, nearly everybody, before having a photograph, studies and chooses an attitude beforehand, by the aid of a mirror, which, in many cases, is quite contrary to their natural bearing; a lady, for instance, of doubtful age, will take the free attitude of a young girl; a small, quiet-looking man, has an ambition to appear proud and bellicose. The result of this is, that a great many portraits appear studied and stiff, of which the least fault is a perfect failure in resemblance, and generally in beauty.' Unknown, 'The Aesthetics of Photography,' *Humphrey's Journal*, September 1863, as quoted in Younger (1987: 21).
6 Disdéri, *Manuel*, 1855, as quoted in McCauley (1985: 41).
7 Hughes, as quoted in Wichard and Wichard (1999: 22).
8 Seeking to contrast his work with that produced by a typical carte-de-visite studio, Nadar claimed to be able to 'render, not an indifferent plastic reproduction that could be made by the lowliest laboratory worker, commonplace and accidental, but the resemblance that is most familiar and most favorable, the intimate resemblance', Nadar, 1856, quoted in Hambourg *et al.* (1995: 25).
9 See, for example, Alison M. Gingeras' response to a letter from Gregory Sholette (2004b: 16). They are arguing over an earlier essay by Gingeras (2004a), in which she claims that German collective of artists 'make political art, but not in the conventional understanding of the term.' She has made a similar argument about the work of Maurizio Cattelan, claiming that 'critics cannot locate critique in Cattelan's practice because there is no search for truth or claims for legitimacy that underlie his actions.' She sees this 'indifference' as a 'subversive scenario'; Cattelan's work, she says, involves the 'relentless reinforcement of the theatrical roles assigned to him and the actors who surround him' but without 'any type of judgement [...]. In lieu of a superficial rehearsal of institutional critique, where prescriptive and ultimately stable interpretations of the world are given, Cattelan points towards the flux of values that motivate the everyday performance of the self' (see Gingeras 2000: 50–53).

10 Karl Marx, as quoted in Wood (1996: 263). For an illuminating history of Marx's use of the word 'fetishism', see Pietz (1993).

11 Holmes, *The Atlantic Monthly*, 1862, quoted in Wichard and Wichard (1999: 33).

12 Eleanor Stanley, 1860, quoted in Ford (1977: 27).

13 Moreover the carte-de-visite format spawned some distinctive creative genres of its own. Disdéri and others, for example, produced composite images consisting of overlapping circular portraits or even a dense collage of shaped photographs that allowed collective entities such as the International Postal Committee or the extended Royal family to be portrayed on a single carte. On April 21, 1863, he patented this type of composite, calling it a 'Mosaique' (see McCauley 1985: 94). Between 1881 and 1898 Canadian photographer Hannah Maynard exploited the process to produce her *Gems of British Columbia*, annual photomontages featuring clusters of colonial babies. As historian Carol Williams has argued, these particular 'mosaiques' 'deserve special attention as their ideological motives match settler sentiment about racial superiority and nation building' (Williams 2003: 125). Similar novelties were periodically announced by other photographers, such as the Diamond Cameo Portrait introduced by F.R. Window in October 1864 and consisting of four small portraits, each showing a different view of the same sitter's head. Some photographers offered yet another innovation, so-called 'Siamese' portraits. These exploited photography's capacity for multiple exposure by showing two views of the same person montaged together in a single scene. Australian photographer Bernard Goode, for example, produced cartes-de-visite of a man and his double shaking hands, and even circulated one showing three versions of himself, two seated on either side of a table (in one of these self-portraits he has a camera on his lap) and the third standing behind it pointing to a carte-de-visite in his hand (could it possibly be a fourth self-portrait?). See the entry on this picture in Davies and Stanbury (1985: 56–57), and Ennis (2000: 30). Defying time and space, these novelties merely underlined the artifice that suffused all carte-de-visite portraits.

14 See the cartoons by Marcelin from February 1860, reproduced in McCauley (1985: 47).

15 See Note 5, above.

16 Anderson (1983: 15). As Anderson says, 'all communities are imagined [...] communities are to be distinguished [...] by the style in which they are imagined'.

17 This information comes from <http://www.getty.edu/art/collections/bio/a1961–1.html>.

18 For more on this, see Owens (1992: 119).

19 It hardly need be said that cartes-de-visite that look the same don't necessarily mean the same thing. What, for example, are we to make of cartes taken in Africa, India, Japan or New Zealand? Do all these cartes, with or without their small traces of regional specificity, mean the same thing in their places of production as their equivalents did in Europe? Could having your carte-de-visite portrait taken in such places say something telling about a desired relationship to Europe and European culture? And what of cartes made in Europe that made their way to these distant colonies? Australian historian Anne-Marie Willis makes a special case for English cartes found in her country. 'In the mid-nineteenth century, before the development of Australian nationalism, photographs of, and from, the "old country" had a special force of meaning. They were substitutes for the absent culture to which colonists aspired and they contributed to a process in which everyday life was lived through constant reference to somewhere else' (Willis 1988: 47).

20 As in so many aspects of his famous essay, Benjamin is ambiguous about exactly how photographic reproduction might replace cult value with exhibition value. 'In photography, exhibition value begins to displace cult value all along the line. But cult value does not give way without resistance. It retires into an ultimate retrenchment: the human countenance [...]. The cult of remembrance of loved ones, absent or dead, offers a last refuge for the cult value of the picture' (1969: 225–226).

21 Berman (1988: 95). Berman's discussion of Marx's thinking suggests another way of looking at the self-imposed banality of the carte-de-visite portrait:'these bourgeois have alienated themselves from their own creativity because they cannot bear to look into the moral, social and psychic abyss that their creativity opens up' (100–101).
22 Gilles Deleuze, from *Différence et Répétition*, quoted in Owens (1992: 120).
23 A French journalist, c.1860, quoted in McCauley (1985: 48).
24 The painting is Solomon Joseph Solomon's *A Conversation Piece*, 1884 (Leighton House, London). See Wood (1976: 34).
25 This paradox perhaps helps to explain why creative writers such as Walter Benjamin (who favoured the work of commercial photographer Jean-Eugène-Auguste Atget), Roland Barthes (who illustrated *Camera Lucida* with strikingly middle-brow pictures), Jorge Luis Borges (who illustrated a book with the most banal photographs ever produced by his countryman Horacio Coppola), and W.G. Sebald (who was notorious for choosing unexceptional illustrations for his books) all picked relatively unimaginative photographs to accompany their texts.

Chapter 6

Race and reproduction in *Camera Lucida*

Shawn Michelle Smith

In his influential study of photography, *Camera Lucida: Reflections on Photography*, Roland Barthes famously makes himself the measure of photographic meaning (1981: 9). The book, in his words, is an attempt 'to formulate the fundamental feature' of photography 'starting from a few personal impulses' to a few photographs (8–9). In other words, Barthes seeks to discover the essential elements of photography through his own particular responses to images. It is this profoundly personal treatment of photography that lends *Camera Lucida* both its most evocative power and its most frustrating limitations.

Barthes's work has been tremendously important and generative, both theoretically and methodologically, for photography scholars, and especially for those who study family photography. As this work has demonstrated, the personal can be a powerful point of departure for critical analysis, and as feminist scholars of family photography insist, 'the personal is political'.[1] Therefore, it is important to reconsider Barthes's individualized path to the universal in *Camera Lucida*, to recognize the political import of his 'personal impulses'. A close reading of the text discovers that many of Barthes's most important and influential insights are informed by complicated, and sometimes vexing, personal–political inclinations. Indeed, Barthes's very conception of photography is laden with anxieties about race and reproduction.[2]

Focusing on Barthes's articulation of the *punctum*, the detail that draws one inexplicably to an image, and the *that-has-been*, the photograph's unique testimonial, this essay traces manifestations of sexual and racial inquietude in *Camera Lucida*. It explores the tangle of racial and sexual problematics that pervades Barthes's text with the ultimate aim of suggesting how one might utilize Barthes's most compelling and significant insights without reproducing the racial and sexual impulses his text sets forth.

The *punctum*

In *Camera Lucida* Barthes identifies two elements fundamental to discerning photographic meaning – the *studium* and the *punctum*. As subsequent scholars have rehearsed, he suggests that the studium includes the cultural knowledge

that informs one's reading of a photograph; the studium is shaped by 'a certain training' (26) that evokes a culturally prescribed reading of a given visual field The punctum is a much more personal response to certain details in the photograph that 'wound' or pierce an individual viewer, punctuating, or breaking through the trained reading of the studium (Barthes 1981: 25–7). Barthes proclaims that 'in order to perceive the *punctum*, no analysis would be of any use to me', thereby suggesting that the punctum cannot be codified or predicted for any individual viewer. As readers of Barthes's text, however, we can nonetheless assess the examples he uses to describe the punctum, and note the subtle patterns that inform them. In short, we can analyse Barthes's punctum for both personal and cultural schemas.

Barthes argues that the punctum 'is a kind of subtle *beyond* – as if the image launched desire beyond what it permits us to see' (59), and for Barthes, the punctum is consistently that detail, that something in a photograph, which triggers a relay of thoughts and emotions back into his personal history. The punctum is the trace that launches Barthes 'beyond' the 'that has been' of the photograph, beyond the photograph's referential denotation, and into his own experience. In other words, the punctum unsettles the fixity of the image, making it available to Barthes's personal narrative.

In a salient example, Barthes explains the workings of the punctum through his reaction to a James VanDerZee photograph, a group portrait made in 1926. Barthes's studium description of the image is notably condescending: he states that the photograph 'utters respectability, family life, conformism, Sunday best, an effort of social advancement in order to assume the White Man's attributes (an effort touching by reason of its naïveté)' (43). Barthes's explanation of the studium is laden with a paternal racism that readers are asked to ignore in pursuit of that which really interests Barthes – the punctum. He calls upon the studium as if it is apparent, transparent, as if this lovely formal portrait could not be read in any other way, as if all readers would share Barthes's bemused reaction to the image and its subjects. While certainly Barthes's reading might be attributed to a predictable set of European cultural codes, readers are not asked to 'see' racism as part and parcel of the studium, but instead, to see through it to the studium meaning Barthes presumes. In other words, Barthes's text asks readers to view this racist paternalism as natural, or beside the point, rather than as a culturally codified part of the studium to be put under examination.

The foundation from which Barthes moves to a discussion of the punctum in the VanDerZee photograph is thus troubling. And his extended rumination on the punctum vis-à-vis this photograph is also curious. Considering the image further, Barthes suggests that what truly interests him in the image, the punctum, the details that prick him, are the strapped pumps worn by the woman who stands in the photograph. He notes: 'strange to say', 'this particular punctum arouses great sympathy in me, almost a kind of tenderness' (43). Here the shiny shoes of an unnamed woman provide the punctum for Barthes, the inexplicable something that compels him and captures his imagination.

Recalling the VanDerZee photograph in a later explanation of the punctum as latent, as the prick that returns to the viewer only after the image itself is no longer under view, only after it has been transformed into a visual memory, Barthes muses:

> Reading Van der Zee's [sic] photograph, I thought I had discerned what moved me: the strapped pumps of the black woman in her Sunday best; but this photograph has *worked* within me, and later on I realized that the real *punctum* was the necklace she was wearing; for (no doubt) it was this same necklace (a slender ribbon of braided gold) which I had seen worn by someone in my own family, and which, once she died, remained shut up in a family box of old jewelry (this sister of my father never married, lived with her mother as an old maid, and I had always been saddened whenever I thought of her dreary life). I had just realized that however immediate and incisive it was, the *punctum* could accommodate a certain latency (but never any scrutiny).
>
> (Barthes 1981: 53)

Barthes's protestations aside, I would like to place this punctum under a bit of scrutiny. In Barthes's memory, the punctum of a woman's strapped pumps transmutes into the punctum of her necklace, 'a slender ribbon of braided gold' that resembles a necklace worn by Barthes's aunt. And yet, if one refuses to rely on Barthes's recollection of the VanDerZee photograph, and turns to look at it again, one finds that both of the women in this photograph wear necklaces, but they are *pearl* necklaces, not the ribbons of braided gold that prick Barthes. *What, then, is the punctum?* Barthes says that 'it is what I add to the photograph', but it is also '*what is nonetheless already there*'. Yet here it would seem that 'what is there' in the photograph, the actual detail (the pearl necklace), can be obfuscated by what Barthes brings to the photograph (the ribbon of braided gold). That which pierces the surface of the photograph may not be visible in the photograph itself.[3] Indeed, the punctum may refer to an entirely subjective signification system.

Surely, Barthes's failure to remember precisely the attributes of a piece of jewellery is a slight offense; it is, however, indicative of a much more fundamental interpretive slippage, whereby personal connotation can efface representational denotation through the mechanism of the punctum. It is not so much the erasure of a pearl necklace for a gold one that is disturbing, but the effacement of an African American woman under the sign of Barthes's aunt. One is left to wonder whether this erasure, effected by the punctum, is in part a result of the studium, of a racist paternalism that disregards an African American woman's self-representation as trite.

While Barthes cannot be faulted for remembering his aunt when contemplating the VanDerZee photograph, neither can other viewers be blamed for being less curious about Barthes's aunt than about the people

actually represented in the photograph. They are, in fact, the maternal aunts and uncle of James VanDerZee, their photographer – Mattie, Estelle, and David Osterhout.[4] While Barthes's musings are compelling for all who are interested in Barthes, they are nevertheless of little use in reading this image in its historical specificity.[5] Indeed, here Barthes sidesteps his most powerful insight into the distinguishing characteristics of photographic signification, the 'that-has-been', the undeniable referentiality of the photograph. In Barthes's punctum response to the VanDerZee photograph, he effaces those who have been for a personal memory (of another who has been), obscuring the indexicality of the photograph with a memory that might have been evoked by any other sign system. Here the punctum would seem to evade the photograph itself, enclosing Barthes in a solipsistic reverie. In making himself (and his memories) the measure of photographic meaning, Barthes obfuscates the presence of other historical subjects, and in so doing, disregards his most compelling claims about photography as a unique sign system – the evocative, provoking presence, or present-absence, of those represented on photographic film.[6] It would seem that the racism registered in his studium response enables Barthes to devalue those who have been, subsuming them under himself, under his own personal history, under the inadequate prick of the punctum.

The photograph, the mask, the slave

VanDerZee's portrait of his aunts and uncle is not the only image of African Americans Barthes calls upon to define the attributes of photography. His discussion of Richard Avedon's 1963 portrait of William Casby, 'born a slave', is also instructive in this regard. In this portrait Barthes proclaims to see 'the essence of slavery' 'laid bare' (34), and also to understand photographic meaning as a kind of mask. According to Barthes, the photograph means nothing, it communicates only 'that has been', unless it becomes a mask, an abstraction greater than a particular subject, a type divorced from an individual, a culturally translated symbol. In language he used to describe the photographic sign in his earlier studies, the 'message without a code' (Barthes 1977a: 43) signifies only to the degree to which it can be abstracted and, in fact, codified. It cannot enter the world of signs proper unless its specificity is transformed. In Barthes's reading, the portrait of William Casby enters the realm of meaning as it comes to signify 'slave', and ceases to register a singular face. Barthes collapses William Casby under the sign of slave, seeing in this portrait not a man who must have lived most of his life as an autonomous subject, but instead, 'the essence of slavery laid bare'. In Barthes's reading, a subject is transformed into an object; in Frederick Douglass's famous words, 'a man is made into a slave'. Barthes then uses the objectification of Casby to comment on the nature of photographic meaning; photographs become readable through a similar process of abstraction and categorization. The photograph enters meaning as its specific subject is transformed into a cultural object.

Elsewhere in *Camera Lucida*, this process of objectification troubles Barthes. Indeed, it particularly disturbs him when he thinks about photographic portraits of himself. As Jane Gallop has recently noted, Barthes very rarely does consider photographs of himself in *Camera Lucida*, choosing instead the role of spectator, of viewer, of the self as politically autonomous subject authorized to look (Gallop 2003: 19). Musing upon the process of being photographed, Barthes suggests that the photograph 'represents that very subtle moment when, to tell the truth, I am neither subject nor object but a subject who feels he is becoming an object' (14). Resisting such objectification, Barthes proclaims: 'It is my *political* right to be a subject which I must protect' (15).[7] The political right of subjecthood is, of course, precisely that which is denied to the enslaved individual; he or she is not legally recognized as a subject, but as an object.

In Barthes's analysis, the photograph is in some ways equated with the slave; the cultural meaning of both is accorded by the extent to which they function as objects. Thus Barthes's choice of the William Casby portrait is particularly telling, for it amplifies the objectification that is central to Barthes's experience of the photographic process, and also central to his description of photographic meaning. In Barthes's musings, the slave figures as the objectified individual who most explicitly emblematizes photography's transformation of private subjects into public objects. The slave is the objectified subject par excellence. Through the portrait of William Casby, Barthes transfers the position of the objectified that he resists for himself to enslaved men and women. Maintaining his own political right to be a subject, Barthes collapses William Casby into the category of the photographed that signifies slave.

That-has-been

Slavery surfaces again in Barthes's articulation of the photographic sign's most unique characteristic – its indexical testimonial – 'that-has-been'. For Barthes, one of the images that registers most powerfully the very ontology of photography, this 'that-has-been', is a photograph of a slave market that he cut from a magazine as a child and carefully saved, a photograph that 'showed a slave market: the slavemaster, in a hat, standing; the slaves, in loincloths, sitting'. The image provoked the child Barthes's 'horror and fascination', for as a photograph it proclaimed with '*certainty* that such a thing had existed' (80).

According to Barthes, the photographic sign, unlike the linguistic sign, first exists as both a temporal and a tactile fact – the photograph records light rays reflected off an object, impressing themselves onto photographic film in a fraction of a second. As Barthes puts it, 'The photograph is literally an *emanation* of the referent' (80). While the photograph may not be able to tell us much more about the subject it makes visible without textual interpretation, it undeniably testifies – 'that has been'. Through the magic of light and chemistry, 'that', as it existed for a fraction of a second, impressed itself on film. This incontrovertible presence is what fascinated and horrified Barthes about the slave market

photograph: The photograph gave evidence of slavery, proving its existence with certainty – as Barthes says, 'without mediation' (80). In other words, to the child Barthes the photograph made slavery uniquely present and even palpable; it impressed the fact of slavery into the time and space of Barthes's consciousness.

Following his brief discussion of the slave market photograph, Barthes notes a secondary effect of the photograph's power to proclaim 'that-has-been', namely the sense that the viewer is literally touched by the subject photographed. 'From a real body, which was there, proceed radiations which ultimately touch me, who am here. ... A sort of umbilical cord links the body of the photographed thing to my gaze: light, though impalpable, is here a carnal medium, *a skin I share* with anyone who has been photographed' (my emphasis, 80–1). The light that touches the surface of the subject photographed, captured on film, also touches the viewer, rebounding as it were, in Barthes's imagination, from subject, to photograph, to viewer. Perhaps this then underscores what is so shocking, for Barthes, about the slave market photograph. For the photograph not only testifies to the existence of slavery, it also *touches* Barthes; in his imagination, Barthes shares a skin with the enslaved men and women. In this provocative shared corporeality, Barthes's own position as a free, white, self-possessed European viewer is unsettled, for his 'shared skin' metonymically links him with slavery, blackness, and objectification under a white gaze. He achieves for a moment, perhaps, a recognition of what Frantz Fanon has called the racial epidermal schema of colonial and post-colonial Europe, the sense of having one's subjectivity subsumed under the sign of one's skin (Fanon 1967: 112). The 'shared skin' that links Barthes to enslaved people must unsettle his own sense of (political) self-possession, reminding him of that which he refuses, namely his own potential to be objectified. But even as the slave market photograph instils anxiety, it also enables him, once again, ultimately to pass off the position of the objectified onto others.

By nature of its literal absence in the text, the slave market photograph occupies a position intriguingly parallel to *Camera Lucida*'s most famous image, the Winter Garden Photograph of Barthes's mother as a young girl. This image is the photograph that sets the second half of Barthes's meditations in motion (Barthes 1981: 73). It is the image that Barthes, mourning his mother's death, ultimately seeks, a photograph that captures her essential self, and in so doing also captures the intrinsic nature of photography, the medium's unique capacity to make the absent present. In the Winter Garden Photograph, Barthes finds his mother's essence captured in the photograph's 'that-has-been'. In this image the mask of photographic meaning suddenly vanishes, and Barthes is left in the presence of his mother's soul (109). In this photograph the 'that-has-been' overwhelms the cultural meaning of the image; the portrait is not confined to or delimited by likeness; it offers truth and identity. As Barthes declares: 'The Winter Garden Photograph was indeed essential, it achieved for me, utopically, *the impossible science of the unique being*' (71). If the portrait of William Casby

exemplifies the mask of photographic meaning whereby a unique individual is translated into a cultural sign, the Winter Garden Photograph secures precisely the opposite; it removes the mask to reveal the unique individual. The Winter Garden Photograph becomes, for Barthes, a 'treasury of rays' that 'emanated' from his mother, 'from her hair, her skin, her dress, her gaze, *on that day*' (82). An image deeply personal and profoundly important to Barthes, it is one he refuses to reproduce for later viewers. Thus, the essential images, those that make the 'that-has-been' most powerfully apparent, are the images that ultimately remain absent from Barthes's text – the slave market photograph and the Winter Garden Photograph.

Barthes's refusal or inability to reproduce examples of his most powerful evidence is curious in such a heavily illustrated text. One can easily, however, understand his reluctance to share the Winter Garden Photograph, an image so profoundly important to him, and one that might prove, for other viewers, as he says, 'nothing but an indifferent picture, one of the thousand manifestations of the "ordinary"' (73).[8] And yet, Barthes's decision not to reproduce this image leaves his readers, once again, only with Barthes's rendition. The photographic evidence is obscured, indeed replaced, by his reading. There is no chance for the represented to stand and meet the gaze of others, and there is no opportunity for another viewer to be authorized. Denied one's own response to the image, ultimately one can only respond to Barthes himself. This accords with Barthes's preferences, for one of the very things he proclaims to have admired about his mother is that he had never known her to make 'a single "observation"' (69). In Barthes's account, she never looked and considered and critiqued.[9] She never performed the intellectual work that was Barthes's entire purpose. She was there to be observed only, and in the case of the Winter Garden Photograph, to be observed only by Barthes.

An umbilical cord of light

As discussed above, Barthes explains the profound impact of the photograph's 'that-has-been', its 'intractable reality' (119), through the metaphor of a 'shared skin' that links viewer and viewed (81). This 'shared skin' is a truly provocative image, especially if one imagines Barthes gazing at the slave market photograph that so intrigued and astonished him as a child. Even more provocative, perhaps, is the *kind* of skin that Barthes imagines links him as viewer to the photographed subject. In Barthes's articulation, 'light' becomes not simply a 'carnal medium' but an '*umbilical cord*' (81, my emphasis), joining viewer and viewed in a surprisingly filial, in fact, *maternal*, relation.

If the photograph is the conduit for the umbilical cord of light, exactly who stands in the place of the mother in this relationship, the viewer or the viewed? Once again, Barthes's discussion of the Winter Garden Photograph is instructive here. In this image, Barthes sees his 'mother-as-child' (71), and recognizes how childlike she actually did become in her last days. Musing on the end of

her life, Barthes suggests, 'She had become my little girl, uniting for me with that essential child she was in her first photograph' (72). As Barthes's mother becomes his little girl, Barthes enters, briefly, the procreative model of genera-tion, of reproduction; he becomes a kind of parent. He declares, 'I who had not procreated, I had, in her very illness, engendered my mother' (72). Barthes, the gay male intellectual without children, is linked through his mother, by becoming his mother's mother, to what he deems the universal; he transcends himself, his particularity, his death, by momentarily creating a child (his ailing mother). And yet, because this child, his elderly mother, will not live on past his own inevitable death, Barthes's parenting provides only a taste of the 'Life Force' through which, according to 'so many philosophers', so many heteronormative philosophers, the individual transcends Death through his or her procreative role in the reproduction of 'the race, the species' (72).

Barthes proclaims that after his mother's death his vision of himself as gay-male-progenitor also dies. After the death of the mother-as-child, Barthes declares that he can no longer do anything but wait for his 'total, undialec-tical death' (72).[10] And yet, Barthes also supposes that his procreative capacity might be re-envisioned in a utopian sense, whereby he might transcend finality through writing, in which he might live beyond himself through the texts he generates. In this sense, writing provides an escape from the body that dies or fails or refuses to procreate; writing enables the proliferation and expansion of the self beyond the awkward limitation and finality of the body.

As Barthes argues in his autobiography, *Roland Barthes by Roland Barthes*, writing also liberates the self from the limitations of its 'narrative continuity', from its autobiography, from its place in the '"family romance"' (1977b: 4, 3). For Barthes, that discrete, continuous self, the self that must be liberated from its singularity and confinement, is construed and anchored by 'imagery', by an 'image-repertoire' – by family photographs (3, 4). It is one's visual insertion into the family line that connects and confines one to a genealogy. However, writing, marking, for Barthes, the beginning of 'productive life', can surpass the image-repertoire (4). Here, then, photographs represent the domain of the discrete, autobiographical, ultimately unproductive self, while writing represents the domain of the self liberated from its private definitions, and made produc-tive. The photograph adheres one to a body, the written text only to an abstract signifier. In Barthes's autobiography, as in *Camera Lucida*, the photograph, like the body it represents, ultimately signifies death. Writing, on the other hand, relying on the abstract linguistic signifier, can liberate one's meaning from the body, and thereby signify beyond life and death.

Following Barthes's ruminations on photography in his autobiography, one might also associate the photograph, as Victor Burgin has, with a kind of expanded semiotic sphere (in Julia Kristeva's sense), an extended pre-symbolic stage, in which the body and its sensations, and the mother's body, dominate self-perception (1986a: 84–5). For Barthes, the image-repertoire, and the biog-raphy it anchors, ends with one's youth, ends as one enters the public social

sphere through the production of writing. The semiotic, associated with the image (and the mother), ends with mastery of the symbolic.

The images that introduce Barthes's autobiography reinforce such a psycho-analytic reading. A photograph of the infant Barthes held by his mother, both of them looking out at the camera, is playfully entitled 'The mirror stage: "That's you"' (1977b: 21). Clearly referencing Lacan's mirror stage, in which the infant comes to recognize himself in and as an image, Barthes's photograph anchors early self-perception in the image, and in the arms of the mother. Another, later photograph, 'The demand for love', replicates 'The mirror stage' image, with the child Barthes held in his mother's arms, and both again looking out at the camera (5). The repetition of the pose is strained, however, by the size of the boy Barthes, no longer able, really, to fit in his mother's arms. In D.A. Miller's wonderful reading of this image, the photograph announces what he calls 'a certain gay male body'. According to Miller, 'His ungainly lower limbs betray the boy. ... They are too long for short pants, and too long to justify what the boy nonetheless evidently persists in wanting: to be carried by his mother' (1992: 32). Refusing the mythos of the (presumably straight) male body's autonomy in his display of the 'mothered body', 'every image of Barthes, whether fully grown or all alone', according to Miller (1992: 33), 'materially reinscribes his mother in the characteristically dejected posture of his body, always ducking and drooping, as though always wanting, but never any longer able, to drop into her arms'.[11] In *Camera Lucida* two things are certain: One is a temporal fact, the 'that-has-been' of the photograph; the other is a spatial fact, namely, as 'Freud says of the maternal body', 'that "there is no other place of which one can say with so much certainty that one has already been there"' (1981: 40).

Those very things that must be superseded by writing in order to liberate the productive self in Barthes's autobiography – the image-repertoire and the mother's body – actually become the source of a procreative impulse and power in *Camera Lucida*. Indeed, in Barthes's final text a powerfully procreative image emerges in his thoughts on photography: as light becomes an umbilical cord that links the photographed to Barthes himself, a vision of the gay male progenitor re-emerges. Photography becomes, as it were, a doubly reproductive medium: as light becomes a carnal medium, mechanical reproduction serves as a kind of surrogate for sexual reproduction.

In an inventive alteration of what one might traditionally think of as photography's creative function, Barthes does not place the photographer in the position of progenitor, but instead invokes the viewer, the spectator, Barthes himself, as the origin point for reproduction. In a stunning statement Barthes declares: 'I am the reference of every photograph' (84). If every photograph refers to Barthes, if he becomes the subject of every photograph, then the images also reproduce him, they become his reproductions, his generative offspring. Suddenly the 'that-has-been', the intractable certainty of a temporal real, of the momentary presence-in-absence of the thing photographed, is subsumed under the sign of the viewer, referring to that viewer, representing and reproducing

him. Through this articulation, Barthes becomes, in his own imagination, the mother of all photographs. *What is one to make of this?*

Returning, as Barthes himself so often does, to the VanDerZee portrait, it is illuminating to reconsider the punctum in light of these thoughts on reproduction. Revisiting Barthes's ruminations on this photograph, one finds that it is really only one woman, Estelle Osterhout, the woman who stands, and the details of her attire, that trigger the punctum for Barthes. Her low belt, her strapped pumps, and finally her pearl necklace, spark Barthes's mournful response to the photograph. He describes this woman as 'the "solacing Mammy"' (43), and thus, once again, his punctum response is informed by a specific studium training; the African American woman becomes 'Mammy' only through the lens of a racialized and gendered class system. Subsuming the woman of colour under the white fantasy of the 'Mammy', Barthes symbolically harnesses her procreative energies to raising a white brood, effacing her own potentially reproductive role as mother.[12]

The necklace Osterhout wears recalls for Barthes that other necklace, the 'slender ribbon of braided gold', which belonged to his aunt. VanDerZee's aunt reminds Barthes of his own aunt, whom he describes, once again, as follows: 'This sister of my father never married, lived with her mother as an old maid, and I had always been saddened whenever I thought of her dreary life' (53). (Remarkably, Estelle Osterhout never married either.[13]) Deeming his aunt an 'old maid', Barthes would seem to denigrate her for failing in her procreative role. And yet, this aunt's 'dreary life', mirrors quite closely Barthes's own. For Barthes himself 'never married' and lived his entire adult life with his mother (Olin 2002: 112). Indeed, Barthes's pity for his aunt may mask an anxiety about his own family position. In a brief discussion of the photograph's capacity to capture a 'genetic feature', Barthes declares: 'In a certain photograph, I have my father's sister's "look"' (1981: 103).[14]

Ultimately, the punctum in VanDerZee's photograph is activated by Barthes's nervous identification with his own aunt. Through a signifying slippage, VanDerZee's aunt recalls Barthes's aunt, who finally recalls Barthes himself. What Barthes sees in this image, in the woman who stands behind and to the side of her relatives, slightly in the shadows, is an image of his own aunt, and ultimately of himself – an image of the one who stands to the side of the family narrative. Barthes is never really the mother of all photographs, but always the aunt.[15]

Barthes's anxieties about race and reproduction thus merge in his response to the VanDerZee photograph. They also intersect elsewhere in his text, notably in his references to Francis Galton, the nineteenth-century founder of eugenics. Galton defined eugenics both as a science of race and a programme of controlled breeding, and he utilized photographs to construct the physical signs of familial lineage and race (Galton 1884, 1892, 1907). In Barthes's discussion of family photographs, he evokes the eugenicist idea of biological inheritance in his discussion of 'the stock' made manifest in the faces of family members caught

on film (1981: 103–5). It is here that he bemoans his resemblance to his aunt (103). Surprisingly, the family likeness that links Barthes to his aunt also evokes their similar role in refusing to reproduce; they carry, but will not continue, the reproduction of 'the stock'. Photographs of their faces may testify to eugenicist thinking, but they will not fulfil eugenicist goals.

Barthes directly refers to Galton in the final pages of his text, celebrating his attempt to read the signs of madness in photographed faces (113). Remarkably, it is this madness – madness conjured by Galton, one of the thinkers most profoundly associated with race and reproduction – that finally might release Barthes from the limitations of his own racial and sexual problematics. Deeming Galton's photographic experiments a failure (113), Barthes nevertheless discovers in all of those mugshots, all of those frontal stares, a different kind of madness. In response to so many direct looks, Barthes declares that the photograph 'bears the effigy to that crazy point where affect (love, compassion, grief, enthusiasm, desire) is a guarantee of Being. It then approaches, to all intents, madness' (113).

Ultimately, then, the photograph insists on its referent. However much the punctum may launch one beyond the photograph's subject, that subject's temporal presence cannot be denied. Perceiving that presence engulfs the viewer in a kind of madness, for the 'effigy', the person photographed, must live, the representation must be real, the absent must be present. 'The Photograph then becomes a bizarre *medium*, a new form of hallucination' (115). The photograph transports the photographed into the time and space of the viewer. To recognize this is to go mad, for ghostly traces become real, and present; they touch and haunt the viewer. It is finally this disruptive madness that Barthes champions.[16] It is this madness that releases him from the solipsism effected, in part, by the racism registered in the studium. Choosing to recognize the radical presence of photographed subjects, Barthes can no longer subsume them under the sign of himself.

In the end, even Estelle Osterhout, the subject elided most extensively in Barthes's meditations on photography, is asserted in her photograph. Finally, Barthes must bear witness to her. Trying to understand the link between 'Photography, madness' and love (116), Barthes returns, once again, to the VanDerZee photograph:

> In the love stirred by Photography (by certain photographs), another music is heard, its name oddly old-fashioned: Pity. I collected in a last thought the images which had 'pricked' me (since this is the action of the *punctum*), like that of the black woman with the gold necklace and the strapped pumps. In each of them, inescapably, I passed beyond the unreality of the thing represented, I entered crazily into the spectacle, into the image, taking into my arms what is dead, what is going to die ... gone mad for Pity's sake.
>
> (1981: 117)

Here Barthes offers a different model of the possible relationship between viewer and viewed. Entering in to a photograph, one might embrace its subject, allowing one's self to be touched, without demanding reference or representation. One might identify without subsuming or consuming the other. In other words, the *presence* of the present-absent might be maintained in the face of one's own response. The that-has-been might be allowed to coexist with the punctum.

This model of photographic engagement acknowledges the that-has-been much more powerfully than mere studium recognition. It maintains the urgency and intensity of response accorded by the punctum, without allowing the viewer's own stories to overwhelm the subject photographed. Such a method of photographic inquiry depends on the labour of the viewer.[17] Such mad recognition requires a viewer willing to enter the spectacle of the photograph, willing to embrace its subject. It requires the effort of a devoted son, perhaps, or an obsessive scholar. Barthes finally commits himself to being this viewer, yet this is the viewer Barthes cannot be certain his own images will secure.

In ending, I would like to look at Barthes – to look at the Barthes who has so persistently placed himself in his text, representing and reproducing himself, symbolically grasping at what he calls the Life Force. Once again, it is his search for his mother's trace, recorded in a photograph, that compels Barthes's thoughts on that Life Force. Looking through photographs to find the truth of the one he loved, Barthes must also wonder who will perform this tender act of mourning for him. Will his own photographs, like his aunt's necklace, remain 'shut up in a family box' (53), neglected by more distant relations? Will they become the abandoned and discarded images David Deitcher describes in his search for a gay archive? Reflecting on one such image, Deitcher states: 'The knowledge that no children of my own will survive to remember me contributes to [my] morbid predisposition; as does the suspicion that among my eight nieces and nephews, some will forget me too' (1998: 33; see also Deitcher 2001, 13–25).

If the writing life frees one from the family narrative, so does a refusal to reproduce. But the latter 'liberation' from the family romance is filled with anxiety for Barthes, because it is also a return to the finitude to which that family narrative, supported by his childhood photographs, seemed to confine him. Surely Barthes has lived on through his writings rather remarkably. His present-absence remains profound. But it is existential mournfulness and anxiety that pervade *Camera Lucida*, his last text. After the death of his mother, Barthes cannot be certain his demands for love will be met. Standing to the side of the family narrative, Barthes finds himself faced with what he calls, once again, 'total, undialectical death' (1981: 72). There will be no heir to reproduce him, no child to mourn his death and to cherish his photograph.

Barthes's personal exploration of photographs demands, in part, a personal response – one I now undertake with some trepidation. I find I can meet Barthes part way, by choosing a path of 'sympathy' to his madness. Using the punctum as pathway to the that-has-been, I will try to meet Barthes as living effigy. As one aunt, I will consider another, and agree to imagine, at least, that I

see Barthes in one of the images he has left behind. I am drawn to a photograph of the adult Barthes preparing himself to tackle the blank slate of his writing tablet.[18] It is an unusual photograph, perhaps taken on vacation. The typically dark clad Barthes, pictured in enclosed, wooden offices, here sits perched on a plush white rug, in a bright airy room, dressed entirely in summer whites. It is an image of the adult Barthes who has liberated himself from the family romance through the symbolic practice of writing. But it is also an image in which his short pants recall that earlier photograph of his 'demand for love', of his demand to be central in the family narrative. I gaze at him from behind and to the side, and wonder which close admirer might have taken this photograph. I marvel at my access to this intimate scene. Entering into the image of Barthes, embracing what is dead, this is the photograph I promise to keep. This is the one I will rescue from the advance of a Life Force that forgets and obscures those who do not biologically reproduce. This is the image I will save from Barthes's own self-referential practice. Finally, then, as one aunt reflecting on another, I find I can both *be* mad, and *go* mad, for sympathy's sake.

Notes

1 I am thinking especially of the following work: Mavor (1999); Spence (1988); Kuhn (1995); Hirsch (1997, 1999); hooks (1994); Gallop (2003); Willis (2005); Matthews and Wexler (2000).

2 I agree with Fred Moten (2003: 202) that 'blackness and maternity play huge roles in the analytic of photography Roland Barthes lays down in *Camera Lucida*', but I take a different critical path through Barthes's text.

3 Margaret Olin (2002) makes a similar observation in her wonderful essay 'Touching Photographs: Roland Barthes's "Mistaken" Identification'.

4 David C. Hart (1996: 11) provides this biographical information. For further information about VanDerZee see also Willis-Braithwaite (1993).

5 I agree, then, with Richard Powell's assessment of the limitations of Barthes's analysis of the VanDerZee photograph (2003: 17).

6 As Fred Moten has argued, in *Camera Lucida* 'historical particularity ... becomes egocentric particularity' (2003: 208).

7 Maren Stange reminded me of the political nature of Barthes's resistance to objectification in a lecture she gave in the 2003/4 American Visual Culture Speaker Series at the Contemporary Art Museum in St Louis, Missouri. Maren Stange, 'Documenting the Private', American Visual Culture Speaker Series, 1 April 2004, St Louis, Missouri.

8 I also agree with Diana Knight (1997: 138) that the Winter Garden Photograph may actually be the image reproduced later in *Camera Lucida* as 'The Stock', for in this image of the mother as child, 'her pose, her expression, and the position of her hands exactly match Barthes's description of the Winter Garden photograph'.

9 As Jane Gallop (2003: 26) states, 'The mother in that book [*Camera Lucida*] is defined precisely as never doing what the author does – observe and comment'. 'He observes; she does not; she is observed'.

10 As Diana Knight (1997: 133) has argued, 'The idea that Barthes himself has reproduced neither the family line nor the human species is omnipresent in the second half of the book', and 'this is obviously linked to the death of his mother and a new awareness of his own mortality'.

11 In Miller's reading, Barthes is defined by his demand for his mother. In her own work

with Barthes's, Carol Mavor takes an interesting theoretical turn, choosing for herself the position of the mother whose 'desire is to be demanded' (1995: 124). Jane Gallop also writes about Barthes's *Camera Lucida* from the position of the mother, but while Mavor chooses the writing mother, Gallop chooses the photographed mother. See especially 'Observations of a Photographed Mother', in Gallop (2003: 19–54).

12 See also David C. Hart's reading of this image (1996: 31–6, 45).

13 According to David C. Hart (1996: 15), none of the Osterhout sisters ever married.

14 Barthes (1977b: 14) reproduces a photograph of his aunt, giving it the caption: 'The father's sister: she was alone all her life'.

15 Diana Knight (1997: 140) has similarly argued: 'Of all Barthes's delvings into the past generations of both sides of his family, I am struck by the sympathetic identification with his aunt. If Barthes perceives his lineage as "a disturbing entity" of which he represents the end point (*CL*, 98), his aunt, too, has contributed to the collapse of the paternal line'.

16 John Tagg (1995) also discusses 'Barthes's final ecstatic embrace of the evidential power of the photograph' (299).

17 Taking a different path through Barthes's work, Victor Burgin (1986a: 88) similarly concludes that *Camera Lucida*'s 'significance for theory is the emphasis thus placed on the active participation of the viewer in producing the meaning/affect of the photograph'.

18 The photograph is reproduced in Barthes (1977b: 39). It is the final image in a short series of photographs of Barthes at his desk on pages 37–9.

Chapter 7

Benjamin, Atget and the 'readymade' politics of postmodern photography studies

Kelly Dennis

In a 1986 review of the Museum of Modern Art's four-volume catalogue of its Atget holdings, Abigail Solomon-Godeau asked whether photography theorists would have had to invent photographer Eugène Atget (1856–1927) if he did not already exist.[1] Atget, she asserted in an essay appropriately titled 'Canon Fodder', had been canonized by photography historians in a wealth of guises: as 'a surrealist Atget, a primitive Atget, a documentary Atget, a modernist Atget, or a Marxist Atget'. In short, Atget had become ensconced as the 'author-father' of the high-modernist aesthetic characterizing the 'art-historicization' of photography scholarship (221, 223). Given that German cultural theorist Walter Benjamin's few essays on photography, and particularly his brief and cryptic remarks on Atget, have been cited both to support and to critique most of the above-named 'Atgets', we might inquire whether Benjamin himself might also have needed inventing by photography studies had he not existed in translation.

The discursive construction of Atget as a modernist art photographer coincided with the critical promotion of contemporary artists who utilized photography independently of the very modernist lineage Atget justified. Artists such as Cindy Sherman, Barbara Kruger, Richard Prince, and Sherrie Levine were lauded as 'postmodern' in their use of photography not for aesthetic ends, but in order to detach the image from its social and cultural referent. Similarly, Benjamin's oft-cited works on photography, 'Little History of Photography' and especially 'The Work of Art in the Age of its Technological Reproducibility', were also canonized during the 1980s in the context of the so-called 'postmodern debate' between photography and painting. Quoted, footnoted, epigraphed, and parenthetically invoked by critics such as Solomon-Godeau, Douglas Crimp, Hal Foster, Rosalind Krauss, and the late Craig Owens, Benjamin was repeatedly cited in order to declare the postmodern death of modern art's aura, to critique modernist notions of artistic uniqueness and authenticity, and to assert photography's privileged role in problematizing not only art but representation.

Yet, as Jacquelynn Baas observed in her 1987 essay, 'Reconsidering Walter Benjamin', '[t]here is some irony in the current privileging of ["The Work of Art"] as the quasi-scriptural origin of a way of thinking that attacks the mystification of the original work'. 'Is there', she asks, 'any more "auratic" text in

contemporary criticism than Benjamin's essay?' (Baas 1987: 338). Indeed, has Benjamin's critical value been reduced to cult value by his embeddedness in photography studies' postmodern history? Given its dependency on Benjamin's writings, is photography studies itself based in a Benjaminian praxis? What is at stake in the canonization of Benjamin's texts on photography at this critical juncture in the birth of photography studies as distinct from and as a critique of photography history, and as coincident with theories of postmodern art? To be sure, within Anglo–American academic scholarship, there are as many Benjamins as there are Atgets: 'Benjamin the Critic, Benjamin the Marxist, Benjamin the Modernist, Benjamin the Jew [...] Benjamin the Philosopher', and, certainly for the above-named art historians and critics, Benjamin the Postmodernist ([Andrew] Benjamin and Osborne 1994: x). Although Benjamin's work was not widely available in English translation until 1968, it took little more than a decade for American critics in particular to auratize his work for numerous critical ends in literature, film, and art.[2]

In what follows, I trace the formation of photography studies and its coincidence with postmodern art criticism in the 1980s, as well as their dual investment in both Atget and Benjamin. Many theorists of postmodern art legitimated and even institutionalized not only a *discourse* on photography, but also certain photographic *practices* that might be said to be constitutive of photography studies. The American version of photography studies in particular originated in the postmodern debate ostensibly as a reaction against a formalist narrative of modernism promulgated by Clement Greenberg, in favour of a conceptualist one begotten by Marcel Duchamp – and thus replaced one canon with another. What, however, is excluded from each of these narratives?

The canonization of the previously obscure journeyman photographer from turn of twentieth-century Paris defines a key moment in the inauguration of a *critical* photography theory as distinct from the *connoisseurial* photography history established after World War II.[3] This assimilation of Atget and other photographers to an aestheticized history of photographic modernism designed to promote museum acquisitions served as a primary target for post-1960 critics who constituted the postmodern field of photography studies, and for whom photography constituted the postmodern site of a general 'shift from production to reproduction' (Solomon-Godeau 1984: 75).[4]

Two of these critics and theorists of photography as the art of postmodernity, Rosalind Krauss and Solomon-Godeau, both identified Atget's canonization as part of a larger endeavour on the part of photography historians to legitimate the medium within a particular view of modernism: one characterized by Clement Greenberg's renowned formalist theory of 'flatness' as characterizing the purity and essence of painting. As Krauss observed in her influential 1982 essay, 'Photography's Discursive Spaces', formalism constructed painting's turn to abstraction as a 'representation of its own space of exhibition' in the museum and the gallery. 'It is now fascinating', Krauss (1985: 133–4) concluded, 'to watch historians of photography assimilating their medium to the logic of

that history'.[5] What was 'fascinating' for Krauss about this formalist assimilation was its *erasure* of the multiplicity of discourses from which photography historically had been produced: in the instance of 'Photography's Discursive Spaces', Krauss identified scientific and topographical photographs that nonetheless had become exemplars of high modernist photography.[6]

The incorporation of Atget's copious and diverse photographic output – some 10,000 known negatives – as an artistic œuvre officially commenced in 1968 with the Museum of Modern Art's purchase of the Abbott-Levy collection. Atget's canonization thus functioned to validate his market value for the museum by inscribing his work within photographic modernism conceived now as a succession of masters begotten by this eccentric 'artist'. By contrast, Krauss argued that historians of photographic modernism were repressing the fact that the true authoring structure for Atget's 'oeuvre' was not the artist himself nor any modernist aesthetic, but the archive as an organizing trope of modernism.

The feminist Solomon-Godeau concurred with Krauss, adding, 'Atget's work is the *function* of a catalogue that he had no hand in inventing and for which *authorship* is an irrelevant term' (1986: 226). Thus, although Atget's work was, as Solomon-Godeau observes, '*physically* available for canonical treatment in 1960 as in 1970', it was not until the 'consolidation of modernism as *the* photographic aesthetic' in museums, the market, and university art history programmes that his canonical status would be assured. Here the Foucauldian critique of the 'author-function', and the archive as a regulatory mechanism for modernist knowledge production, were joined to a feminist critique of the patriarchal canon and its exclusions. Each of these critical modes was then activated in the critique of photographic modernism, fomenting the artistic and critical production that constitutes photography studies in the United States.

Throughout her work during this period, Krauss repeatedly referred to Benjamin's assertion that reproducibility voids authenticity, and that the use of captions for photographs in the context of the illustrated magazine points to the fact that photography's function is semiological rather than formal-aesthetic.[7] Her essays on Surrealist photography, on Marcel Duchamp, on Auguste Rodin's *Gates of Hell*, and on the 'indexical' art of the 1970s, all cite these Benjaminian 'facts'. In short, Krauss argued consistently that art historical modernism relied on a series of 'myths' about uniqueness, authorship, and authenticity negated by the actual practices of modernism, embodied for Krauss by artists or works previously excluded from art historical modernism. She saw in Benjamin's theories of photography and, indeed, in photography itself, corroboration of this argument.

Thus, what Eugène Atget's work did for an aestheticized, photographic modernism, Walter Benjamin's work did for photography studies and its critique of that history. Indeed, it was Krauss's graduate students from art history courses at CUNY – Douglas Crimp, Craig Owens, Benjamin Buchloh, and Hal Foster – who would spearhead much of the postmodern debate in art criticism, and who would author a particular version of Benjamin's critical legacy for contemporary photographic practices.[8] Like the fruitful critique of the archive

as an Enlightenment-inspired paradigm for developing forms of professional-ized knowledge in modernism,[9] the critique of art's aura, of art's presumed uniqueness and authenticity, and of the impact of photographic reproducibility on art, formed the basis of a larger critical enterprise that would counter the traditional narratives of modernist art in the name of 'postmodernism'.[10]

During the 1960s and 1970s, conceptual art's *use* of photography in ways other than those newly legitimated by photographic modernism highlighted what, by the 1980s, was theorized as photography's *functional* rather than aesthetic qualities – including indexical referencing, framing, and recording – functional qualities repressed from modernist narratives about photography's nineteenth-century origins. Conceptual works by artists such as Ed Ruscha, Robert Smithson, Bernd and Hilla Becher, and Mel Bochner, used photography as a framing or recording device for Duchampian 'found' images in the world:[11] Ruscha's gas stations and swimming pools, Smithson's signs and drainage pipes in Passaic, New Jersey, the Bechers' manhole covers, and Bochner's 'actual size' body parts. Indeed, it is tempting to speculate that Atget's work, veritable still-life depictions of empty Paris streets, doorways, and architectural embel-lishments, paradoxically was made *visible* to photography connoisseurs thanks to Ruscha's considerably more ironic, deadpan depictions of gas stations on Route 66, or his photographic cataloguing of every building along the Sunset Strip.[12] Surely, however, the coincidence of Atget's canonization with a concep-tual art practice that called such efforts into question could only function as a confirmation of the latter's threat to the former. Indeed, John Szarkowski's 1977 photography exhibit, 'Mirrors and Windows' at MoMA, which included artists such as Robert Rauschenberg and Andy Warhol, was characterized by Solomon-Godeau as an effort to neutralize the 'challenge' they represented to the curator's connoisseurial investment in photography (1984: 75).

The conceptually based photographic practice that Solomon-Godeau char-acterized as 'photography *after* art photography' (75–85) highlighted not the formal and aesthetic qualities of photography lauded by photography aesthetes such as Szarkowski, but photography's referential *function*. In radical contrast, then, to Clement Greenberg's characterization of modern art's 'self-critical' enterprise of paring down each distinct medium to its essential qualities (most infamously, 'flatness' in painting), Douglas Crimp would assert that postmod-ernism is defined by the fact that 'the actual characteristics of the medium, per se, cannot any longer tell us much about an artist's activity' (Crimp 1984: 176). Indeed, Krauss even suggested that Cindy Sherman's photographs do not 'construct an object for art criticism but constitute [...] an *act* of such criticism' (1990: 27, emphasis added).[13] It would seem, then, that for theorists of photog-raphy as the medium of postmodernism, the medium itself may be 'practically deconstructive', as Jacques Derrida ironically suggested in his own essay on Benjamin's canonization (Derrida 1987: 175).

But why Benjamin in particular in the 1980s? Though the scene of American art criticism had initially failed to acknowledge European art production during

the 1970s, it nonetheless relied for its theoretical apparatus on Benjamin, as well as on contemporary European thinkers such as Derrida, Roland Barthes, Michel Foucault, and Jean Baudrillard, whose works had begun to appear in English translation during the 1960s and 1970s.[14] Several key points taken from Benjamin – including photography's ability to technologically 'reproduce' art, the destruction of art's 'aura' by photography, the death of the subject (metonymically presupposed by his characterization of Atget's empty Paris streets as 'scenes of a crime'), and his claim that photography politicized aesthetics in opposition to fascism's aestheticization of politics – all bear a certain prominence in theories of postmodernism and in postmodern theories of photography.

To be sure, Benjamin was among the first to historicize and contextualize photography, as well as to define its social function and aesthetic impact. Benjamin provocatively suggested politics as an ontological dimension of photography as well. The importance of Benjamin, then, as a theorist and historian of modernity is undeniable, and his account of modernism's 'crisis of meaning' seemingly enabled the would-be postmodern critique of modernism.[15] The Atget about whom Benjamin himself wrote was the 'Surrealist Atget' – or, more accurately, the proto-Surrealist Atget – discovered by Man Ray in 1926. Benjamin had learned of the photographer through Berenice Abbott's 1930 publication of *The World of Atget*, and echoed Abbott in labelling him a 'virtuoso' and 'forerunner' (Benjamin 1980: 208). Indeed, Molly Nesbit claimed that Abbott's book on Atget instigated Benjamin's 'Little History of Photography' (Benjamin 1980; first published in 1931).[16] In this oft-cited essay, Benjamin traces said history from the 'fog' of photography's 'beginnings' to New Objectivity, and promotes constructivist and Surrealist photography for their revolutionary service.

In her review of MoMA's Atget volumes, however, Solomon-Godeau uncharacteristically took Benjamin to task for participating in Atget's canonization. Rather than indicting Benjamin for echoing Abbott's valuation of Atget as a modern photographic master (which he did), Solomon-Godeau chided Benjamin for his idealism: for his desire for photography 'to be an emancipatory, democratic, politically and culturally demystifying medium', and for his claim that Atget's photographs make apparent 'capitalism's [legacy of] exploitation and expropriation – inscribed (but masked) in its cultural achievements (of which the modern city is one)'. 'The historical joke', Solomon-Godeau sneered, 'is assuredly on Benjamin both for pinning revolutionary hopes on what we now know as the mass media and, even more ironically', for celebrating Atget's work as anti-auratic 'when, 50 years later, it is Atget's photographs that are industriously being pumped with aura' (1986: 222).

Despite, however, dismissing Benjamin's revolutionary desires for the camera image by referring to photography's widespread mass media use, by the end of her essay, Solomon-Godeau makes her own revolutionary claims for photography. As for Krauss, so for Solomon-Godeau, the very diversity of Atget's photographic production proved a larger point about photography itself: namely, 'the way photography anarchically disrupts the attempt to circumscribe

it in formalist or auteurist boundaries' (226). Similarly, Crimp insisted that photography is postmodern in a way that painting can never be, and that as such photography *as a medium* has ruptured the paradigms of art, history, representation, and subjectivity that subtend the discourses of aesthetic modernism. Both Crimp and Solomon-Godeau also valorized photography's *inherent* ambiguity, insisting that its opacity is a 'critical' tool, one that reveals our (modernist) desires for *meaning* from pictures, an opacity that Craig Owens (1980a, 1980b) would also laud as 'allegorical' in *his* promotion of photography's postmodernity.

Notwithstanding the critique of representation, then, postmodern photography theorists wanted to have their representational critique *and* their essentialized photography, too. Despite claiming the primacy of representation over medium, postmodern theorists nonetheless declared photography to be *the* medium of postmodernism, and claimed that the characteristics of photography made it uniquely suited to postmodern 'institutional and/or representational critique, analysis, or address' (Solomon-Godeau 1984: 76). Crimp and Solomon-Godeau both charged that photography history had 'repressed' or 'disavowed' photography's numerous discursive histories, and so, Crimp (1980: 91) suggested, 'it seems that we may accurately say of postmodernism that it constitutes precisely the return of the repressed', and thus the 'return' of photography, heralded as uniquely postmodern.

In 'Pictures', an essay developed from an exhibit Crimp curated that introduced the works of Cindy Sherman, Sherrie Levine, Troy Brauntuch, Jack Goldstein, and Robert Longo, Crimp celebrated the dissolution of purity in artistic media. Citing Michael Fried's 1967 'Art and Objecthood', in which Fried advocated Greenberg's formalist criteria for media, and warned that what lay 'between the arts' was 'theater', Crimp characterized postmodern art practice as wilfully occupying that 'corrupted' space and employing 'film, photography, video, [and] performance' in works that evoked the very temporality condemned by Fried.[17] Crimp and others lauded works by Levine and Sherman for deconstructively referring *beyond* themselves rather than self-critically referring *to* themselves. Sherman's 'Untitled Film Stills', Levine's appropriation of high art photographs as her own, Prince's appropriation of Marlboro Man advertisements, and Longo's performative tableaux were 'pictures' first, ones that drew upon familiar images to serve unfamiliar or opaque ends deemed 'critical' – not of themselves, in modernist fashion, but of the unreflective consumption of such images in mainstream culture and of their underlying social conditions.

Although the tactics may have been different, the modernist model for this acclaimed postmodern critical practice is the historical avant-garde. Avant-garde 'anti-aesthetic' art – *entre guerre* movements such as Dada, Constructivism, and Surrealism – traditionally excluded from formalist modernism, often deployed photography and, specifically, photomontage, toward critical ends: namely, as a critique of traditional and even early twentieth-century art that had attained to bourgeois respectability and profitability. More significantly, the historical avant-garde's various negations were aimed at the bourgeois society responsible

for World War I. This constellation of avant-garde art movements was championed by Benjamin and even structurally mimicked in his efforts to write the history of modernity (see Jennings 2004).

Against Greenberg's formalist lineage of modern art, one that trivialized the anti-aesthetic of the historical avant-garde, Krauss heroically recuperated Surrealism, and especially Surrealist photography, for a postmodernist canon and anointed Marcel Duchamp as the conceptual father of postmodern art.[18] Indeed, Duchamp could easily fulfil the third term in a postmodernist trinity including Atget and Benjamin, so ubiquitous was the legitimation of a postmodern practice in his name.[19] Duchamp's Readymades, in which the artist claimed as 'art' the mass-produced objects he (often barely) altered, are the most frequent conceptual sources claimed for postmodern appropriations.

But whereas Benjamin's ideas on aura, on the technological reproducibility of art, on the use of captions with images, and on authenticity have provided fuel for his postmodern canonization, most postmodern photography theorists have been discreetly silent about Benjamin's attendant hopes for photography and for mass culture to 'politicize aesthetics' as a response to fascism's aestheticization of politics.[20] After all, Theodor Adorno had charged Benjamin with failing to dialecticize his ideas on autonomous art (which Benjamin condemned as art's 'retreat' into art for art's sake) and thus for being too Brechtian both in his 'underestimat[ion…]' of autonomous art', and his 'overestimat[ion] of (utilitarian) art'.[21] Benjamin's call for 'politicizing aesthetics' has functioned, in Duchampian fashion, as a political 'readymade' for postmodern art criticism.

Thus, I would suggest that, more than the aura, more than photography's reproductive technology, more than his observation of Atget's empty streets as photographs of 'scenes of a crime', it is precisely Benjamin's idealism and failure of dialectical thinking that remain his *unacknowledged* contribution to photography studies, if not to theories of postmodernism.[22] As Solomon-Godeau herself demonstrated in her proclamation of photography's 'anarchy', postmodern critics and photography theorists are guilty of the same idealism and essentialism with regard to photography of which she accused Benjamin. Might we not apply postmodern theorists' ideas that photography reveals our desire for *meaning from* images to those same critics' desire for a truly politicized avant-garde art, or even for a truly politicized criticism *from* Benjamin – that is, a desire to locate the political as somehow inherent in photography?[23]

For postmodern art criticism participated in a larger discursive fetishization of Benjamin in literature, film, and cultural studies. Along with reproducing the auratic photographs of Benjamin himself – almost impossible to read, now, outside the context of his suicide, so often have they been used to cast this aspect of his biographical shadow – the ubiquitous Benjamin epigraph *signifies* to the reader something about an essay's author, the postmodern or photography theorist. It signifies, for instance, that she or he 'sides with' the knight-errant of the Frankfurt School's roundtable; that he or she is all too aware that the Jewish philosopher and essayist committed suicide fleeing occupied France

to avoid capture by the Nazis during World War II. A Benjamin epigraph thus speaks to our intellectual and scholarly empathies and to an awareness of the loaded history that World War II continues to signify.

But too often, that 'readymade' awareness has taken problematic form: for the postmodern debate in art criticism negotiated another 'return of the repressed' as well; namely, the putative 'return' of expressionist painting and, moreover, a return of European art to the American art market, which it began to dominate in the 1980s for the first time since World War II. In this light, for American critics to rely on Benjamin in the 1980s was to be complicit with a historical erasure of our own. For the other 'side' to the postmodern privileging of photography was the corresponding condemnation of German and Italian Neo-Expressionist painting as not only regressively modernist but even neo-fascist. The first generation of European artists born *anno zero*, painters such as the Italian 'Three C's' – Enzo Cucchi, Sandro Chia, Francesco Clemente – and Germans Georg Baselitz, Markus Lupertz, Jorge Immendorf, and Anselm Kiefer, notably invoked in their work the styles and symbols of their fascist history, earning them, in the words of one American critic, the historically weighted epithet, 'collaborators'.[24] Having initially missed the works on the art world's soon-to-be-globalized stage,[25] several of the above-mentioned postmodern photography critics roundly condemned the paintings for 'appropriating' power, faking transgression, and indulging authoritarianism (Owens 1992: 143–55; Buchloh 1984).

With the Vietnam war less than a decade behind them, American critics in the early 1980s nonetheless felt secure in condemning European artists for attempting to negotiate their own loaded post-war history nearly forty years later – a history in which the United States envisioned itself as the 'good guy' during World War II. By attributing the horrors of genocidal and imperialist war solely to the figure of Adolf Hitler, and thus rendering them distant and 'other', 'progressive' art criticism was complicit with the American culture industry's erasure of our own shameful and more recent history in Vietnam. Douglas Crimp's exhibition *Pictures*, featuring Troy Brauntuch's eerily banal reproduction of 'Hitler asleep in his Mercedes, 1934' from Albert Speer's *Inside the Third Reich* – an image that nonetheless refused to confirm an American audience's expectations for images of Hitler as a singularly monstrous 'other' – debuted in 1977,[26] the same year that George Lucas's ground-breaking science fiction movie *Star Wars* pitted his young heroes against the Evil Empire and its dehumanized Storm Troopers. Moreover, the earliest conference presentations and published articles on postmodern photographic practices began to appear between 1979 and 1980, roughly five years after the end of the American war in Vietnam and around the time that Steven Spielberg's matinee-style *Raiders of the Lost Ark* (1981) matched up academic archaeologist Indiana Jones against Hitler for possession of a Jewish relic, and *First Blood*'s Sylvester Stallone as John Rambo re-fought the Vietnam war in a small American town to establish veterans returning from this unpopular war as the enemy within.[27] In short, the United States was licking its wounds over its failed cold war adventure in

Vietnam, repressing its own recent history in favour of a more conventional narrative about our heroism during World War II, a repression in which post-modern art criticism was implicated.

Thus the reception of Benjamin's oft-cited essays on photography, 'The Work of Art in the Age of its Technological Reproducibility' and 'Little History of Photography', have been significantly over-determined in the context of the postmodern art debate's pitting of Hitler's Germany against the concep-tual art tradition of the United States. Neither the modernist Greenberg art trajectory nor the postmodernist Duchamp lineage that usurped it included political art of the Vietnam War era, which might rightly have claimed affinity with *entre guerre* avant-garde art. I point to the erasure of protest art to demon-strate, finally, the conformity of the postmodern narrative of post-war art to an all-too-familiar lineage of 'begats' stemming now from Duchamp rather than Matisse or Picasso or Manet, despite the postmodern diagnosis of decentred subjects and rejection of such grand historical narratives. I am also remarking a more general aesthetic exclusion of political art from the postmodern narrative, one consistent with Greenberg's exclusion of the historical avant-garde from formalist modernism. Indeed, such characteristically 'postmodern' historical amnesia could itself be considered complicit with the reactionary, Reagan-era conservatism of the 1980s.

Nonetheless, postmodern art critics ignored their own rhetoric about the centrality of representation over medium in order to herald photography as a particularly charged medium, indeed as *the* medium of postmodernism. In this way, they claimed that photography enabled us to see modernism anew, and that photography had the 'potential for institutional and/or representa-tional critique, analysis, or address' (Solomon-Godeau 1984: 77), suggesting that photography's potential for critique, irony, and political efficacy was somehow inherent in the medium.[28]

Largely theorized as 'play', postmodern resistance was characterized as momentary, interstitial, a short-lived guerilla attack using the master's tools to tear down the master's house, with the expectation that the master would reap-propriate and repackage any such resistance and sell it to willing consumers.[29] But in their silence regarding the historical circumstances surrounding Benjamin's theorization of technological reproducibility, and in their willingness to use the epithet 'fascism' against a medium, painting, rather than an economic and political reality – the increasingly globalized military–industrial–entertain-ment complex – postmodern photography theorists missed what theorists of modernism such as Benjamin, but also Adorno and even Greenberg had identified decades earlier. That is to say, they overlooked an ideological culture industry in the United States that reproduced and propagandized unequal social conditions in similar fashion to German fascism's manipulation of mass culture (whence Greenberg derived the term 'kitsch').[30]

Benjamin's hopes for photography and film lay in their participation in industrial capitalism's mode of production: photography, a 'machine' of the

industrial revolution, possessed, for Benjamin, the ability 'to penetrate behind the commodity-induced illusions of the lived world', particularly the avant-garde montage forms of Dada and Constructivist anti-art (Jennings 2004: 32). As Jan Mieszkowski has proposed, Benjamin's introductory assertion in 'The Work of Art in an Age of its Technological Reproducibility' – that '[t]he concepts which are introduced into the theory of art in what follows [...] are completely useless for the purposes of fascism; they are, on the other hand, useful for the formulation of *revolutionary demands* in the politics of art' (my emphasis) – is based in his idea that art is not necessarily of its *own* historical moment. Thus, new technological media make 'revolutionary demands' on art that cannot necessarily be met or even understood. According to Mieszkowski, the historical materialist must then 'confront [...] the present of something that by definition has no present', a task he claims Benjamin himself had undertaken in 'The Work of Art' in his effort to theorize how the technological reproducibility of art lends to its politicization (Mieszkowski 2004: 38).

Benjamin had observed that the 'nineteenth-century dispute over the relative artistic merits of painting and photography', although 'misguided and confused', nonetheless was a symptom of a 'world-historical upheaval whose true nature was concealed from both parties'. Indeed, in his second version of the essay, Benjamin qualified this premise further: 'commentators had earlier expended much fruitless ingenuity on the question of whether photography was an art – without asking the more fundamental question of whether the invention of photography had not transformed the entire character of art' (2002: 109).

Benjamin had written in 1934 that the nineteenth-century dispute between painting and photography concealed a recognition that technological reproducibility had transformed the very function of art from one of auratic, ruling-class affirmation to one of politics: namely, focusing the collective potential of the masses. Fifty years later, the postmodern dispute between painting and photography held that politics was implicit in the medium itself. But as Mieszkowski asks, is 'the change in the aura a change in what art is or in what we think about it?' More to the point, 'is the object of aesthetic inquiry something inherent to the material work or the ideologies of its audience?' (2004: 39). Indeed, the postmodern moment of photography studies' inception marks a conflation of the two. Whereas Tagg, Burgin, Sekula, and Rosler subjected cultural productions of photography – including mass media, documentary, and other practices of social regulation – to ideology critique, postmodern theorists promoted a photographic *art practice* that performed this same ideological critique by virtue of its appropriation of the aforementioned photographs. Consequently, postmodernist art critics in some cases displaced their own function as critics onto the medium.[31]

If the full implication of 'the nineteenth-century dispute over the artistic merits of painting and photography' was only later realized, perhaps the question, then, should be what the postmodern dispute between photography and painting might belatedly tell us some twenty-five years later. Postmodern theory today retains little critical bite, having largely assisted in the transition

from an international market for white male European and American artists to a globalized and biennialized market that includes women artists and artists of colour (Stallabrass 2004: 11).[32] Perhaps the 'revolutionary demands' Benjamin claimed were made by photography and film will yet be realized in digital and electronic media, aspects of which, despite rampant corporatization, continue to thwart corporate property law and profitability.[33]

Indeed, like Benjamin, and like the postmodern art critics, 'photography studies' remains today invested in the medium of photography in more than name. After all, what form of essentialism are we practising under the auspices of this volume, which commemorates the twenty-fifth anniversary of Victor Burgin's edited volume, *Thinking Photography*, as the critical 'origins' of photography studies? It is undoubtedly useful to rethink the field of study as it becomes increasingly institutionalized and thus subject to the dogmatism, cult value, and embeddedness of any institutionalized field of study.[34] Yet this is not at all a bad thing: we do so under the auspices of inaugurating yet another institutionalization of the medium in the form of a graduate degree programme in Photography Studies – neither fine arts photography nor art history.[35]

Such institutionalization does, however, point to the possibility, perhaps even the inevitability, of 'photography studies' becoming neutralized as a readymade critical practice. Like Benjamin, 'photography studies' is invested in the medium, its discourses, and the critical possibilities that are believed to be inherent in reading it. In this, we may be equally essentialist and idealist *because of*, not despite, our postmodernist theoretical baggage.

It is undoubtedly a lot to ask of photography, if not of Benjamin; as much, perhaps, as Benjamin's own futile hope that photography might empower the masses to resist fascism. Yet in an era of globalized capitalism and the de-industrialization of the United States, wherein the cold war economic and foreign policies set in motion by Margaret Thatcher and Ronald Reagan in the 1980s seem to be in the process of being fully realized, perhaps we can also be excused if we find the urgency, the idealism of Benjamin's hopes for photography still relevant.

Notes

1 The essay was later reprinted in Solomon-Godeau (1991). Solomon-Godeau's review concerned the four-volume *The Work of Atget* (Szarkowski and Hambourg 1981–5). As always, Steve Brown has polished both the argument and the prose, any remaining infelicities are the sole responsibility of the author.
2 An important corrective to readings of the essay as 'melancholic' about the loss of aura is Gasché (1994).
3 The reliance of post-war photography historians and connoisseurs on the formalist paradigms of art historical modernism constituted the subject of many of Krauss's early postmodernist essays published in *October* and later collected in Krauss (1985).
4 Solomon-Godeau cited Benjamin's essay 'The Author as Producer' as having charted this 'shift'.
5 'Photography's Discursive Spaces' was originally published in *October*, 42 (1982): 311–19.

6 See Tagg (1988: 117–19). Although Krauss merely observed rather than redressed this erasure in her discussion of Timothy O'Sullivan's and Clarence King's topographical survey photographs, others, including Tagg, Allan Sekula, Martha Rosler, and Deborah Bright, have done significant work in establishing the social history of documentary photography.

7 See, for example, the chapter 'The Photographic Conditions of Surrealism' (Krauss 1985: 101). Benjamin's statements on the collusion of caption and photograph in the illustrated magazine appear repeatedly in this text.

8 As early as 1987, Baas observed that the journal *October*, begun by Krauss and Annette Michelson, 'served as the chief vehicle for the dissemination' of Benjamin's 'Work of Art' essay as 'the "signifier" of a semiotically-based dichotomy between the photograph as the paradigm of an "age of mechanical reproduction" and the work of art as the fetishized object of a culture that has been surpassed' (337).

9 The critique of the archive derives primarily from Michel Foucault's *Archaeology of Knowledge* and is realized most fruitfully in the work of Sekula, Crimp, and Tagg.

10 Benjamin's essay, 'The Author as Producer', which briefly addresses the photographs of John Heartfield, Albert Renger-Patzsch, and August Sander, also played a significant role in art criticism of this period; however, I am confining my analysis of the appropriation of Benjamin's two most-cited works that explicitly concern photography.

11 Conceptual photography in the 1960–70s was itself preceded by the incorporation of photography in works by Robert Rauschenberg and Andy Warhol: see Solomon-Godeau (1984: 75–6).

12 Clark Worswick (2002: 27) confirmed that 'it was not until the 1980s and 1990s that [Atget's] role in twentieth-century photography began to be appreciated' (13), and referred, without irony, to such scholarship as 'Atget-werk'.

13 See Craig Owens's observation that Krauss was notorious for objecting to art that aspired to art criticism (1992: 308).

14 Craig Owens attributed this initial failure to the dominance of the American art market both in the States and abroad. See the interview in Owens (1992, especially 301–4).

15 Amongst the most evocative accounts of Benjamin's writing, and particularly his essays on photography, as a history of modernity is Cadava (1997).

16 Molly Nesbit in Lemagny and Rouillé (1987: 112).

17 Fried cited in Crimp (1984: 176).

18 The seminal text is Krauss's 'The Photographic Conditions of Surrealism' (1981); reprinted in Krauss (1995: 87–118). Key in establishing this lineage was Krauss and Jane Livingston's landmark exhibition, *L'Amour fou: Photography and Surrealism* at the Corcoran Gallery of Art in 1985, and their accompanying exhibition catalogue (Krauss and Livingston 1985). Krauss's 'Notes on the Index: Seventies Art in America' (1977) identified Duchamp's work as 'establish[ing] the connection between the index (as a type of sign) and the photograph' (71), an idea that much subsequent scholarship on postmodern art from the 1970–80s took as gospel. See also a special issue on 'The Duchamp Effect', *October*, 70 (Autumn 1994).

19 For a feminist critique of this revisionist canon, see Jones (1994).

20 James Meyer (2003: 63–5) has observed, however, that Owens later questioned the orthodoxy by which Benjamin's 'Work of Art' essay was cited.

21 Editor's chronology, Benjamin (2002: 428).

22 Two essays in particular complicate Benjamin as a dialectical thinker by acknowledging his engagement with Kant: Mieszkowski (2004) and Nägele (2004). Samuel Weber (1996) first alerted me to the dialectical imposition of Harry Zohn's translation of Benjamin's essays in Benjamin (1969).

23 Thus the commitment to identifying a critical avant-garde aesthetic within postmodernism signals the 'modernism' of the *October* group's critical and theoretical enterprise, despite Krauss's foundational critique of her mentor, Greenberg.

24 'Honor, Power, and the Love of Women' in Owens (1992: 147, 150). Originally published in *Art in America* (January 1983), 7–13. In a related vein, Benjamin H. D. Buchloh (1984) compared the Neo-Expressionist works to their proto-fascist stylistic and ideological precursors. See also Donald B. Kuspit's rejoinder published in this same volume (Kuspit 1984).

25 Owens acknowledged this Americentrism in art criticism in the 1970s and early 1980s in an interview published in Owens 1992: 301–2. See also *Art in America*'s original apology for neglecting post-war European art in its editorial (1982: 5). On the globalization of the art world since 1989 and its relation to recession-era politics and economics, see Stallabrass (2004).

26 Crimp's essay for this exhibition in fact acknowledges the implicit critique of this historical 'othering' of World War II's history in his discussion of Brauntuch's work (1984:183–5).

27 On the 'othering' of the Vietnam veteran as a 'V(i)et' in American popular film see Berg (1991). On the Reagan-era conformism and authoritarianism of the Lucas–Spielberg blockbusters, see Wood (2003); and Ryan and Kellner (1988: 217–43). Peter Biskind similarly argues that although Spielberg and Lucas's initial impulses stem from 1960s counterculture, their post-Vietnam era blockbuster films nonetheless symbolically mimic the Reagan administration's hawkish Third World foreign policy.

28 That is, that photography's ontology – what it *is* – is somehow equivalent to what it *does*.

29 'The master's tools will never dismantle the master's house', is, of course, Audre Lorde's phrase; postmodernists recognize that there *are* no other ideological tools.

30 Whereas Adorno and Greenberg promoted a realm of autonomous art that would resist capitalist assimilation, Benjamin advocated both an avant-garde art of negation and an understanding of the mass audience for the media of technological reproducibility as a collective, critical 'matrix' that could potentially slip beyond the control of totalitarianism. Mieszkowski characterizes the '*massive* mode [as] a mode of experience not entirely within our control'. Consequently, he observes, technical practices in art 'threaten to outgrow the bourgeois aesthetic by making it impossible to understand art as a set of given forms or processes' (2004: 50).

31 A notable exception was Crimp's admirably politicized and effective work on the AIDS crisis, and his work on developing queer cultural criticism as part of the group, Bad Object-Choices, which would lead to his break with the *October* group for his insistence on critical praxis and his abandonment of the *October* group's investment in aesthetic avant-gardism. Conference proceedings from *How Do I Look? Queer Film and Video* (Bad Object-Choices 1991) were originally to be published in *October*.

32 The degree to which a postmodern avant-garde lineage was successfully launched in the pages of *October* some 25 years ago is confirmed by the Ivy League academic positions now held by some of its main proponents, as well as the publication of a two-volume survey text of twentieth-century art by Krauss, Foster, Buchloh, and Yve-Alain Bois. After the bulk of this essay was written, the summer 2006 issue of *The Art Bulletin* featured an eight-person book review of Foster *et al.* (2005), testifying to the 'hegemony', in one reviewer's words, of the *October* group's perspective on the construction of post-war art history. Several of the reviewers remarked on the absence of the American war in Vietnam in the survey's historical account, as well as the superficial treatment of art in a globalized context.

33 On the question of Benjamin's 'Work of Art' essay and its relevance to new media, see Gumbrecht *et al.* (2003).

34 See, for example, my discussion of it in the context of sexuality studies in Dennis (2006).

35 The conference at which this paper was originally delivered inaugurated at Durham University the University's new Master's degree programme in the Photographic Image.

Chapter 8

Being exposed

Thinking photography and community in Spencer Tunick's naked world through the lens of Jean-Luc Nancy

Louis Kaplan

Getting naked in Newcastle

On Sunday 17 July 2005, a major art happening took place in Newcastle-upon-Tyne that opened up a space for thought and reflection about photography, community, and their intimate relationship with each other as discourses of exposure. This event brought the New York-based photographer and installation artist Spencer Tunick to the new BALTIC Centre for Contemporary Art accompanied by a cast of seventeen hundred photographic subjects in order to stage another round of 'getting naked' and documenting it in the name of public art and the temporary site-specific installation. The press release for this event promised a lot to potential participants of the photo shoot, most of whom are barely recognizable in the photographic prints that resulted from the installation. 'Those involved will be immortalized by participating nude in a series of installations taking place on 17 July' (BALTIC Centre for Contemporary Art 2005).[1] The punctual and puncturing rhetoric of photography and its intimate relationship to temporality – with death, mortality, and finitude – have been repressed and glossed over in favour of the seductive promise of becoming immortalized in and through the work of art. By invoking immortality, the potential volunteer is promised something usually associated with the fame and celebrity of the unique individual whereas Tunick's photographs, usually teeming with masses of flesh, yield nothing if not a staring into the face of anonymity.

Sponsored by BALTIC and with the financial support of 'culture' (the cultural programme managed by the destination marketing agency NewcastleGateshead Initiative), the press release also reveals the unholy alliance between high-minded public art making and the blatant promotion of the region's tourist industry via a not-so-cheap publicity stunt. The BALTIC installation was driven by the hope and the vision of a mass spectacle of thousands of naked bodies, lying about the NewcastleGateshead quays and the new Millennium Bridge. They were to be exposed to Spencer Tunick's photographic lens, and the resulting images subsequently disseminated around the world to give the region some 'good exposure'. As Tim Bartlett, the chief executive of NewcastleGateshead

Initiative states: 'Spencer Tunick's installation will be seen by millions of people across the UK and the world, once again showcasing NewcastleGateshead's spectacular and iconic landscapes on an international stage' (BALTIC Centre for Contemporary Art 2005). In this description, the mass spectacle of public nudity gets coupled with the landscape itself becoming a spectacle. Such associations contribute to framing Tunick's work as a new (and nude) type of land art in the tradition of British artists Richard Long or Andy Goldsworthy, using people instead of wood or stones.[2] But the key factor as to why Tunick's project will be seen by millions does not rely on his own camera alone, and this brings us to the other partner involved in the project – BBC Three. In addition to the usual press happily covering Tunick's free show of flesh, the installation acquired the official stamp of a major media event through the support and coverage of the cutting-edge network BBC Three who produced a television programme (*Naked City: Spencer Tunick in NewcastleGateshead*) about this nude photo-happening with all its voyeuristic appeal. According to controller Stuart Murphy, 'audiences can look forward to television unlike anything they have seen before' (BALTIC Centre for Contemporary Art 2005).

In the intertwining of art and capital, the summer happening is not to be viewed as only an end in itself. It rather served as the gathering of the raw material that was refined into the BALTIC exhibition (*Spencer Tunick*) that resulted six months later (21 January to 26 March 2006). This is a perfect example of the privileging of the product (the art commodity) over the process (the encounter with being-in-common). It underscores how the participants give way to the art spectacle and to the name of the art star in the title of the exhibition. The performance is thereby viewed instrumentally as a means to an end. The question of community and of our being with others is overshadowed by the reframing of the happening as yet another occasion for the art market and its marketing.

What was staged in NewcastleGateshead in July 2005 was just one of a series of events around the globe that have rapidly established Spencer Tunick's status as a contemporary art star in the past decade and that have situated his practice and projects (including *Nudes Adrift*, *Naked States*, and *Naked World*) primarily among the discourses of aesthetics and public art, media spectacle, and (depending on the severity of the penalties for nudity in public spaces) the law.[3] Amid the art and media hype, it is unfortunately much less common these days to find Tunick's work discussed in terms of a discourse of sociality and community and how his work addresses our being-in-common or being-with. In his 1996 essay 'Of Being Singular Plural', the French philosopher Jean-Luc Nancy writes, 'That Being is being-with, absolutely, this is what we must think. The *with* is the most basic feature of Being, the mark [*trait*] of the singular plurality of the origin or origins in it' (Nancy 2000: 61–2). Taking off from Heidegger's co-existential analytic in *Being and Time*, Nancy's insistence on Being as 'being-with' has major ramifications for thinking about photography as a mode of sharing. But the mad rush to the final image as art commodity (transforming it

into 'a genuine Spencer Tunick' on the art market) or the mass media's fixation on sensational spectacle have overwritten the fascinating questions raised by the staging of these strange and ephemeral performances where beings are exposed to each other and to the camera lens, and in ways that force a reconsideration and an unravelling of doxological concepts regarding identity, individuality, and subjectivity as primary and originary.

Nancy's formulation of Being in the 'singular plural' – in the singular as plural, wherein the other (being–with–another) always inhabits the same – insists on the fallacy of the self-contained, interiorized subject and any claim to its unity or originary status. Instead, Nancy writes: 'Its being singular is plural in its very Being. It follows then that not only must being-with-one-another not be understood starting from the presupposition of being-one, but on the contrary being-one can only be understood by starting from being-with-one-another. That question which we still call a "question of social Being" must, in fact, constitute the ontological question' (Nancy 2000: 57). The goal of this essay is to think the limits of the discourses of aesthetics and media spectacle as the means by which to interpret Tunick's photography and installations and instead to focus on how this photographic practice foregrounds in its bare naked way the 'question of social Being' (of being-with-one-another) through the lens of Jean-Luc Nancy and his ideas about community – about being-in-common as 'being exposed'. It is to think those aspects of Tunick's photographic practice that offer route into an ontology (and an ethics) of being-with that exposes us to our sharing and separation at the limit – but to do this without investing in a discourse of communal fusion which would deny our being-exposed.

Exposure

In focusing on the concept of 'exposure' in Nancy's thinking, I am interested in what this term means for his articulation of being-in-common as well as how the concept of 'being exposed' is equally translatable and transferable to photographic discourse and in such a way that it can provide new theoretical resources for photography studies – particularly for thinking about the relationship of photography and community.[4] The ontology of the photograph and its being in the world and Nancy's ontological approach to community as being-with communicate around the concept of exposure. For Nancy, Being as being-with happens because we are exposed to one other and this exposure is constitutive of what it means to be a 'self'. Nancy introduces the importance of exposure in the 'Preface' of his book, *La Communauté désœuvrée/ The Inoperative Community* (1991b (1986)). This is a book that forges a non-communitarian mode of being-in-common – one that resists the temptations of communal fusion by acknowledging being-in-common as the simultaneous sharing and splitting of singularly plural beings. Nancy writes, 'The mode of existence and appropriation of a "self" (which is not necessarily, nor exclusively, an individual) is the mode of an exposition in common and to the in-common and that this

exposition exposes the self even in its "in itself"' (Nancy 1991b: xxxvii). What Nancy stresses repeatedly is that ex-position and ex-propriation are constitutive of selfhood and, in this way, his ontology of 'being-with' counters the individualist assumption of the appropriation of a self-same identity in and of itself. Moreover, it is very important to resist the appropriation of the liminal discourse of exposure to any logic of identity – to recuperate it in terms of the rhetoric of either pure interiority or pure exteriority. That is why Nancy always writes of exposure in a way that places it on edge – as a touching of the limits or as a passing from the one to the other (what comes between us). In such a liminal state, '"being with" is exposed simultaneously to relationship and to absence of relationship', and Nancy therefore refers to this expository structure as 'a relation without relation' (1991a: 7). These Möbius-like manoeuvres are quite apparent in the following extended quotation that can be read as much as a reflection on photography as it is upon being-in-common.

> 'To be exposed' means to be 'posed' in exteriority, according to an exteriority, having to do with an outside in the very intimacy of an inside. Or again: having access to what is proper to existence, and therefore, of course, to the proper of one's own existence only through an 'expropriation' whose exemplary reality is that of 'my' face always exposed to others, always turned toward an other and faced by him or her, never facing myself. This is the archi-original impossibility of Narcissus that opens straight away onto the possibility of the political.
>
> (Nancy 1991b: xxxvii)

The formulation of being in terms of being-exposed and of being-exposed as being posed in exteriority is full of photographic resonances. Using language that bears equal traces of the work of Emmanuel Levinas on the face and the ethics of alterity[5] as well as the work of Jacques Lacan on the misrecognition of the self in the mirror stage, Nancy's expository approach reminds us that photography as exposure is always a turning towards and a facing outwards and something that happens before identification takes place. It is 'my' face – marked in quotation marks in Nancy's text as if to challenge the very utterance of the pronoun of self-identity for that which is always already ex-propriated from the self through the stolen glance of the camera. It is 'my' face always exposed to others – to the camera, to the film (when it is exposed to the light), to the photographer, and, most commonly, to the look of others – one that is anterior to the gaze that entraps.[6] (It is in this latter sense of exposure that photography comes into contact with the question of being-in-common.) Photography in its most popular variety alludes to an act of sharing where we are exposed to each other and where we mark the insufficiency of the individual subject as an interiorized and self-contained entity. If we take a picture of another person or of a group, we pose them in a relationship with exteriority – exposing them to the look of others and even to themselves as other. Indeed, such an approach

points to the category of self-portraiture as a misnomer because the photo-
graphic exposure of the self to itself faces itself as ex-position. As Nancy puts
it, 'Being-self is being-unto itself, being-exposed-to-itself, but "*soi*" in itself is
nothing but the exposition' (1991a: 7). From this perspective, photography as
a mode of exposition in common and to the in-common is aligned to both
the ethical and the political because it opens a space of communication at the
border of the sharing and splitting of singular beings.

Nancy's analysis speaks against any narcissistic fantasy of self-absorption that
would seek to make photographic discourse collapse into itself – to become
congruent to itself or reduce it to a discourse of identity rather than to think it
in terms of an exposure to the other. One should recall that the rhetoric of inte-
riority – of an originary narcissism often attributed to photography – is crucial
to Charles Baudelaire's infamous critique directed against the daguerreotype
and the birth of photography in the essay 'The Salon of 1859'. Baudelaire rants:
'From that moment our squalid society rushed, Narcissus to a man, to gaze at its
trivial image on a scrap of metal. A madness, an extraordinary fanaticism took
possession of these new sun-worshippers' (1981: 124). In Baudelaire's account,
photography is said to encourage a society of self-identical monads and indi-
viduals who fall in love with their own images. Photography therefore engen-
ders a society that has been reduced to squalor (a 'squalid society') because it
has lost track of sociality on account of a new technological apparatus that can
only breed and reproduce a self-absorbed narcissism. Baudelaire focuses on the
vanity of photographic self-portraiture and deflates its navel-gazing as some-
thing that is 'Narcissus to a man' (again one notices this phrasing in terms of the
individual monad). In framing photography in terms of the Narcissus myth and
in striking the pose of the moralist, Baudelaire chastises photography as and in
terms of a repression of relationality.[7]

In starting from the assumption of a being singular plural, Nancy's exposi-
tory approach to sociality, community, and (by extension) photography could
not be more opposed to Baudelaire's perspective. Nancy's philosophy rejects
any unitary vision of the self-sufficient individual that takes the monad and
its integral unity as its starting point. Instead, Nancy invokes the structure of
the *clinamen* (swerve or inclination) which he derives from Lucretius as the
X-factor which cannot be accounted for by any model of subjectivity that
focuses solely on individual monads or atoms and that does not acknowledge
their relational status – in other words, the excess to their integral unity that
comes from their being-exposed to each other. To quote Nancy: 'In the atomist
model, there are atoms plus the *clinamen*. But the *clinamen* is not something
else, another element outside of the atoms; it is not in addition to them; it is
the "more" of their exposition. Being many, they cannot but incline or decline,
they are ones in relation to others' (Nancy 2000: 39–40). It is the excessive
movement of the *clinamen* (what inclines the one towards the other so that the
one is somehow always more than one) that underscores the archi-original
impossibility of the self-identifying Narcissus and why the Greek myth cannot

serve as the basis of any photo theory that thinks photography and community in terms of being-exposed. From this perspective, Nancy would insist that the very fact that Baudelaire frames his analysis so that society rushes in the manner of Narcissus to vainly gaze at its own photographic image means that only a 'being-in-common can make possible a being-separated' (1991b: xxxvii).

In the photographic practice of Spencer Tunick, the concept of exposure acquires another dimension, but it acquires this dimension by stripping down, by stripping itself down. Here, exposure has literally become naked thanks to the actions of these willing volunteers who bare themselves and who remind us, according to Nancy, that 'only the body fulfils the concept of the words "exposition" and "being exposed"' (1993a: 205). It is as if Tunick's installations and images can be viewed as performances of Nancy's expository approach. The linking of exposure to the space of 'exposition' takes on greater significance for these projects when we consider that the word in French means exhibition. In this way, Tunick's work forces a thinking of the connection between being-exposed and the space of exhibition. It should be recalled that many of Tunick's happenings (like the one at BALTIC) have been instigated by contemporary art museums around the world that not only want to expose themselves and their facilities via the nude photo shoot but to exhibit the provocative results as well. In these collaborations, Tunick's work becomes legitimated as art by using the museum site as the backdrop for the staging of the nudes. Instead of the traditional museum where the painted nudes are found on the walls of the gallery, Tunick's live nudes are on exhibition outside and around the contemporary museum.

One of the many examples of this type of mutually beneficial expository endeavour can be found at the Museum of Contemporary Art in Montreal (Musée d'Art Contemporain de Montréal) in May 2001 and their subsequent exhibition a few months later. Using the plaza of the Museum as the staging ground for the *tableau vivant*, the Montreal event featured the encounter of the soft flesh of bodies in their vulnerability pitted against the hard concrete surface and architectural surroundings of this urban space. Moving the usual privacy of nudity into the public square, the final images show naked bodies filling this great expanse and lying across the steps that lead up to the Museum itself. The Montreal event was a breakthrough for Tunick because of the support that he received from institutional authorities (art and civic) that sanctioned this work. While Tunick only expected three hundred participants, over two thousand showed up for the event. While some may point to the more permissive Catholic roots of Quebec's social fabric as well as its large artist population as reasons to account for the large turnout and the willingness to participate, Tunick certainly capitalized on the framing of this event in terms of the museum institution and its drive toward exhibition/exposition.[8]

For both Nancy's philosophy and Tunick's photography, exposure is enacted through the body. It is enacted in space (and through espacement) in the exposure of naked bodies to the camera lens and to each other. It is tempting to

coin the neologism 'ectopic photopography' to refer to Tunick's praxis – a topographical exposure by means of photography that involves the spacing of naked bodies that have placed themselves in a variety of dispositions and out of habitual place in answering the call of photography. One could say that Tunick's images expose in the flesh what 'community exposed photography' has been baring all along – photography as a mode of what Nancy calls '*la pensée dérobée*'. This is a paradoxical *praxis* that simultaneously disrobes and conceals at the same time. For being-exposed as disclosure is not to be viewed as revelatory. It is rather the experience of limits that arrives in the face of unknowing. As Nancy writes in *The Experience of Freedom*, 'For this reason, disclosure also offers itself – this is the logic of *aletheia* in Heidegger – as the renewed concealment of the very being that discloses itself and of the being of disclosure itself' (1993b: 94).

The next sections of this essay will explicate further how the concept of 'being-exposed' *à la* Nancy offers access to what is at stake in Tunick's images. More importantly, it will focus on how Nancy's thinking of photography and community can be deployed to counteract a few approaches to Tunick's work that overlook this 'ontological exposure' or how Tunick's images offer a photo-graphic praxis of being-with. Such approaches function as so many 'cover-ups' of the naked truth of being-exposed. Specifically, I want to review the prob-lems inherent in two ways of framing Tunick's practice and its significance– the lure of aesthetic meaning and the lure of communal meaning. In both cases, it is important to look to Tunick's practice via the lens of Nancy's concept of exposure to resist either a facile desire for a politics of liberation that would equate Tunick's work with utopian liberation or a simplistic fascistic reading that would collapse Tunick's project into a politically reactionary totalitarian framework. (These responses have ranged from hailing Tunick as a liberator in Chile and to condemning him as a fascist spectacle maker.) These reductions miss the intense ambivalence and indecision of a body of work that can lend itself to such antithetical readings. Indeed, these extreme responses recall the controversy and notoriety surrounding the work of Diane Arbus of an earlier generation where she was simultaneously condemned as an exploitative anti-humanist (by Susan Sontag) and hailed as a moralist (by Lisette Model).[9] The indecision generated by Tunick's work also points to the inability to separate democracy and fascism and the great degree of slippage that exists between them in a zone of indistinction.

But even as they make sense of Tunick's projects, these readings and these lures of meaning distract us from seeing the Spencer Tunick experience for what it is – the chiasmic structure that opens up at the limits of sense and meaning posed in and by our being-exposed – or, in Nancy's words, 'the sense of this naked absence of sense that we ultimately *know* and share as our very nudity, humbly yet gladly, in the everyday or in what is truly exceptional' (2003: 47). Only in this way can Tunick's images be viewed not as something that yields discursive meaning but rather as what sets the stage and opens the space for meaning in general – 'being-with'. In other words, Tunick's photography

allows us to see how Being has no other meaning than the exposition and the 'dis-position of this between'. To apply this citation from Nancy to the singularly plural spacing of Tunick's photo-installations: 'It brings to light the fact that "meaning", used in this absolute way, has become the bared name of our being-with-one-another' (2000: 27).

The communal cover up

When the discourse of community is invoked to explicate Tunick's work, it is too often conceived using the nostalgic rhetoric of an organic model of community. This romantic and mythic formulation looks to community as a lost state of communion that it seeks to recover. Communalism thinks community in terms of fusional unity caught up in the idea that one can come out of many. In its Christian version, it is the mystical body of Christ around which communion and communal bonding take place. The communitarian way of thinking posits community as a single and unified entity or substance whether it is expressed as a commune, tribe, or clan. On the contrary, Nancy's post-romantic articulation of 'community without communion' retreats from the thinking of community in any fusional way. Nancy warns against any nostalgic longing for a mythic return to a pre-modern 'organic' community. This warning is also linked to Nancy's critique of *immanence* or what Ignaas Devisch defines as 'the communal desire for a closed and undivided social identity' that is 'fully present' and 'closed upon' itself (see Devisch 2005). Clearly, this self-enclosed communal desire is unable to deal with the articulation of being-in-common as being-exposed and as the experience of limits. The sharing *and* splitting that moves Nancy's inoperative community or 'community at loose ends' – what he marks in the French with the word *partage* – cannot be reified into a fixed entity closed in on itself or into a single totalizable body (e.g. the lure of Nazism to which Heidegger himself succumbed and for which Nancy critiques him). Such 'immanent' strategies also risk losing community as the experience of finitude and as a complex of relations that are always incomplete. Being-exposed and being-in-common give way to the totalizing and totalitarian risks of a 'common being'. As Nancy writes in the 'Preface' to *The Inoperative Community*, 'The community that becomes a single thing (body, mind, fatherland, Leader ...) necessarily loses the *in* of being-*in*-common. Or, it loses the *with* or the *together* that defines it. It yields its being-together to a being *of* togetherness. The truth of community, on the contrary, resides in the retreat of such a being' (1991b: xxxix). The community-exposed installations and photography of Spencer Tunick can contribute to this retreat from communion, but only in a manner that does not lose track of community in or as relation, in or as being-exposed. In other words, if the viewer becomes fixated only on the finished products of these formalized masses as objects of art, then we miss the potentiality for open-ended and indecisive encounters with being with one another that are a crucial part of these photographic exposures and the process of their enactment.

In contrast to the myth of the organic community clustered around the self-identified family, clan, or the tribe, Tunick brings into relation a group whose membership is compiled out of a random group of naked strangers who meet for the very first time. The advent of the stranger strips away any positive characteristics that may adhere to these people as an identifiable group. It stages a scene wherein the only thing that these singular beings share is their finitude and mortality (and paradoxically this is also what divides them from each other). Asked by *Psychology Today* to explain his project, Tunick (in one of the rare occasions in which he discusses his work primarily in terms of the question of community) takes up the importance of the stranger in his body of work, but then loses this point by further justifying his practice in communal terms. "'To lie nude on your back next to a stranger amongst 1,000 people is a new experience", Tunick himself says. "The fact they together form something in a communal process gives people a new way to think about why they are shedding their clothing'" (McGowan 2003). In appropriating the sense of community to this communitarian rationale, Tunick ironically nullifies the bare and naked truth of being-with exposed by his photo-happenings.

The same article contains another glaring instance of the attribution of communal rhetoric to Tunick's project. It was published just before the broadcast of *Naked World*, Arlene Donnelly's second HBO documentary about Tunick. This global expedition brought Tunick to over thirty countries including two installations in London in 2002. The article by Kathleen McGowan addresses the motives of the naked participants in the Spencer Tunick experience. The first answer pauses at the lure of aesthetic meaning, only to move on to the communal cover-up. 'Why are so many so willing to bare it all? Perhaps it's just the love of art. But many of the participants interviewed in an upcoming HBO documentary about Tunick's work say that being part of a naked horde is a communitarian thrill' (McGowan 2003). Already the positing of the group in terms of a 'naked horde' reeks of the rhetoric of communal fusion that remains oblivious to a being singular plural. Furthermore, if something thrilling is at stake here and if it is to be associated with ecstasy as 'being-outside-of-itself', then it is important to resist a reading that thinks the relationship between community and ecstasy in a manner that merely assumes its being-present. Instead, Nancy posits a more paradoxical connection that exists between community (as being-shared) and ecstasy (as being-outside of itself), 'If existence transcends, if it is the being-outside-of-itself of the being-shared, it is therefore what it is by being outside of itself'.[10]

The festival that launched Tunick's career was the Phish concert held at the former Loring Air Force Base in Limestone, Maine, in August 1997 with 60,000 people in attendance. Known as the heirs to the music and hippie culture of the Grateful Dead and the communal strivings central to that ideological formation, the Phish Great Went event became an overdetermined site for Tunick's breakthrough. In her 'Naked States Tour Journal', Tunick's partner Kristin Bowler begins by acknowledging the flashbacks to the American counterculture of

the sixties in fashioning the community of those who have Phish in common. 'There are so many people here. Hippies galore! Long hair, kerchiefs, granny dresses, halter tops straight across the front open in the back. Big pants dragging on the ground, dread locks, braids, friendly people.'[11] Given this neo-hippie revivalist ambience, it is not surprising to learn that Ken (one of the participants interviewed in Arlene Donnelly's 2000 film on Tunick's American tour, *Naked States*) describes his experience of the making of the photograph in terms of an immanent and organic model of community that invests in fusional unity and the dissolving liberation that comes in losing oneself: 'Once I was lying down everything became quiet and this huge rowdy crowd of a thousand people was suddenly silent and it just gave me an incredibly calm and peaceful feeling and I started suddenly to feel as if I was part of this one group organism. I felt really at one with all the people there.'

In positing the Phish installation and photograph as a transformative and profound experience where the individuals are submerged into 'this one group organism', Ken delivers an account of community as communion where there is no room for being posed in exteriority. Whether viewed as stifling or liberating, there is an active forgetting that 'the law of touching is separation' (Donnelly 2000: 5). Ken's rhapsodizing account has yielded authority to a romantic idea – to the totality of the organic community. It is another perfect example of how being-in-common gives way to common being, how being-with gives way to 'being at one with'. It is to view 'to be' as a noun of consistency rather than as a verb of ex-position and dis-position. To cite Nancy:

> Being-with is exactly this: that Being, or rather that to be neither gathers itself as a resultant *commune* of being nor shares itself out as their common substance. *To be* is nothing that is in-common, but *nothing* as the dispersal where what is in-common is dis-posed and measured, the in-common as the with, the beside-itself of *to be* as such [...] not as their individual and/or common 'self', but as the proximity that disperses them.
>
> (2000: 5)

This is another example of how the contiguity of singularly plural bodies yields to communitarian continuity.[12] In placing all his trust in the unity of community, Ken represses the prefix *cum* (with) that has no need to rely on transcendental authority when posed in and as exposition. 'As a result, this *cum* is the *cum* of a co-appearance, wherein we do nothing but appear together with one another, co-appearing before no other authority [*l'instance*] than this "with" itself' (63).

One of the most fascinating moments of the set-up in the Phish photo-shoot is captured by Arlene Donnelly's camera when she shows the group doing the 'wave' – that activity common to groups of people at sporting events where they trigger a chain reaction by setting themselves off in order to stage a moving image. It is that image of circulation from one singular being to another and the

simultaneous sharing and separating of being-in-touch that provides a filmic exposure of what is at stake in this mutual exposition of bodies that relies on *partage*. Nancy's vision does not rely on the dream of communal fusion or what is reified in the worship of the final object of art. Instead, this contiguous situation is described in *Being Singular Plural* as follows: 'From one singular to another, there is contiguity but not continuity. There is proximity, but only to the extent that extreme closeness emphasizes the distancing it opens up. All of being is in touch with all of being, but the law of touching is separation' (2000: 5).

The aesthetic cover up

At the start of the catalogue essay for *Spencer Tunick: Reaction Zone* (2000), Lisa Liebmann wastes no time in distancing Tunick's work from the communitarian impulse only to take up an aesthetic interpretation in no uncertain terms. 'It should be said that Spencer Tunick's pictures of naked people in public spaces have little in common with "free love" or the "Woodstock Nation", because their fundamental message is neither sexual nor communitarian. Once the sixties gestalt dissipates – which happens rather quickly – the aesthetically hyperaware spirit that characterizes this turn-of-the-century asserts itself in no uncertain terms' (Liebmann 2001). Given that the early success of Tunick owed much to the help that he received from the neo-hippie group Phish and to the sensibility that it nourished (as discussed in detail in the last section), this statement is riddled with disavowal. But from Nancy's perspective, Liebmann has traded one dogmatic position for another – covering up, in this aesthetic manner, the naked truth of 'being exposed'.

Spencer Tunick repeatedly frames the meaning of his naked photographic and installation works in terms of aesthetic issues and according to a discourse about contemporary art. These claims should not come as a surprise given Tunick's grand artistic ambitions from the start as exemplified in the scene in the *Naked States* film where he is perusing the hip art magazines of the day and where he offers a lesson on the collusion of art and capital noting the importance of getting art reviews in order to get 'the collectors to believe that investment in your art will have some sort of value'.[13] We also should recall Tunick's need to cast his work in an artistic framework in order to avoid the legal complications that plagued his practice in the United States in the early years of his career, his work being repeatedly charged with violating laws against public nudity. Indeed, it is well known that Tunick was arrested five times in New York City alone before he was finally vindicated on 3 June 2000. That was the date when the U.S. Supreme Court overruled the State of New York decreeing that Tunick's community exposed photography was covered under an artistic licence exempting him from a state law banning public nudity and that his photo shoots were equivalent to nude performances in an indoor play, exhibition, or show (Leibowitz 2000). In more recent years, the celebration and sanctioning of Tunick's work by art institutions around the world who

have invited him to stage large-scale nude photos to showcase their public spaces (as in Newcastle) have taken the edge off the transgressive aspects of the work and brought it into the respectable photo-based art establishment. As David Cohen of the *New York Sun* puts it: 'He has seen his motif progress from a spontaneous, somewhat anarchic gesture into something officially sanctioned across the globe' (2004). This process of art capitalization branding Tunick as a known product and a signature style – like Christo and Jean-Claude and their wrapping of buildings but in reverse (i.e. the disrobing of bodies) – also helps to explain the shift in attention from the radical and resistant experience of being-with set off by these happenings to the valorization of the final image as art commodity and the media spectacle that surrounds its production.

In framing his work as aesthetic discourse, Tunick repeatedly uses the artful language of form, shape, colour, and abstraction. 'I'm just forming shapes with bodies. I'm not a nudist', Tunick declares in *Naked States*. This comment occurs in the context of the film's most hilarious scene, when he exposes himself during a photo shoot at a nudist beach and loses control of the shoot, complaining about his inability to get the nudists to cooperate with him. In an interview with National Public Radio in Cleveland, Tunick talks about his work in terms of abstraction and provides the following definition. 'When the bodies become these giant rivers of flesh and you can't really tell where one body starts and where the other ends and then it becomes an abstraction and then it becomes really powerful'.[14] From the perspective of 'being-exposed', the inability to know where one body ends and where another body starts has nothing to do with abstraction. It rather relates to our being singular plural. As Nancy reminds us, 'singularity is not an identity: it is a movement, an incessant displacement in the self and in relation to others' (Pontbriand 2000: 2). Therefore Tunick's totalizing conversion of these bodies into 'giant rivers of flesh' for the sake of spectacle and photo-art appreciation may be viewed as an attempt to hide under the cover of aesthetics rather than to remain with the very nakedness that his photography opens up via the question of being-with.

When asked to give his expert opinion on skin for *National Geographic News* in the article entitled 'Skin as Art and Anthropology', Tunick focuses on colour tonalities and shadings in his installations. He states, 'You get all shades of colours – browns, yellows, tans, many, many pinks – all moulded together, forming a sea of colour, a kind of visual poetry' (Mayell 2002). Here, Tunick's aestheticization of the skin as a type of 'visual poetry' also loses track of how the skin engages with the question of being-exposed (let alone with the question of race). Making a word play in French, Nancy turns to the 'skin' as *ex-peau-sition*. As he writes in 'Corpus' (his meditation on the body in terms of being-exposed): 'But the skin is always exhibition' (1993a: 206). For Nancy, the skin is the liminal site that touches upon the question of being-with where singular beings brush up against each other. He writes elsewhere: 'Being exposed, exposing: it is the skin, all the various types of skin ... continually passing from one to the other, always coming back to itself without either a locus or place where it can establish itself,

and so always coming back to the world, to other bodies to which it is exposed, in the same gesture that exposes them to itself' (205). This is by no means a moulding together (that would partake of the communal language of fusion), but rather an ongoing exposure of singular beings at the limit.

Meanwhile, if we look at the artist's press release at his own website, we find that it too is sprinkled with the language of aesthetic formalism and framed in terms of an organic model of community as communion:

> The individuals en masse, without their clothing, grouped together meta-morphose into a new shape. The bodies extend into and upon the land-scape like a substance. These grouped masses, which do not underscore sexuality, become abstractions that challenge and reconfigure one's views of nudity and privacy. The work also refers to the complex issues of presenting art in permanent or temporary public spaces.[15]

This press release offers a perfect case study of how the erotic undercurrent of Tunick's *Naked States* (as orgies *in potentia*) is deflected or sublimated by focusing on the work as aesthetic form, as public art, and as site-specific installation. This displacement is very common in Tunick's interviews with the press. Tunick offers the same line to the BBC: 'It's not pornography, it's not lewd. It's forming a shape with living bodies [...] It's a way to use your body as an art object which I think is something new'.[16] And Tunick uses similar language at the Biennale in Sao Paulo in 2003. 'Using your body to make a shape as art object is a very pure experience and it's a wonderful thing [...] I don't use the body as a sex object but as an art object. And the body is used in a new way in my work. It's used to make a mass sculpture. It's liberating, it's an unbelievable situation to be in, and I think other people feel the same way' (Murray 2002). But amid all these aesthetic assurances, artistic posturings, and claims at liberation, this does not change the fact that Tunick participates in a discourse about the body as objectified and substantialized whether in terms of an art object, mass sculpture, a new shape, a substance on the landscape, or even as grouped masses. In each and every one of these cases, Tunick's rhetoric of fusion neglects to think about the body in terms of being-exposed – in terms of relation (and non-relation), in terms of spacing. Even stronger, one can say that Tunick's rhetoric effaces, erases, and even obliterates spacing in order to create a totalizing work of art. While in no way discounting the materiality of the body, Nancy reminds us: 'Body means spacing, gap, leap, nearness/withdrawal. Body is a thinking of the gap whereby we touch' (Pontbriand 2000: 4). All of Tunick's substantial terms look to the body in ways that preclude the body as exposition and as being-outside-itself – thinking the body in terms of 'the fact that the subject is in exteriority to itself' (3). Rather than framing Tunick's photo-installations as 'individuals en masse' (and thereby adding up individuals to calculate the communal), Nancy's approach looks to Tunick's *Naked States* as a chance to encounter the disposition and exposition of co-existing and singularly plural bodies.

Oscillations: liberating and/or totalitarian exposures of bare life

From the beginning, Spencer Tunick has staked his claim on the side of freedom – of getting naked in the service of personal liberation. This is always the way he markets his projects to potential participants and many of Tunick's 'free agents' have responded in kind. As one woman at the Montréal event states, using an escapist Freudian oceanic metaphor that would again dissolve the ego, 'The first moment when everyone took off their clothes was like a lot of people running into the ocean at the same time, like diving into something very liberating'.[17]

It is a rare honour for a photographer to be given the Man of the Year award in any nation of the world. Yet Spencer Tunick holds that distinction in Chile where he was named 2002 Man of the Year by the national newspaper *La Tercera*. On 30 June 2002, Tunick organized another photo-happening in relation to the space of exposition and being-exposed. The shoot featured more than 4,500 people in the Forestal Park where the Museum of Contemporary Art (Museo de Arte Contemporáneo) is located in Santiago. Given the particular political circumstances of the end of the dictatorship of Augusto Pinochet and the fact that part of the shoot took place adjacent to the Presidential Palace, Tunick's photographic practice and its rhetoric of liberation struck a chord with the people of this Latin American nation ready to leave artistic, religious, and polit-ical repression behind with such a symbolic gesture. In reviewing Tunick's acco-lade as covered by *Art in America*, it is also important to note the controversy sparked by the work with the Chilean religious right branding it 'immoral'.

> Riding a wave of free speech and expression that has swept the country since the end of the Pinochet dictatorship, many Chileans saw Tunick's work as symbol-izing a new beginning for Chile. The phenomenal success of the event, however, shocked many others. Even before the shoot took place a team of lawyers tried to prevent it and a crowd of 400 protesters gathered outside the artist's hotel room to chant 'Tunick is immoral!'. TV and newspaper images of the event sparked outrage throughout the country. Tunick provoked a broad debate on personal freedom and emerged as something of a hero in the process.
>
> (*Art in America* 2003: 35).

The Chilean case study provides a perfect example of how particular political circumstances have shaped and informed Tunick's work and its reception in radi-cally different ways. In this context, Spencer Tunick emerged from the photo-happening as a hero of democracy and as a defender of personal freedom.

However, the reading of Tunick's work in other contexts has been less than sympathetic, pointing to the fascistic risks embedded in the communitarian project. In writing about the Cleveland shoot on 26 June 2004, Amy Bracken Sparks makes the following uncomfortable analogy. 'Despite the gaiety of it all, there are aspects of Tunick's work that are inescapably uncomfortable.

A gaunt woman, hunched and shivering, and a single file of naked people hugging themselves look like herded sheep, or worse, haunting images of the Holocaust' (Sparks 2004). Isabel Murray also reports on Tunick's installation at the Sao Paulo Biennale in a similar manner. 'Many critics compare them to those photos taken in concentration camps during the Second World War'. When Murray asked Tunick to comment on this loaded framing of his work, the photographer gave an equivocating response that begins by acknowledging disaster in general as a motivator of his work only to deny it. 'You could also think of the massacres in Rwanda, Bosnia, the Armenian Holocaust, or of disasters such as earthquakes or landslides that rip the clothes off thirty thousand people [...] There are so many ways to think of a mass of bodies as death, but what I'm dealing with here is life. My work is a celebration of life' (Murray 2002). However, Tunick stressed in an earlier interview that he has a strong interest in apocalypse and that some of his shots allow him to deal with his 'fear of terrorism and loss of life' (Laurence 1998: 6, 16). Even as such images reconnect with the Holocaust and Hiroshima, they become coping mechanisms that make an aesthetic out of disaster and the unrepresentable. Of course, one has to be careful about setting up such an analogy (between Tunick's image simulations and concentration camp images) for obvious reasons including the fact that his contemporary images feature willing volunteers who have signed releases rather than captive prisoners in a concentration camp awaiting gas chambers or already murdered.

But a further question remains – is there something in what Tunick says about his images or something in these performances that engages totalitarian rhetoric? Is there something in the way Tunick conceives of the 'aesthetic' or the 'communal' aspects of his projects that lends itself to a fascist interpretation? In utilizing the language of abstract form and the rationale of aesthetic discourse to talk about his community-exposed photography, Tunick loses the 'in' of being-in-common so that community becomes one thing ('a common being') and, in this way, he walks the slippery slope of a totalitarian formulation of community as communion – as an organic substance and as a fused unity. As a result, the project whose selling point is 'get naked and become liberated' threatens to become its polar opposite with Tunick occupying the directorial (if not dictatorial) role. Tunick's aesthetic analysis turns an occasion for being-with into a fixation on and substantiation of abstract form as well as a valorization of the art object. This is what becomes of being-with when the 'with' appears as composition instead of exposition, when bodies are viewed as organic substances or as 'organic extensions of the landscape' (Laurence 1998) instead of serial spacings and shared/divided co-existences (Nancy 2000: 47). Tunick's essentialist assertion that 'the bodies extend into and upon the landscape like a substance' is not a statement that can be applied to being singular plural that can never be essentialized. As Nancy relates: 'On the contrary, the singular-plural constitutes the essence of Being, a constitution that undoes or dislocates every single, substantial essence of Being itself' (2000: 29–30). And Nancy also

notes, 'exposition, precisely, is not a "being" that one can sup-pose (like a sub-stance) to be in community' (1991b: xxxix). In other words, community is not supposed, only exposed. Rather than congealing into an aesthetic substance in the landscape, Spencer Tunick's works communicate being singular plural as the exposition of bodies in the realm of the naked image.

So what does one make of these oscillations in reading that simultaneously place Tunick in the guise of a democratic liberation hero and a fascist photo director? It is here that we turn to the writings of Giorgio Agamben and to a concept that appears to be most appropriate for a discussion of Spencer Tunick's practice of photographic exposure in the raw – *bare life*. For Agamben, bare life refers to what the Greek philosophers called *zoe* – 'the simple fact of living common to all living beings' in contradistinction to *bios* 'the form or way of living proper to an individual or group'.[18] The key to modernity for Agamben is the 'politicization of bare life as such' or what he understands to be 'the entry of *zoe* into the sphere of *polis*' (Agamben 1998: 4). Agamben spends a lot of time in *Homo Sacer* thinking about the Holocaust and he sees the concentration camp as a paradigm for this new order of things where bare life becomes subject to political control and organization. Yet, Agamben also sees the same type of threat coming from modern 'democracy' (or the decadence of democracy) that subjects everything into the totalizing spheres of biopolitics and commodity spectacle. Modern democracy contains the following *aporia*: 'it wants to put the freedom and happiness of men into play in the very place – "bare life" – that marked their subjection' (9–10). Agamben writes, 'Modern democracy's deca-dence and gradual convergence with totalitarian states in post-democratic spec-tacular societies (which begins to become evident with Alexis de Tocqueville and finds its final sanction in the analyses of Guy Debord) may well be rooted in this *aporia*, which marks the beginning of modern democracy and forces it into complicity with its most implacable enemy' (10). One could argue that this *aporia* is also at the heart of Spencer Tunick's photographic exposures. While they preach the rhetoric of freedom and happiness – of stripping down and getting naked as an expression of and the means to liberation, they objec-tify those who are subjected to the process as spectacle and art commodity. Agamben's understanding of the politicization of 'bare life' in modernity helps us to understand the limits of any countercultural impulse equating bare life with liberation and absolute freedom. In other words, Tunick's images preach liberation while immersed in the logic of instrumentality that gobbles up everything as image in the spectacular society and that recuperates the posture of liberation as works of art.

In this way, Tunick's photographic exposures of bare life are enmeshed in what Guy Debord discerned in *The Society of the Spectacle* – the accumulation of capital to such a degree that it becomes image.[19] These happenings designed to liberate people via the fundamental exposure of bare life become entangled with spectacular and biopolitical considerations – serving the interests of art and capital and exposing the risks of totalitarianism. According to Agamben,

there is a final outcome of this analysis of bare life that has an impact on the clarity of political positioning. 'Once their fundamental referent becomes bare life, traditional political distinctions (such as those between Right and Left, liberalism and totalitarianism, private and public) lose their clarity and intelligibility and enter a zone of indistinction' (1998: 122). If the fundamental referent of Spencer Tunick's photographs is the exposure of bare life, then these images have entered a zone of indistinction where it becomes very difficult to make clear-cut distinctions between Left and Right and this helps to account for the oscillations in reading that are communicated by Tunick's *Nudes Adrift* (to recite the title of an early series).[20]

All in all, Agamben's intervention of 'bare life' does much to navigate the competing claims of the liberating and fascist interpretations of Tunick's project.[21] Yet, the staging of naked bodies and the exposure of being in common do not always have to be framed within the terms of absolute liberation or totalitarianism. For example, Slavoj Žižek's affirmation of Jacques Rancière's *The Politics of Aesthetics: The Distribution of the Sensible* provides a more nuanced reading of this issue. It is important to note that the title of Rancière's book in French *Le Partage du sensible* engages Nancy's concept of *The Inoperative Community* – the concept of *partage* at the border of sharing and splitting. Žižek (2004: 76) asserts that the 'Lesson of Rancière' is that one should 'be careful not to succumb to the liberal temptation of condemning all collective artistic performances as inherently "totalitarian"'.[22] (Conversely, one should not be so naïve to assume that such performances deliver what was promised by the hippie generation.) Interestingly enough, Žižek looks to the tactical media of the present and his analysis of the flash mob resonates with the practice that goes under the name of Spencer Tunick:[23]

> Is not precisely the 'post-modern' politics of resistance permeated with aesthetic phenomena, from body piercing and cross-dressing to public spectacles? Does not the curious phenomenon of 'flash mobs' stand for the aesthetico-political protest at its purest, reduced to its minimal frame? People show up at an assigned place at a certain time and perform some brief (and usually trivial and ridiculous) acts, and then disperse again – no wonder flash mobs are described as being urban poetry with no real purpose.

The application of Žižek's analysis to Tunick's happenings and thinking its alliance with the ephemeral sharing and splitting of the flash mob does much to recast them in terms of their aesthetico-political dimension and 'how we are to continue to resist' (Žižek 2004: 79). Nevertheless, such an aesthetico-political analysis also demands a resistance to valorizing Tunick's photography in the name of art or of an artistic formalism (i.e. what I have marked as the aesthetic cover-up). Substituting Rancière and Žižek's aesthetico-political discourse for one that turns around questions of sociality and community, the lens of Jean-Luc Nancy and the ontology of being-with provide another way of framing Tunick's performances and their exposure of the naked truth and the truth of nakedness.

Thinking *Naked States* as *photographie dérobée*

In his profound essay, 'La Pensée dérobée', Jean-Luc Nancy approaches the thinking of Georges Bataille as thinking at the limits of thinking and he insists that we keep in mind a 'knowledge' of that which exceeds knowing (what Bataille calls *non-savoir* or non-knowledge). For Nancy (as for Bataille), this is not just something that happens to thinking in extreme cases. Rather it is something that is endemic to all thinking. 'There is no thinking, no articulation of sense, that doesn't have something of the uncompletable about it, that doesn't exceed sense, like an intimation, a binding, implacable obligation, logical as much as ethical, to conceal itself as thinking in the very act of thinking, "in order", if you'll allow me to risk the phrase, to be thinking' (2003: 34). In this paradoxical way, Nancy introduces a rupture into thinking itself so that thinking conceals itself from itself. Nancy uses the French word 'dérobée' in order to designate and to modify thinking in this way. It is a polysemic adjective that means concealed, hidden, secret, stolen (as in stealing a glance), and most literally 'disrobed', and Nancy plays out these different valences in the essay.

Pensée dérobée generates this fascinating paradox – 'a thinking that conceals itself, therefore, is one that undresses itself, that disrobes ...' (39). How would concealed thinking also be disrobed or naked thinking? One would think in terms of common sense that nakedness would expose in terms of a revelation in order to produce a naked state where there would be nothing left to hide, nothing left to conceal. But things are more complicated than that – for here we are dealing with exposure to the plenitude of non-knowledge, meaning that there is nothing to reveal. As Nancy writes in 'Corpus': 'A naked body gives no sign and reveals nothing, nothing other than this: that there is nothing to reveal, that everything is there, exposed'.[24] Exposed in this way, nudity is what conceals and what conceals itself. Or to put it in the language of Tunick's photographic subject Reg, who poses nude in front of the statehouse building in Tennessee and philosophizes quite bluntly: 'People think they're revealing themselves when they take their clothes off. They're not. They're revealing themselves when they put clothes on.'[25] Resisting communal fusion, nakedness leads 'into the renewed concealment of not-knowing that, rather than uniting us, divides us: an infinite agitation of sense. Concealed thinking is identical to communication, and this identity is itself the night of not-knowing' (2003: 45). The Enlightenment rhetoric of illumination – of which photography's bringing to light is certainly a symptom – is subverted when stumbling about in this night of non-knowing – 'which insists in the night as an "illumination"' (43).

Taking all this into consideration, this approach to Spencer Tunick's *Naked States* as informed by Jean-Luc Nancy has offered it as an exemplar of *photographie dérobée* – as a photographic practice that simultaneously conceals and disrobes, that conceals itself in the very act of its photographic and performative disrobing and exposing. Here, nakedness is linked to concealment because such a practice of being-in-common exposes nothing but a relationship of alterity

(being-exposed as being posed in exteriority) and, in this way, it outlines a photographic practice that preserves the alterity of singular beings in the space of non-knowledge. It is a photography that underscores what lies between us (what shares and divides us) and, according to Nancy, 'the between-us, whenever it takes place, is always the between of nakednesses'. It is this 'between of nakednesses' that is staged in front of the BALTIC structure in Tunick's image 'Newcastle Gateshead 4' as nude figures of various shapes and sizes stand side by side on the steps of this futuristic-looking space of exposition. The 'between of nakednesses' is what the *photographie dérobée* of Spencer Tunick exposes, but this is what too often has been forgotten in the mad dash to cover it over or to substantiate it with meanings and values that are at times aesthetic, communal, spectacular, or legal. To offer just one more instance, Tunick justifies his work in the *National Geographic* essay in the following manner: 'It's allowing people to be part of creating art while at the same time celebrating the dignity of the human body.'[26] In this variant of the attribution of positive value to his work, the aesthetic lure ('creating art') is combined with an unproblematic humanist appeal to the dignity of the human body. This again dresses and props up the body on a pedestal of value attributing to it positive characteristics over and beyond the bare-naked body as 'nothing but the being exposed' (1993a: 204). We must return Spencer Tunick's naked exposures of bodies next to, against, nearby, and with other bodies as the unsubstantiated opening of that which is between-us rather than burdening it with meanings that obliterate its sense as the naked absence of sense. Such thinking turns to *photographie dérobée* as naked and exposed photography – as photography that opens/closes the space of the sense of sense, the sense of passage from the one to the other (being-with). To think Tunick's *photographie dérobée* is to think 'naked thinking: a thinking that appeals to its passage to the other alone, without intention, beyond all intention, for nothing, nothing except being between us, nothing except our being in the world' (2003: 41).

When addressing our relation (and non-relation) to Spencer Tunick's so-called *Naked States*, it is important not to lose track of *photographie dérobée* – the practice of a concealed/disrobed photography and its thinking. For 'being-exposed' and the experience of photography and community (of 'being-with' photography) addresses itself to the doubled thinking of *dérobée*. To recall Nancy once more, 'we members of a humanity laid bare and exposed, we members of a concealed humanity' (46).

Acknowledgements

I thank Jonathan Long, Andrea Noble, and Ed Welch for their gracious invitation to the University of Durham so that my current thinking on photography and community could play a vital part in the theoretical debates of *Thinking Photography (Again)*.

Notes

1 The title of the press release, 'B. Part of It', unconsciously points to the logic of *partage* and the sharing and the separating of being that adheres to Nancy's concept of 'being-in-common'.

2 The press release also refers to them as 'temporary site-specific landscapes'.

3 For an informed discussion of Tunick's work raising a number of legal issues related to public nudity and the attempt to regulate the nude body in public space, see Chapter 2 ('Aesthetic Vertigo: Disgust and the Illegitimate Touchings of Art') of Young (2005: 20–44).

4 This is indeed the focus of my book *American Exposures: Photography and Community in the Twentieth Century* (Kaplan 2005).

5 See Levinas (1978). As Lingis notes in his 'Introduction': 'Now Levinas actually sets out to see in the exposedness to alterity in the face of another the original form of openness' (vii).

6 To cite Nancy directly, 'It is anterior to entrapment by the stare that captures its prey or takes its hostage. Exposure comes before any identification and singularity is not an identity' (1991a: 7).

7 Interestingly enough, this approach to thinking about the reproducible image has continued in more recent times with Rosalind Krauss's pivotal essay on early video art as 'The Aesthetics of Narcissism' (Krauss 1976).

8 For the BBC's coverage of the Montréal event, see BBC News 2001.

9 For the negative reading, see Susan Sontag, 'America, Seen through Photographs, Darkly' (1977: 27–50). For the positive reading, see the interview with Arbus' teacher Lisette Model in the short film *Going Where I've Never Been: Photography of Diane Arbus*, Camera Three Productions, 1989.

10 Nancy (1993b: 70). Similarly, it is important to maintain the distinction between Nancy's work that opens Tunick's photographs onto the uncertain space of exhibition in contrast to a mode of exhibitionism that would constitute an essential state of being for those who participate in Tunick's photographs.

11 Kristin Bowler is quoted here from 'Naked States Tour Journal' at the time of Phish's Great Went event at the former Loring Air Force Base in Limestone, Maine, in August 1997 (see Bowler 2003).

12 Nancy discusses this point in (2000: 5).

13 Spencer Tunick quoted in the film *Naked States*.

14 Tunick made these remarks on 'Around Noon Presents: Spencer Tunick – The Naked Truth' on the National Public Radio affiliate WCPN in Cleveland, Ohio on 28 June 2004. The online broadcast can be found at: <http://www.wcpn.org/an/features/2004/0628naked_truth.html> (accessed 12 May 2008).

15 The press release is located at <http://www.artnet.com/galleries/ArtFairs.asp?gid=114890&cid=140893>.

16 This citation is found in Tunick's interview with the BBC (Tunick n.d.).

17 While this was originally published in *Montreal Gazette* on 30 May 2001, I have located it online at <http://www.dazereader.com/archive052801.htm> (accessed 18 May 2008).

18 Agamben (1998: 1). I thank Ritu Birla for pointing out how the slippage between liberalism and totalitarianism can be applied to Tunick's images through the apt vehicle of Agamben's 'bare life'.

19 This is how Guy Debord concludes the first chapter ('Separation Perfected') of his classic *The Society of the Spectacle* (1967).

20 The controversy over Tunick's image spectacles replays to some extent the intellectual debate surrounding the 'mass ornament' in Weimar and then in Nazi Germany. While he had a number of criticisms regarding 'these spectacular pageants' including their imposition of a regimented Taylorism in the aesthetic realm, the anti-elitist Marxist

Siegfried Kracauer still saw something of value (e.g. aesthetic pleasure) in these cultural displays and even potentially revolutionary if they enabled the workers to realize their working conditions and acknowledge political reality. Kracauer writes in 'The Mass Ornament', 'Certain intellectuals have taken offense at the emergence of the Tiller Girls and the image created by the stadium pageants. Whatever amuses the masses, they judge as a diversion of the masses. Contrary to such opinion, I would argue that the *aesthetic* pleasure gained from the ornamental mass movements is *legitimate*' (1975: 70). Here we see the same type of intellectual disdain for the pleasures of the masses as derived from a nude Tunick photo shoot if viewed as exploiting and manipulating the masses. Meanwhile, Walter Benjamin believed that nothing good could come from mass aesthetic spectacle and he severely criticized the mass formations of the Führer cult featured in Leni Riefenstahl's *The Triumph of the Will* (see Benjamin 1969). This is of course in line with Benjamin's view 'that the logical result of Fascism is the introduction of aesthetics into political life' (241). It is harder to know what Benjamin thought of the Tiller Girls as a phenomenon of the Weimar Republic rather than an appendage of the Nazi dictatorship. I thank Carolin Duttlinger for suggesting how Tunick's work might be viewed as continuing the intellectual debate on the mass ornament in Germany in the 1920s and 1930s.

21 Interestingly, the question of bare life in both its liberating and totalitarian guises is on the Agambenist agenda for the international contemporary art exhibition, Documenta 12, beginning 16 June 2007. According to the press release, it is the second of three leitmotifs. 'What is bare life? This second question underscores the sheer vulnerability and complete exposure of being. Bare life deals with that part of our existence from which no measure of security will ever protect us. But as in sexuality, absolute exposure is intricately connected with infinite pleasure. There is an apocalyptic and obviously political dimension to bare life (brought out by torture and the concentration camp). There is, however, also a lyrical or even ecstatic dimension to it – a freedom for new and unexpected possibilities (in human relations as well as in our relationship to nature or, more generally, the world in which we live)'. I thank John Paul Ricco for alerting me to this pronouncement. See <http://www.documenta.de/leitmotifs.html>.

22 Žižek also argues that the Nazis stole the mass performance medium from the workers' movement, as the genealogy from the Tiller Girls to *The Triumph of the Will* would attest.

23 It should be pointed out that one review of Tunick casts his work in this exact frame of reference. See *Beaux Arts Magazine* (2003: 82–7).

24 Nancy writes elsewhere: 'It is to reveal everything but, at the same time, to show there is nothing more to see. It is to show that there's nothing beyond nakedness except still more nakedness' (1993a: 205).

25 Reg is quoted in Arlene Donnelly's documentary, *Naked States* (2000).

26 Tunick quoted in Mayell (2002).

Chapter 9

Plato's dilemma

'And in this fairy world of labour see A type of what the actual world should be'

Donald Preziosi

A few years ago, in a book about the 'objects' of architecture, Jean Baudrillard made the following cryptic remarks about photography:

> The great majority of images are no longer the expression of a subject, or the reality of an object, but almost exclusively the technical fulfilment of (photography's) intrinsic possibilities. It's the photographic medium that does all the work. People think they're photographing a scene, but they're only technical operators of the device's infinite virtuality.
>
> (Baudrillard and Nouvel 2002: 47–8)

Few contemporary philosophers have the knack of being simultaneously as enlightening and frustrating as Baudrillard, but let us try to figure out what these words might mean for us today. Are photographers merely 'technical operators of the device's infinite virtuality'? Exactly which 'device' is being imagined? And what is photography's 'infinite virtuality'? What social practices do not have infinite virtuality? It may well be that the products of photography, like those of poetry, painting, or building, do not simply 'express' or 'represent' what is already there but rather fabricate *what should have been there* for what the maker and/or user of the photograph or of media more generally are *themselves* in the process of becoming. Photography, like architecture or poetry, might then be imagined as *anticipatory illusions*. But then does this mean that photography is not part of 'reality' but part of the 'fiction' of a society, its 'fairy world' of labour, weaving us into a world of seduction?

It becomes apparent that in dealing with photography (no less than with poetry, painting, or building) we always seem immediately confronted by fundamental philosophical, epistemological, and ideological problems, and what seems always at stake, always piercing the surface of our activities, haunting all of our houses, is the question of 'representation' and of its *truth*: the 'truth' of photography. Or of 'art'.

Photographic technology in the nineteenth century was one of an interlinked series of social symptomatologies, whose efficacy was a function of a larger network of practices and institutions. These included not only the various visual

and spatial 'arts' and optical devices of the time, but also burgeoning enterprises such as tourism, the heritage and fashion industries, aesthetic philosophy, art history, connoisseurship, art markets, and art criticism. In this chapter, I wish to consider the following question: What would it mean – methodologically, theoretically, politically – to envision such practices holistically, as a linked series of semi-autonomous or deponent practices, rather than as reified 'disciplines'? To envision what we distinguish rhetorically, professionally, and institutionally more in the light of what they share and how they function together socially than in how they (and their 'operators') might be opposed?

I

The sibtitle of my essay is taken from a remarkable 150-page poem published in 1852 about the Crystal Palace Exhibition of 1851 in London, the first great international or 'universal' exposition. In a general sense, my subject is the tragedy which the belief articulated in the quoted lines of the poem has helped foster in all of our lives over the past century and a half. I will argue that it is time to move on from what is implied in the title – namely, that there exists a dichotomous, dialogic, and causal 'relationship' between a 'fairy world' of artifice and an 'actual world' in which we live our daily lives, in which the former appears either as subservient to the materiality of the latter, or as its opposite. My subject, then, is the 'fairy world' of representation, in its photographic and related dimensions. I want to talk about what it might mean to move on from contemporary regimes of representation and their phantasmagoric machineries, professions, and institutions. Of course, one cannot talk about art or photography without talking about their theological foundations, and in particular, the fundamental *materialism / immaterialism* double-bind – the phantasm of a distinction between 'matter' and 'spirit' – that needs to be addressed more and more urgently in the face of the catastrophe of contemporary social and political life. And not just simply 'addressed', as if it were an abstract academic matter, for this is an issue which goes to the core of what needs to be done, today, about the catastrophic dreamworlds of globalization, militarization, and spiritualization that have in concert blighted our lives for so long and which threaten to destroy our world.

My chapter is entitled 'Plato's dilemma', and I use the phrase to invoke our very ancient yet persistent ambivalence about what images consist of and what their ends or purposes are or should be – an ambivalence articulated in the double-bind of artifice mentioned a moment ago. What is a photograph *for*? And for whom is it 'for' something? Is photography a 'what' or a 'when'? I would like us to deal more explicitly than recent visual culture studies generally have with the *problem* that is photography; photography specifically, and artifice more broadly, as *the* problem, at the centre of our modernities, whether plain or 'post': the enabling paradox of social life in modernity – that what is claimed to be 'real' must be 'fictionalized' in order to be thought at all.[1]

For some time, there has been a very palpable need to articulate an effective challenge to the contemporary discourse about imagery and its powers which has been endemic in the most widespread practices of art history, visual culture and media studies, aesthetic philosophy, and the various critiques centred on photography, cinema, digital and virtual imagery, and the like. A challenge is needed that would shift critical attention to the issue of what it is we imagine artistry to actually create. What if art creates the 'real world' in which we live, rather than some 'second world' of 'art' imagined to stand alongside (and in some tortuous way 'represent' or 'express') the world of everyday life? If what art creates is no such 'second world' but in fact the very world in which we *do* live, then that world – our world as it exists – is in every respect a world of artifice; and the proper study of imagery and human productivity would be an engagement with the epistemological technologies of artifice as such, in all its ramifications.

My title refers to this ambivalence. Plato was writing of what would constitute an ideal city (and an ideal citizen of such a place) as regards the powers of artistry to both create and problematize hegemonic power: a power simultaneously glorious and terror-producing (what was called 'divine terror', the *theios phobos*). The mimetic arts, he argued, should ideally be employed to articulate and give proper expression to a polity and its social moieties; its hierarchies of individuals and groups mapped onto space and time in and as a *polis*, a city-state; a world in which what is materially fabricated decorously evokes the order constituting that world or *cosmos*. A world in which the ancient Greek homonyms *ethos* and *ēthos*, ethics and familiar place, are in reflective concordance.

Plato would have banished the arts from his ideal city-state because of their potentially destabilizing influence on the imaginations of its citizens, causing them quite literally to *think otherwise*. If the state is recognized for what it is, namely a fabrication, then other kinds of states (and other modes of civic life) might be imagined and given form, problematizing and thus destabilizing the state one has. What is necessary for an ideal polity or an ideal *polis* is that it be taken as natural rather than as a product of artistry. It must be *seen* to be on the side of fact rather than of fiction; on the side of the gods or of history or of true and undistorted nature. In this sense it is not unlike the contemporary global catastrophe that is euphemistically termed 'free market' enterprise, the 'naturalness' of whose hegemony is sustained by its Orwellian double-speak, that is to say, by its rhetorical artistry.

In the ideal city a political distribution of tasks and powers is paramount, and a division must be maintained between those who act and those who are acted upon; between those who have access to a greater totality of lived experience (who 'live large' as neocon pundits in the US put it) and those indentured classes whose lives are immersed in the parcelling out of work, and who thus (and therefore) live fragmentary lives for whom the very idea of self-governance (rather than governance by their betters) is inappropriate, indecorous, a sin, or a crime. The maintenance of this division requires an epistemological grounding in a certain predestined decorum; a purported *natural* order of things, so that the

state is conforming in its social system to a 'mapping' imposed by 'nature' or by the command of some personified abstract cosmic principle such as a god.

Aesthetic philosophy has been blamed for many things in its two-and-a-half centuries of existence, yet it should be recognized that it was the idea of the *aesthetic* beginning in the eighteenth century, and its efflorescence in the philosophical and social programme of German idealism, which *simultaneously opened up the possibility of radically challenging that order*. Art becomes more than mimesis and its decorum; it also brings about the transformation of thought into the sensory experience of the populace construed as a community. More properly speaking, the transformation of thought into a community's sensory experience is what came to be reified as what we call 'art'. The modern cult and institution of art presupposed a revalorization of the abilities attached to the very idea of labour or work, and 'a recomposition of the relationship between doing, making, being, seeing, and saying' (Rancière 2004: 45). In the nineteenth century, and with the appearance of the masses on the scene of history, *the ordinary becomes beautiful as a trace of the true*. This was the ostensible brief of that facet of artistry we call photography. The revolution engendered by the new 'science' of the perception and reception of the sensible, or aesthetics, effectively allowed honour to be accorded to the commonplace and the anonymous, which, invoked by the pictorial and literary (before being photographic or cinematic), constituted a powerfully evocative symptomatology of society.

II

What then of the nature and functions of the kinds of objects and object-relations that have normally interested art historians, critics, theorists, and museologists in modern times? Who has benefited from them over the last two centuries? Understanding the explicit philosophical traditions of aesthetics is in itself insufficient to understanding how historians, critics, theorists, museologists, and citizens think with, use, and even 'believe in' objects. Equally important are the social and cultural institutions and material practices that evolved in the nineteenth century in connection with the establishment and legitimization of modern nation states. I will take as exemplary what was perhaps the most important and most powerfully influential of such institutions – and one that was a synthesis of so many modern ideas and practices.

I am speaking of the extraordinary building that came to be known as the Crystal Palace, which housed the first great international Exhibition of the Arts and Manufactures of all Nations, in London, in 1851. And while you think about the Crystal Palace building, I want you to have in mind the opening lines of the 150-page poem mentioned above. It was written by an anonymous woman author who had previously written very long and very popular poems praising various districts of London, such as Belgravia. Listening closely to the words in this poem can tell us much about the general attitudes toward this extraordinary spectacle. The poem speaks of

> ... the CRYSTAL PALACE! – theme sublime,
> That shall astound the world throughout all time!

And speaks of

> Fair sculptured forms, whose classic beauty bears
> The spirit back to Rome's enchanted years

And it goes on to say:

> Yet shall this crystal pile – this mighty plan,
> An influence wield upon the mind of man,
> Free as itself, as wondrous and as vast,
> And lasting still – whilst time itself shall last.
> No narrow views – no rights exclusive, bar
> This brilliant scene – nor its enchantments mar!
> The prince and serf, the peasant and the peer,
> Alike may revel in the beauties here;
> Alike must feel how feeble and how small,
> Each man alone – how great, how glorious all!
> And in this fairy world of labour, see
> A type of what the actual world should be.

This opening section of the poem ends this way:

> Here, in one Brotherhood, the nations greet
> With but one heart – as 'neath one roof they meet.
> How wide soe'er their home – uncouth their name,
> Or wild their nature, here they feel the same.
> The same bright visions glad their eager eyes,
> The same strange marvels strike them with surprise;
> Their bosoms beat with rapture, or with woe,
> Whether from India's heat, or Russia's snow;
> And each high work of art, or priceless gem,
> Calls forth responsive tear or smile from them.
> They meet – as all in this cold world should meet,
> (One Heaven above – one Earth beneath their feet),
> In peace and simple faith – a quiet band
> Of Brothers – greeting in a foreign land.
> From East to West – from North to South they come,
> As to a father's feast, a common home;
> Partake with joy of all that varied store,
> And part at last – to meet again no more.
>
> (Gascoigne 1852: 3–6)[2]

There are several interesting claims made in this very widely read, greatly admired, and much cited poem. The most obvious is an assumption that the objects in the exhibition from around the world could evoke similar responses from people of very different origins, nationalities, ethnicities, or classes. Whoever they are, wherever they come from, however 'uncouth their name', all were similarly touched by what they saw here. This is itself an interesting claim. Let us consider not so much whether the claim is true or false – on the face of it, it seems unlikely to be true, and there is enough documentary evidence that many were bewildered by so many bizarre things – but rather we might consider *why* it might have been important to make such claims, and why would it have been necessary or desirable to believe this. Who benefits from such a belief? And what exactly does such a belief imply? Is this simply a question of creating larger markets for the objects on view? Let us consider, then, what it means for an understanding of the relationships between subjects and objects.

For one thing, the claims suggest that objects have certain inherent properties or qualities, which form the basis of a common response. It also presupposes that there are certain aesthetic responses, perhaps a certain 'taste', which is generally shared by people regardless of their backgrounds. (This was a very Kantian poem.) An appreciation of fine art, and of well-designed and crafted artefacts, is assumed to be widespread, and it is further implied that it is a good thing to exhibit one's good taste in things.

But why should one want to exhibit good taste or be *au courant* with the latest fashions? Why should one appreciate what arbiters of taste consider good design? What benefits accrue to those who show good taste or are knowledgeable about the direction of fashion, to those who appreciate art and are (ac)cultur(at)ed? What does it benefit a society to have its citizens interested in knowing about style, taste, art, or fashion? Is this more than a stunningly effective means for providing citizens with a kind of cultural *livelihood*; a rationale for contributing to the common good by being a good customer or consumer? Does being a good consumer equate to being a good citizen? Is the modern metamorphosis of doing good works (in a religious sense) now to be that of doing (or delighting in) good work?

There was perhaps no more brilliant stage upon which the ideas I have been mentioning were demonstrated and realized than the Great Exhibition at the Crystal Palace.[3] This most radically transparent of nineteenth-century constructions may well have been modernity's most unsurpassable social and cultural artefact; a kind of Grand Opera of art and architecture; a kind of *Gesamtkunstwerk* in its combination of so many technologies, themes, modes of articulation and presentation. It was the lucent embodiment and semiological *summa* of the principle of modern order itself. This was a building that was infinitely more than a building: infinitely expandable, scale-less, anonymous; transparently and stylelessly abstract. It was the first monument to the idea and practice of globalization.

Arguably the largest building in the world at that time, there were also in fact no structurally compelling reasons why it could not have been extended to cover the entire city of London. A 'mighty plan', as the poem says, and a '*type of what the actual world should be*' that is in fact '*lasting still*'. It is indeed lasting still, everywhere in us and around us in its 'infinite virtuality', as Baudrillard might have said. The very diagram of the modern Symbolic Order, it was, in the words of the poem, 'as wondrous and as vast' as 'the mind of man' itself. It was the mapping out in three dimensions of a utopian vision of a universal world order – defined and controlled by Europe, and more specifically, of course, by Great Britain.

For its time, the Crystal Palace seemed to offer, to paraphrase Freud speaking of his own new practice of psychoanalysis half a century later, an 'impartial instrument, like the infinitesimal calculus' for *making legible* both the differences and similarities, and the cognitive, aesthetic, and ethical hierarchies amongst peoples by means of their juxtaposed and plainly seen products and effects. It made the visible *legible*: all the world in one room; at once the modern apotheosis and metamorphosis of the *Wunderkammer* (in which objects were catalysts for a fraternal dialogue bent toward making conversational sense of a jumble-puzzle of things) (see Bennett 1998 and Findlen 1994: 100–9), and the implicit ideal horizon of the more fragmented and piecemeal arcades of Paris and other cities – which some seventy-five years later so fascinated Walter Benjamin. While Benjamin of course knew of the Crystal Palace, he did not really seem to know very much about it and what he wrote about it, and that very briefly, was primarily as an early precursor of the 1937 Paris Exposition that he was more directly interested in.

The Crystal Palace was in fact the *system* of modern museology, consumerism, and art historicism as such, stripped to the bone. It was a dream from which we have yet to awaken, and that haunts us still, this vision of a globalized world order just below the surface of our own contemporary institutions. It was one of the nineteenth century's most powerfully effective instances of thinking with things. *It was the embodiment of the principle of photography itself: of artifice as anticipatory illusion.* And of the *placement* of objects; the institutionalization of the subject–object relation, the 'matrix of representational thinking', as Samuel Weber, commenting upon Heidegger's notion of emplacement or the staking-out of a proper place (*Gestell*, or installation), argues in his book *Mass Mediauras* (Weber 1996: 74–5).

Modern disciplines such as art history cannot be appreciated or substantially understood apart from this particular 'impartial instrument', this 'father's feast' as our poet puts it. It was a feast, moreover, that was itself haunted by the presence of the greatest Patriarch of them all, Queen Victoria, who was herself present (like a kind of permanent strolling exhibit) virtually every other day of the building's 165-day *in situ* existence. Victoria – not inconsequentially the ceremonial head of the Church of England – was in law the mortal representative of what our poet called that 'great First Cause' seen behind all the 'wonders

wrought' here in this 'common home' – the projective *Umwelt* ('one Heaven above – one Earth beneath') of a British Imperial Imaginary; and a 'fair temple' whose 'classic beauty bears / The spirit back to Rome's enchanted years'.

The modern disciplinary practices of art history and museology are both among the more powerful *effects* of this 'mighty plan', this ideology of things and thingness, and among its indispensable instruments. Art history was and remains the ghost *in* this (now absent) crystalline machinery, perpetually carrying the memory of this 'Muses' seat' as *its* innermost fixation. The eidetic image of this place and its scenography is permanently imprinted on the art-historical gaze in part through the instrumentality of all its architectural progeny. Its exhibitionary order was in fact the concrete epistemological technology of *orientalism* as such. It was the laboratory table upon which all things and peoples could be clearly, crisply, and 'objectively' compared and contrasted in a uniform light, and phylogenetically and ontogenetically ranked, on the basis of the style and quality of their products: a kind of three-dimensional photography. All this, furthermore, has to be understood in relation to a Europe that had learned to stage itself as the eyes and ears of the world; as the present of the world's past; as, indeed, the veritable *brain of the earth's body*. The Crystal Palace was precisely the paradigm of the loom of modernity on which art and capital came to be woven tightly together into a sturdy, enduring fabric which has in fact not only hardly frayed since, but which grows ever more durable.

It is difficult, today, to appreciate fully the enduring effect of this extraordinary building and its contents throughout the nineteenth century. Between 1 May and 15 October 1851, the duration of the exhibition, some 6 million visitors came here from all over the world. (The population of Britain itself at the time was only about 15 million.) Part of our own difficulty in fully appreciating the breathtaking radicality of this enterprise is that it presents us with a world that is already perfectly familiar to us: this *is* the world in which we continue to live, the psychosocial and epistemological core of modernity as such. It is globalization's anticipatory illusion.

One of the most enthusiastic supporters of the Great Exhibition was Queen Victoria herself, whose husband, Prince Albert, was the originator and guiding mind behind the project. Albert's mission was explicitly educational, economic, political, and industrial. His aim was to promote trade, to exemplify good design to British manufacturers, to the general British public and to the world at large, and to educate the general populace in good taste and excellence in design whilst serving as a powerful catalyst for market expansions of various kinds. As noted above, Victoria visited the Crystal Palace some sixty times, nearly every other day the Exhibition was open. All its visitors had a more than even chance of seeing the Queen herself with her entourage browsing through the many aisles and pavilions; *seeing Victoria seeing* was an extremely popular attraction for countless numbers of ordinary visitors. It also provided the Queen as well as others with a vicarious or virtual world tour without having to leave home.

But when a Queen browses, it is not the same as when you and I do. One of the privileges of royalty at the time (and to some extent even today) was that when a royal person expressed an interest in an object, it *became* his or hers, it being proper protocol for the maker or owner to donate it as a gift to the royal person (there are in fact many stories of stately homes in Britain being denuded of their possessions by visiting royalty, whose presence came to be dreaded by many precisely because of this). It is almost magical: the royal gaze evokes and indeed literally *elicits* ownership. As hard as you or I may ogle an object in a shop window, it does not fly into our arms unless we buy it. Victoria's browsing, observed by countless thousands from around the world, in a sense embodied the pure ideal spirit of consumption: consumption without debt; pure consuming, with a direct connection, a cause-and-effect relation, between looking and having. This is the magical ideal, the dreamworld of the modern consumer society: the conflation of seeing, desiring, and possessing. A virtual reality in which we still live, which is, as our poet exquisitely put it, a 'fairy world of labour' that is in fact 'living still'. We remain caught like insects in the bright amber of this phantasmatic nexus of desires. We are still *mesmerized* by the ideal that was exemplified, embodied, and performed by Victoria. Indeed, we live in a world in which we are made desirous of being convinced that we are what our things appear to say about us, so that we may become desirous of that which even better things may be able to say to ourselves and others about our continually evolving sense of ourselves.

In May 2006, in Shanghai, at the centre of that city, in People's Park (built on the site of what used to be the racecourse of the old British community), I visited the City Planning Museum, whose entire top floor is divided between a huge and obsessively detailed wooden scale model of this city of 20 million, and a 'Virtual World' theatre which surrounds you with the promises of the Shanghai of the future, a 360-degree Imax film in which you fly over and around that future Shanghai in an adventure titled 'New City, New Life', where you see spread out before you a twenty-first-century version of the arts and manufactures of the whole world. It was like visiting one of the imaginary cities in Italo Calvino's famous 1970s book *Invisible Cities*, and in particular the city of Eudoxia, at whose centre was a temple with a carpet in whose intricate patterns visitors would trace the details of their lives, their fate, and which the citizens of Eudoxia believed was a map of the universe and the order the gods gave the cosmos. One of the most popular activities for local visitors to the model of Shanghai, ringed by an elevated viewing walkway, is to locate one's house (in the case of Shanghai today, usually a high-rise apartment block), and photograph it, its neighbourhood, and the whole city model.

We always seem to be confronted by Plato and his 'dilemma' wherever we turn, for Calvino, in commenting on the beliefs of the citizens of Eudoxia, ends his description by questioning if indeed the carpet at the centre of the temple which is at the centre of the city at the centre of its world does in fact echo the cosmos made by the gods, saying that rather the true 'map' of the universe

is the city of Eudoxia itself, just as it is, with all its flaws and impermanence. The world artifice creates is not a second (phantasmatic) world alongside the world in which we live, but is precisely the very world in which we really do live. Think of the ideological fiction of what is really entailed in convincing ourselves that art is fiction. For whom would this have mattered in the past, or today?

III

The enterprise of the modern discipline of art history *pre-figured* by thinkers such as Vasari, Diderot, Winckelmann, Kant, and Hegel was clearly and concretely *figured* in the 1851 Great Exhibition – a building that was itself an epistemological technology and a psycho-semiological machinery for simultaneously rendering visible both all of Europe's facets and all of Europe's Others.[4] In such a parliament of products, such visibility was both the *proof* and *condition* of the presence of Others, their existence in effect guaranteed by the imprimatur of their exhibitionary *representation*. Differences between peoples become reduced here to differences in style or to what became for the stylistic historian Alois Riegl half a century later differing 'approaches to form', or *Kunstwollen*. Otherness, in short, breathtakingly and effectively disciplined and domesticated.

Looking at the Crystal Palace you can imagine what this virtual visit to other places and cultures entailed. Here you have the French; there the Greeks; next to them the Turks, the Persians, the Indians, the Canadians, the Americans, the Austro-Hungarian Empire, the Chinese … Later on, there were sections devoted to the past – you could visit Ancient Rome, Pharaonic Egypt, Muslim Spain, or Mediaeval Christian Europe itself. All things and all peoples were commodified together, all times and places made starkly tangible and present. The Crystal Palace was the first grand modern synthesis of history, geography, and identity: a disciplinary order and image of *what the real world should* be, as our poet says: a delimitation of modernity by juxtaposing its products and peoples with those of all others. Although to leave Europe was staged as a leave-taking of the present, the past of others was recuperated as an exotic product for present consumption.

The erasure of difference (this 'abstraction') in favour of a 'universal' and uniform 'fairy world of labour' endowed everything (as the effective *condition* of its visibility in modernity) with a commodified, reified, and fetishized value, making it crystal-clear that at the core of modernity is precisely the perfect conflation and synthesis of aesthetics, ethics, economics, and sexuality in the commodity – and in the citizen, for you cannot be a citizen unless you can be commodified and perceived in the theatrical role of 'a citizen'. The specificity of your being can be accepted only insofar as it can be objectified and represented. This was the epistemological crux both of Heidegger's world-as-image and what Benjamin's arcades project was aiming to demonstrate (Buck-Morss 1989: 211).

It is perhaps fitting that (despite its dismantling and rebuilding in Sydenham in South London, where it was destroyed by fire in 1936) the original Crystal Palace was but a momentary, five-month phenomenon: a brief and blinding flash in mid-century that revealed, like the quick shine of a torch in the night, an unexpected and uncanny landscape. That flash has remained imprinted on the modern optic nerve now for well over a century; the uncanny landscape revealed being, in Walter Benjamin's words, capitalism; what he called that catastrophic 'new dream sleep (that) fell over Europe' (Benjamin 1982: 494). The building was *a three-dimensional maquette of photography's anticipatory illusion.*

Objects were juxtaposed and assembled together according to a certain uniform system of display, which could only have effectively existed after the invention of photography and its pragmatic exemplifying of common scale and perspective, with every 'place' in the world constituting tableaux of roughly equal proportions, resonating with, reinvigorating, and reinforcing the exhibitionary practices of museums and markets. Such a system made what was visible truly legible, presupposing a proper way of looking at things, an effective way of reading things. Only by taking up a proper perspective, stance, and distance elicited by the exhibition would all these bits and pieces be seen as joining up to create a figure or physiognomy of the character or mentality of a person, people, or period. Cultures and peoples are all made to fit into this ideal taxonomic and, I think one must insist, this photographic machinery. This is precisely what is set out by Heidegger as the *bringing-forth-and-setting-before (the subject) of all things* in his essay 'The Age (Time) of the World Picture'.[5]

It is the pursuit of such *perspectival positions* presupposed by this exhibitionary order of the 'fairy world of labour' that still constitutes the modern discipline of art history as a disciplining of the gaze; as an instrumental technology for fabricating comparative genealogies of value, character, race, spirit, or mentality through the mediating fictions of style, intention, authorship, and reflection. In this regard, Queen Victoria embodied a royal perspectival eye; the ideal of the strolling, browsing gaze. One learned how to look by watching others, but especially by seeing the Queen herself seeing.

IV

The key metaphorical conundrum, the central and perpetually repeated obsession of modernity is that the *form* of your work is − and should properly be *legible as* − the *figure* or physiognomy of your truth; the emblem of who and what you are. This amalgam of ethics and aesthetics is what the system of the Crystal Palace, and of photography, museology and art historicism entailed and afforded: every object staged as an object-*lesson*. Museological and art historical, theoretical, and critical practices were interlinked sites for the manufacture of the present and the production of the past, in particular here the present that constituted Europe in its relation to all possible Others − that 'modernity', that perfect co-option of all possible ethnocentrisms, that has since come to cover

the planet through its extensions, imitations, and recapitulations everywhere. Art history is no less a factory for the production of the fictions that make up the load-bearing walls of that modernity – the phantasms of ethnicity, race, gender, nation, sex, indigeneity, and otherness.

All of this has to be thought of in relation to that key enabling fiction, that phantasmagoric black hole around which all our modernities circulate, the aesthetic idea of 'art' itself. The Crystal Palace was the first complete materialization, the first encyclopedic vision, of what that astonishing European Enlightenment invention, the 'art' of aesthetic philosophy and of art history and museology, was to be *for* in modernity. It may be seen, along with Hegel's theoretical apparatus, as one variant, one allomorph, of a modern answer to the fundamental question of what defines the human. Hegel's response to Aristotle's answer as to what distinguishes humans from other animals, namely their self-conscious artistic capacity, was the idea of a pan-human capacity for symbolizing; for the Symbolic, albeit differentially, manifested itself in different nations and races: a time-factored capacity articulated by ecumenically linking together all peoples and times into a common evolutionary thread or episodic chain from the primitive to the civilized. In radically seeing all humans as related members of the same species, Hegel at the same time articulated this universal system of kinship not only horizontally but vertically, with Europe, of course, as the leading edge of the evolution of this World Spirit.

V

The Crystal Palace engendered a masquerade of utopian egalitarianism. Yet its embodying of the Enlightenment dream of commensurability was belied, first, by the hierarchical order distinguishing the British nave of the building, replete with the massive new instruments and powerful heavy metal of the (British) Industrial Revolution; the successor to the charming crafts and exotic products of all others, grouped together in the other, 'foreign' nave; the site of a feminized and domesticated Other. It was belied, secondly, by the material and virtual presence of Victoria as the royal Being that actively 'read'; that gazed; that gave corporeal voice to this object-world; simultaneously its perspectival vanishing point and its hegemonic articulating source. The Crystal Palace was in essence an anamorphic optical device – like photography itself.

Where are we today if not living out our lives in an even more intensely universalized phantasmagoria than that staged in and by the Crystal Palace? It was the 'degree zero' of a newly globalized vision of the embodiment of a fairy world of labour, its *cosmos* the descendant of a Platonic ideal *polis*; a world-picture crafted to disremember the artifice of its own fabrication; the anticipation of our own more fully materialized and militarized globalization. Today, the *masquerade* of a utopian egalitarianism is even more grotesquely pronounced, and the role of Victoria has been assumed by corporate elites for whom whole populations, not to mention whole nations, have become permanently indentured to service

capital, and who have become, in their millions, a permanent migratory underclass: completely interchangeable and replaceable parts in the neo-feudalist machinery of world capital. It is precisely here that we are obliged to play out our lives today, where even the conscious ideologies of rebellion and negative critique are woven in advance (like planned obsolescence) into the fabric of the play. What all this has to do with photography should be perfectly clear. As anticipatory illusion, photography and its media progeny are in fact the enabling devices of globalization, manufacturing our needs, desires, and consent in the service of capital, with ourselves as 'the technical operators' of the device's infinite virtuality.

I began this chapter commenting on Baudrillard's claim that images are almost exclusively the technical fulfilment of photography's intrinsic possibilities, it being the medium itself that 'does all the work'. I also began with what I called 'Plato's dilemma', which referred to the essential ambivalence of the powers of art to fabricate and simultaneously problematize the hegemonic power materialized in the city's forms and practices: the ambiguity of *artifice* as such in not simply reflecting but also fabricating the world in which we live. Artifice – art – problematizes any opposition between the poles of 'fact' and 'fiction', history and poetry, between 'fairy worlds' of labour and the 'actual world' in which we live. If we forget that radical and terrifying power of art (which hegemonic power works tirelessly to ensure we do forget, using the tools of artistry against us), we ensure our own demise. We must be very clear indeed about what is at stake in reckoning with photography.

Notes

1 Such a claim is not, of course, unique to modernity.
2 This remarkable 150-page poem, initially published anonymously by the unidentified authoress of *Belgravia, A Poem*, 2nd edn, 1852, is divided into six parts, devoted, respectively, to an overview of the year of the Exhibition from its opening on 1 May to its Autumn close, morning in the Crystal Palace (with the joyous arrival of the Queen), a discussion of the building's resemblance to great edifices of ice seen by Arctic mariners, the lamentation of a mother for her daughter lost in the crowds, a description of the progress of two anonymous persons through the Exhibition one day, closing with a discussion of 'the ties that exist between a great Author and those of his Readers who appreciate his works' (137). The building opened 1 May 1851 and closed 12 October, 165 days later.
3 A useful introduction to the building and to a good sample of the recent literature is McKean (1994). The present discussion expands on several earlier versions: a lecture entitled 'The Crystalline Veil and the Phallomorphic Imaginary', part 6 of the Slade Lectures, Oxford, 2001, and the publication of those lectures (Preziosi 2003). An earlier draft appeared under the title 'The Crystalline Veil and the Phallomorphic Imaginary: Walter Benjamin's Pantographic Riegl' (Preziosi 1999).
4 My perspectives here are indebted to the work of, and to work in the wake of, Luce Irigaray. See the special issue of *Diacritics*, 28, 1 (1998), devoted to her work, especially Berger (1998); see also Irigaray, 'The Blind Spot of an Old Dream of Symmetry' (1985: 41–68).
5 I follow here the reading of Samuel Weber (1996: 76–8) in his essay 'Mass Mediauras, or: Art, Aura and Media in the Work of Walter Benjamin'.

Bibliography

Agamben, Giorgio (1998) *Homo Sacer: Sovereign Power and Bare Life*, trans. Daniel Heller-Roazen, Stanford, CA: Stanford University Press.

Amelunxen, Hubertus von (ed.) (2000) *Theorie der Fotografie*, vol. 4, 1980–1995, Munich: Schirmer/Mosel.

Anderson, Benedict (1983) *Imagined Communities: Reflections on the Origin and Spread of Nationalism*, London: Verso.

Apel, Dora (2005) 'Torture Culture: Lynching Photographs and the Images of Abu Ghraib', *Art Journal*, 64(2): 88–100.

Arditti, Rita (1999) *Searching for Life: The Grandmothers of the Plaza de Mayo and the Disappeared Children of Argentina*, London: University of California Press.

Arnaud, Jean (2005) 'Touching to See', *October*, 114: 5–16.

Art in America (1982) 'Editorial', 70(8): 5.

Art in America (2003) 'Chile's Man of the Year', March: 35.

Aubenas, Sylvie (ed.) (2002) *Gustave Le Gray 1820–1884*, Los Angeles: J. Paul Getty Museum.

Avilés, Jaime (2004) 'Familiares de víctimas de la *guerra sucia* se manifiestan ante la casa de Echeverría', *La Jornada*, 15 August. Available online: <http://www.jornada.unam.mx/2004/08/15/007n1pol.php?printver=1&fly=1>.

Baas, Jacquelynn (1987) 'Reconsidering Walter Benjamin: "The Age of Mechanical Reproduction" in Retrospect', in Gabriel P. Weisberg and Laurinda S. Dixon (eds) *The Documented Image: Visions in Art History*, Syracuse: Syracuse University Press.

Bad Object-Choices (ed.) (1991) *How Do I Look? Queer Film and Video*, Port Townsend, WA: Bay Press.

Bal, Mieke (2003) 'Visual Essentialism and the Object of Visual Culture', *Journal of Visual Culture*, 2(1): 5–32.

BALTIC Centre for Contemporary Art (2005) 'B. Part of It', Media Release, 17 July 2005. Available online: <http://www.balticmill.com/downloads/Spencer_Tunick.pdf>.

Barthes, Roland (1973) *Mythologies*, trans. Annette Lavers, London: Paladin.

—— (1975) *Roland Barthes par Roland Barthes*, Paris: Seuil.

—— (1977a) 'Rhetoric of the Image' in Stephen Heath (ed. and trans.) *Image–Music–Text*, London: Fontana.

—— (1977b) *Roland Barthes by Roland Barthes*, trans. Richard Howard, New York: Hill and Wang.

—— (1980) *La Chambre claire: note sur la photographie*, Paris: Cahiers du cinéma/Gallimard/Seuil.

Barthes, Roland (1981) *Camera Lucida: Reflections on Photography*, trans. Richard Howard, New York: Hill and Wang.

Batchen, Geoffrey (2004) *Forget Me Not: Photography and Remembrance*, New York: Princeton Architectural Press.

Baudelaire, Charles (1981) 'The Salon of 1859', trans. Jonathan Mayne, in Vicky Goldberg (ed.) *Photography in Print: Writings from 1816 to the Present*, New York: Simon and Schuster.

Baudrillard, Jean and Jean Nouvel (2002) *The Singular Objects of Architecture*, trans. Robert Bononno, Minneapolis and London: University of Minnesota Press.

BBC News (2001) 'Canadians flock to strip off'. Available online: <http://news.bbc.co.uk/2/hi/americas/1355162.stm>.

Beaux Arts Magazine (2003) 'Flash Mobs', 233: 82–7.

Bell, Joshua A. (2003) 'Looking to See: Reflections on Visual Repatriation in the Purari Delta, Papua New Guinea', in Laura Peers and Alison Brown (eds) *Museums and Source Communities*, London: Routledge.

Belting, Hans (2005) 'Image, Medium, Body: A New Approach to Iconology', *Critical Inquiry*, 31(2): 302–19.

Benjamin, Andrew and Osborne, Peter (eds) (1994) *Walter Benjamin's Philosophy: Destruction and Experience*, New York and London: Routledge.

Benjamin, Walter (1965) *Das Kunstwerk im Zeitalter seiner mechanischen Reproduzierbarkeit*, Frankfurt am Main: Suhrkamp.

—— ([1936] 1969) 'The Work of Art in the Age of Mechanical Reproduction', in Hannah Arendt (ed.) *Illuminations*, trans. Harry Zohn, New York: Schocken.

—— (1973) *Understanding Brecht*, trans. Anna Bostock, London: New Left Books.

—— (1980) 'A Short History of Photography', in Alan Trachtenberg (ed.) *Classic Essays on Photography*, New Haven: Leete's Island Books.

—— (1982) *Das Passagen-Werk, Gesammelte Schriften*, Rolf Tiedemann and Hermann Schweppenhäuser (eds), vol. 5, Frankfurt am Main: Suhrkamp.

—— (1999) *Selected Writings Volume 4: 1938–1940*, Michael W. Jennings and Howard Eiland (eds), trans. Rodney Livingstone *et al.*, Cambridge, MA, and London: The Belknap Press of Harvard University Press.

—— (2002) *Selected Writings Volume 3: 1935–1938*, Howard Eiland and Michael W. Jennings (eds), trans. Edmund Jephcott, Cambridge, MA, and London: The Belknap Press of Harvard University Press.

Bennett, Tony (1998) 'Pedagogic Objects, Clean Eyes, and Popular Instruction: On Sensory Regimes and Museum Didactics', *Configurations*, 6(3): 345–71.

Berg, Rick (1991) 'Losing Vietnam: Covering the War in an Age of Technology', in John Carlos Rowe and Rick Berg (eds) *The Vietnam War and American Culture*, New York: Columbia University Press.

Berger, Anne-Emmanuelle (1998) 'The Newly Veiled Woman: Irigaray, Specularity, and the Islamic Veil', *Diacritics*, 28(1): 93–119.

Berlant, Lauren (1997) *The Queen of America Goes to Washington City: Essays on Sex and Citizenship*, Durham: Duke University Press.

Berman, Marshall (1988) *All That is Solid Melts into Air: The Experience of Modernity*, New York: Penguin.

Bourdieu, Pierre (1984) *Homo academicus*, Paris: Editions de Minuit.

—— (2001) *Science de la science et réflexivité*, Paris: Raisons d'agir.

Bourdieu, Pierre, Boltanski, Luc, Castel, Robert and Chambordeon, Jean-Claude (1990)

Photography: A Middle-Brow Art, trans. Shaun Whiteside, Cambridge: Polity Press.

Bowler, Kristin (2003) 'Everyone Strips', *Naked States Tour Journal*, Available online: <http://www.keepgoing.org/issue11_naked/farm.asp?page=blurb2>.

Brown, Alison and Laura Peers (2005) *Pictures Bring us Messages*, Toronto: University of Toronto Press.

Buchloh, Benjamin H. D. (1984) 'Figures of Authority, Ciphers of Regression', in Brian Wallis (ed.) *Art After Modernism: Rethinking Representation*, New York and Boston: The New Museum of Contemporary Art and Godine.

Buck-Morss, Susan (1989) *The Dialectics of Seeing: Walter Benjamin and the Arcades Project*, Cambridge, MA: The MIT Press.

—— (1992) 'Aesthetics and Anaesthetics: Walter Benjamin's Artwork Essay Reconsidered', *October*, 62: 3–41

Burgin, Victor (ed.) (1982) *Thinking Photography*, London: Macmillan.

—— (1986a) 'Re-reading Camera Lucida', in *The End of Art Theory: Criticism and Postmodernity*, Basingstoke: Macmillan.

—— (1986b) 'Seeing Senses', in *The End of Art Theory: Criticism and Postmodernity*, Basingstoke: Macmillan.

Butler, Judith (2004) *Precarious Life: The Powers of Mourning and Violence*, London: Verso.

Cadava, Eduardo (1997) *Words of Light: Thesis on the Photography of History*, Princeton, NJ: Princeton University Press.

Carter, Paul (2004) 'Ambiguous Traces: Mishearing and Auditory Space', in Veit Erlmann (ed.) *Hearing Cultures: Essays on Sound, Listening and Modernity*, Oxford: Berg.

Clark, Andy (1997) *Being There: Putting Brain, Body and the World Together Again*, Cambridge, MA: The MIT Press.

Classen, Constance (1993) *Worlds of Sense: Exploring the Senses in History and across Cultures*, London: Routledge.

—— (ed.) (2005) 'Fingerprints: Writing about Touch', *The Book of Touch*, Oxford: Berg.

Clifford, James (1986) 'Introduction', in James Clifford and George E. Marcus (eds) *Writing Culture: The Poetics and Politics of Ethnography*, Berkeley: University of California Press.

Cohen, David (2004) Review of 'Spencer Tunick: Public Works 2001–2004' at I-20 Gallery, *New York Sun*, 10 June. Available online: <http://www.artcritical.com/DavidCohen/SUN56.htm>.

Communications (1964) Issue 4.

Connor, Steven (2004) 'Edison's Teeth: Touching Hearing', in Veit Erlmann (ed.) *Hearing Cultures: Essays on Sound, Listening and Modernity*, Oxford: Berg.

Crary, Jonathan (1990) *Techniques of the Observer: On Vision and Modernity in the Nineteenth Century*, Cambridge, MA: The MIT Press.

Crimp, Douglas (1980) 'The Photographic Activity of Postmodernism', *October*, 15: 91–101.

—— (1984) 'Pictures', in Brian Wallis (ed.) *Art after Modernism: Rethinking Representation*, New York and Boston: The New Museum of Contemporary Art and Godine.

Csordas, Thomas J. (1994) 'Introduction: The Body as Representation and Being-in-the-World', in Thomas J. Csordas (ed.) *Embodiment and Experience*, Cambridge: Cambridge University Press.

Cubitt, Sean (1998) *Digital Aesthetics,* London: Sage.

Daston, Lorraine (2004) 'Introduction' in Lorraine Daston (ed.) *Things That Talk: Object Lessons from Art and Science*, New York: Zone Press.

Davies, Alan and Peter Stanbury (1985) *The Mechanical Eye in Australia: Photography 1841–1900*, Melbourne: Oxford University Press.

de Certeau, Michel (1984) *The Practice of Everyday Life*, Berkeley: University of California Press.

Debord, Guy ([1967] 1995) *The Society of the Spectacle*, trans. Donald Nicholson-Smith, Cambridge, MA: MIT Press.

DeBray, Régis (1996) *Media Manifestos,* trans. Eric Rauth, London: Verso.

Deitcher, David (1998) 'Looking for a Photograph, Looking for a History', in Deborah Bright (ed.) *The Passionate Camera: Photography and Bodies of Desire*, London: Routledge.

—— (2001) *Dear Friends: American Photographs of Men Together, 1840–1918*, New York: Harry N. Abrams.

Deleuze, Gilles and Félix Guattari (1987) *A Thousand Plateaus: Capitalism and Schizophrenia*, trans. Brian Massumi, Minneapolis: University of Minnesota Press.

Dennis, Kelly (2006) 'The Hegelian Implications of the Museum of Sex; or, Does MoSex Mean No Sex?' *Art Journal*, 65(2): 8–22.

Derrida, Jacques ([1967] 1976) *Of Grammatology*, trans. Gayatri Chakravorty Spivak, Baltimore: Johns Hopkins University Press.

—— ([1967] 2001) *Writing and Difference*, trans. and intro. Alan Bass, London: Routledge.

—— (1987) *The Truth in Painting*, trans. Geoff Bennington and Ian McLeod, Chicago: The University of Chicago Press.

Devisch, Ignaas (2005) 'Jean-Luc Nancy' in *The Internet Encyclopedia of Philosophy*. Available online: <http://www.utm.edu/research/iep/n/JLNancy.htm#Community>.

Donnelly, Arelene (2000), *Naked States: America's in for a Nude Awakening*, DVD: HBO.

Drinan, Robert F. (2001), *The Mobilization of Shame: A World View of Human Rights*, New Haven/London: Yale University Press.

Dubois, Philippe (1983) *L'Acte photographique*, Paris: Nathan.

Eagleton, Terry (1983) *Literary Theory: An Introduction*, Oxford: Blackwell.

Edwards, Elizabeth (1999) 'Photographs as Objects of Memory', in Marius Kwint, Christopher Breward and Jeremy Aynsley (eds) *Material Memories: Design and Evocation*, Oxford: Berg.

—— (2001) *Raw Histories: Photographs, Anthropology and Museums*, Oxford and New York: Berg.

—— (2005) 'Photography and the Sound of History', *Visual Anthropology Review*, 21(1/2): 27–46.

Edwards, Elizabeth and Janice Hart (eds) (2004) *Photographs Objects Histories: On the Materiality of Images*, London: Routledge.

Edwards, Elizabeth, Chris Gosden and Ruth Bliss Phillips (eds) (2006) *Sensible Objects: Colonialism, Museums and Material Culture*, Oxford: Berg.

Elkins, James (1999) *The Domain of Images*, Ithaca: Cornell University Press.

—— (ed.) (2007) *Photography Theory (Art Seminar)*, London: Routledge.

Ennis, Helen (ed.) (2000) *Mirror with a Memory: Photographic Portraiture in Australia*, Canberra: National Portrait Gallery.

Erlmann, Veit (ed.) (2004) 'But What of the Ethnographic Ear?', *Hearing Cultures: Essays on Sound, Listening and Modernity*, Oxford: Berg.

Fanon, Frantz (1967) *Black Skin, White Masks: The Experiences of a Black Man in a White World*, trans. Charles Lam Markmann, New York: Grove.

Farnell, Brenda (1999) 'Moving Bodies, Acting Selves', *Annual Review of Anthropology*, 28: 341–73.

Feitlowitz, Marguerite (1998) *A Lexicon of Terror: Argentina and the Legacies of Torture*, Oxford: University of Oxford Press.

Feld, Steven (1990) *Sound and Sentiment: Birds, Weeping, Poetics, and Song in Kaluli Expression*, Chicago: Chicago University Press.

—— (1996) 'Waterfalls of Song', in Steven Feld and Keith H. Basso (eds) *Senses of Place*, Santa Fe: School of American Research Press.

Findlen, Paula (1994) *Possessing Nature: Museums, Collecting, and Scientific Culture in Early Modern Italy*, Berkeley and London: University of California Press

Finnigan, Ruth H. (1970) *Oral Literature in Africa*, Oxford: Clarendon Press.

—— (2002) *Communicating: The Multiple Modes of Human Interconnection*, London: Routledge.

Ford, Colin, (ed.) (1977) *Happy and Glorious: Six Reigns of Royal Photography*, New York: Macmillan.

Foster, Hal, Rosalind Krauss, Yve-Alain Bois and Benjamin H. D. Buchloh (2005) *Art since 1900*, 2 vols, London: Thames and Hudson.

Foucault, Michel ([1969] 1989) *The Archaeology of Knowledge*, trans. A. M. Sheridan Smith, London: Routledge.

—— ([1975] 1979) *Discipline and Punish: The Birth of the Prison*, trans. A. M Sheridan Smith, New York: Vintage.

—— (1991) 'Politics and the Study of Discourse', in Graham Burchell, Colin Gordon and Peter Miller (eds) *The Foucault Effect: Studies in Governmentality*, Chicago: University of Chicago Press.

Frank, Robert (1978) *The Americans*, intro. Jack Kerouac, New York: Aperture.

Freud, Sigmund (1953) *The Interpretation of Dreams*, in James Strachey (ed.) *The Standard Edition of the Complete Psychological Works,* trans. James Strachey, vols IV and V, London: The Hogarth Press.

Gallop, Jane (2003) *Living with his Camera*, photographs by Dick Blau, Durham: Duke University Press

Galton, Francis (1884) *The Life History Album*, London: Macmillan.

—— (1892) *Hereditary Genius: An Inquiry into Its Laws and Consequences*, London: Macmillan.

—— (1907) *Inquiries into Human Faculty and Its Development*, 2nd edn, London: J. M. Dent and Sons.

Gasché, Rodolphe (1994) 'Objective Diversions: On Some Kantian Themes in Benjamin's "The Work of Art in the Age of Mechanical Reproduction"', in Andrew Benjamin and Peter Osborne (eds) *Walter Benjamin's Philosophy: Destruction and Experience*, New York and London: Routledge.

Gascoigne, Caroline Leigh Smith (1852) *Recollections and Tales of the Crystal Palace*, London: Shoberl.

Gell, Alfred (1998) *Art and Agency*, Oxford: Clarendon Press.

Gernsheim, Helmut (1988) 'The *carte-de-visite* period', in *The Rise of Photography 1850–1880: The Age of Collodion*, London: Thames and Hudson.

The J. Paul Getty Museum. Available online: <http://www.getty.edu/art/gettyguide/artMakerDetails?maker=1961>.

Gingeras, Alison M. (2000) 'A Sociology without Truth,' *Parkett*, 59: 50–53.

—— (2004a) 'hobbypopMUSEUM,' *Artforum*, 42(10): 16.

—— (2004b) Response to a letter from Gregory Sholette, *Artforum*, 43(7): 174–5.

Ginzberg, Victoria (2004) 'Para purificar este dinero espurio', *Página/12.com*, 24 August. Available online: <http://www.pagina12.com.ar/diario/elpais/1-40103-2004-08-24.html>.

Goldberg, Vicky (1991) *The Power of Photography: How Photographs Changed Our Lives*, New York: Abbeville Press.

Goldblatt, Mark (2004) 'Sontag Logic', *The National Review*, May 28. Available online: <http://www.nationalreview.com/comment/goldblatt200405280825.asp>.

Grant, Catherine (2003) 'Still Moving Images: Images of the Disappeared in Films about the Dirty War in Argentina', in Alex Hughes and Andrea Noble (eds) *Phototextualities: Intersections of Photography and Narrative*, Albuquerque: University of New Mexico Press.

Grierson, John (1946), *Grierson on Documentary*, edited by Forsyth Hardy, London: Collins.

—— (1981) 'What I Look For' (1932), in Forsyth Hardy (ed.) *Grierson on the Movies*, London and Boston: Faber and Faber.

Gumbrecht, Hans Ulrich and Michael Marrinan (2003) *Mapping Benjamin: The Work of Art in the Digital Age*, Stanford, CA: Stanford University Press.

Guzman Bouvard, Marguerite (1994) *Revolutionizing Motherhood: The Mothers of the Plaza de Mayo*, Wilmington DE: Scholarly Resources.

Hambourg, Maria Morris, Françoise Heilbrun and Philippe Néagu (eds) (1995) *Nadar*, New York: Metropolitan Museum of Art.

Hardt, Michael and Antonio Negri (2000) *Empire*, Cambridge, MA: Harvard University Press.

Hariman, Robert and John Louis Lucaites (2007) *No Caption Needed: Iconic Photographs, Public Culture, and Liberal Democracy*, Chicago: University of Chicago Press.

Harkin, Michael Eugene (2003) 'Feeling and Thinking in Memory and Forgetting: Towards an Ethnohistory of the Emotions', *Ethnohistory*, 50: 261–84.

Hart, David C. (1996) 'Differing Views: Roland Barthes, Race and James VanDerZee's *Family Portrait*,' unpublished master's dissertation, University of North Carolina, Chapel Hill.

Hayles, N. Katherine (1998) *How We Became Posthuman: Virtual Bodies in Cybernetics, Literature, and Informatics*, Chicago and London; University of Chicago Press.

Hegel, G. W. F. (1956), *The Philosophy of History*, trans. J. Sibree, New York: Dover Publications.

—— (1977) *Phenomenology of Spirit*, trans. A. V. Miller, Oxford and New York: Oxford University Press.

Hersh, Seymour (2004) 'The Gray Zone: Annals of National Security', *The New Yorker*, May 24.

Hirsch, Julia (1981) *Family Photographs: Content, Meaning, and Effect*, New York: Oxford University Press.

Hirsch, Marianne (1997) *Family Frames: Photography, Narrative, and Postmemory*, Cambridge: Harvard University Press.

—— (ed.) (1999) *The Familial Gaze*, Hanover: University Press of New England.

Hirsch, Marianne and Valerie Smith (2002) 'Feminism and Cultural Memory: An Introduction', *Signs*, 28(1): 1–19.

hooks, bell (1994) 'In Our Glory: Photography and Black Life', in Deborah Willis (ed.) *Picturing Us: African American Identity in Photography*, New York: New Press

Howes, David (ed.) (2005) *Empire of the Senses: The Sensual Culture Reader*, Oxford: Berg.

Ihde, Don (1991) *Instrumental Realism: The Interface between Philosophy of Science and Philosophy of Technology*, Bloomington and Indianapolis: Indiana University Press.

—— (1998) *Expanding Hermeneutics: Visualism in Science*, Evanston, Illinois: Northwestern University Press.

Ingold, Tim (2000) *The Perception of the Environment: Essays on Livelihood, Dwelling and Skill*, London: Routledge.

Irigaray, Luce (1985) *Speculum of the Other Woman*, trans. Gillian C. Gill, Ithaca: Cornell University Press.

Jackson, Michael (ed.) (1996) *Things as They Are: New Directions in Phenomenological Anthropology*, Bloomington: Indiana University Press.

Jay, Martin (1993) *Downcast Eyes: The Denigration of Sight in Twentieth Century Thought*, Berkeley: University of California Press.

Jennings, Michael (2004) 'Walter Benjamin and the European Avant-garde,' in David S. Ferris (ed.) *The Cambridge Companion to Walter Benjamin*, Cambridge and New York: Cambridge University Press.

Jones, Amelia (1994) *Postmodernism and the En-gendering of Marcel Duchamp*, Cambridge: Cambridge University Press.

Kaiser, Susana (2002) 'Escraches: Demonstrations, Communication and Political Memory in Post-Dictatorial Argentina', *Media, Culture & Society*, 24(4): 499–516.

Kaplan, Louis (2005) *American Exposures: Photography and Community in the Twentieth Century*, Minneapolis and London: University of Minnesota Press.

Keenan, Thomas (2002) 'Publicity and Indifference (Sarajevo on Television)', *PMLA*, 117(1): 104–15.

—— (2004) 'Mobilizing Shame', *The South Atlantic Quarterly*, 103(2/3): 435–49.

Keene, Webb (2005), 'Signs are not the Garb of Meaning: On the Social Analysis of Material Things', in Daniel Miller (ed.) *Materiality*, Durham, NC: Duke University Press.

Keller, Ulrich (1995) 'Sorting out Nadar: An Examination of Nadar's Photographic Legacy', in Marie Morris Hambourg, Françoise Heilbrun and Philippe Neagu (eds) *Nadar*, New York: Metropolitan Museum of Art.

Kemp, Wolfgang (ed.) (1979) *Theorie der Fotografie*, vol. 1: 1839–1912. Munich: Schirmer/Mosel.

—— (ed.) (1980) *Theorie der Fotografie*, vol. 2: 1912–1945. Munich: Schirmer/Mosel.

—— (ed.) (1983) *Theorie der Fotografie*, vol. 3: 1945–1980. Munich: Schirmer/Mosel.

Knight, Diana (1997) 'Roland Barthes, or The Woman Without a Shadow,' in Jean-Michel Rabaté (ed.) *Writing the Image After Roland Barthes*, Philadelphia: University of Pennsylvania Press.

Koonings, Kees and Dirk Kruijt (eds) (1999) *Societies of Fear: The Legacy of Civil War, Violence and Terror in Latin America*, London: Zed Books.

Kracauer, Siegfried (1975) 'The Mass Ornament', trans. Barbara Correll and Jack Zipes, *New German Critique*, 5: 67–76.

—— (1995a) *History: The Last Things Before the Last*, ed. Paul Oscar Kristeller, Princeton, NJ: Markus Wiener Publications.

—— (1995b) *The Mass Ornament: Weimar Essays*, trans. and ed. Thomas Y. Levin, Cambridge, MA: Harvard University Press.

Krauss, Rolf H. (1998) *Walter Benjamin und der neue Blick auf die Photographie*, Ostfildern: Hatje Cantz.

Krauss, Rosalind E. (1976) 'The Aesthetics of Narcissism', *October*, 1: 50–64.

—— (1977) 'Notes on the Index: Seventies Art in America', *October*, 3: 68–81.

—— (1981) 'The Photographic Conditions of Surrealism', *October*, 19: 3–34.

—— (1982) 'Photography's Discursive Spaces', *October*, 42: 311–19.

—— (1985) *The Originality of the Avant-Garde and Other Modernist Myths*, Cambridge, MA: The MIT Press.

—— (1990) 'A Note on Photography and the Simulacral', in Carol Squiers (ed.) *The Critical Image*, Washington: Bay Press.

Krauss, Rosalind E. and Jane Livingston (1985) *L'Amour fou: Photography and Surrealism*, New York: Abbeville Press.

Kuhn, Annette (1995) *Family Secrets: Acts of Memory and Imagination*, London: Verso.

Kuspit, Donald B. (1984) 'Flak from the "Radicals": The American Case against German Painting', in Brian Wallis (ed.) *Art After Modernism: Rethinking Representation*, New York and Boston: The New Museum of Contemporary Art and Godine.

Lacan, Jacques (1966) *Écrits*, Paris: Seuil

—— (1973) *Le Séminaire, Livre XI, Les quatre concepts fondamentaux de la psychanalyse*, ed. Jacques-Alain Miller, Paris: Seuil.

—— (1979) *The Four Fundamental Concepts of Psycho-Analysis*, ed. Jacques-Alain Miller, trans. Alan Sheridan, Harmondsworth: Penguin.

Lalvani, Suren (1996) *Photography, Vision, and the Production of Modern Bodies*, Albany: State University of New York Press.

Langford, Martha (2001) *Suspended Conversations: The Afterlife of Memory in Photographic Albums*, Montreal: McGill-Queen's University Press.

Laurence, Alexander (1998) 'States of Nakedness', *Masthead Literary Arts Magazine*, October.

Leibowitz, Cathy (2000) 'Another Tunick Reprieve', *Art in America*, 88(9): 35.

Lemagny, Jean-Claude and André Rouillé (eds) (1987) *A History of Photography*, Cambridge and New York: University of Cambridge Press.

Levinas, Emmanuel (1978) *Otherwise than Being or Beyond Essence*, trans. Alphonso Lingis, Dordrecht: Kluver Academic Publishers.

Liebmann, Lisa (2001) 'Spencer Tunick: An Update', in *Spencer Tunick: Reaction Zone*, New York: I–20 Gallery

Lippard, Lucy (ed.) (1992) *Partial Recall: Photographs of Native Americans*, New York: The New Press.

Lost Identities: A Journey of Rediscovery (1999). Available online: <http://www.head-smashed-in.com/identity.html>.

Lyotard, Jean-François (1991) *The Inhuman: Reflections on Time,* trans. Geoffrey Bennington and Rachel Bowlby, Stanford, CA: Stanford University Press.

—— (1997) 'The Zone', in his *Postmodern Fables*, trans. Georges Van Den Abbeele, Minneapolis and London: University of Minnesota Press.

MacDonald, Gaynor (2003) 'Photos in Wiradjuri Biscuit Tins: Negotiating Relatedness and Validating Colonial Histories', *Oceania*, 73(4): 225–42.

MacDougall, David (2006) *The Corporeal Image: Film Ethnography and the Senses*, Princeton, NJ: Princeton University Press.

Marien, Mary Warner (2002) *Photography: A Cultural History*, New York: Prentice-Hall.

Matthews, Sandra, and Laura Wexler (2000) *Pregnant Pictures*, New York: Routledge.

Mavor, Carol (1995) *Pleasures Taken: Performances of Sexuality and Loss in Victorian Photographs*, Durham, NC: Duke University Press.

—— (1999) *Becoming: The Photographs of Clementina, Viscountess Hawarden*, Durham, NC: Duke University Press.

Mayell, Hillary (2002) 'Skin as Art and Anthropology,' *National Geographic News*, November 13. Available online:<http://news.nationalgeographic.com/news/2002/11/1113_021113_Skin.html>.

McCauley, Elizabeth Anne (1985) *A.A.E. Disdéri and the Carte de Visite Portrait Photograph*, New Haven & London: Yale University Press.

McElroy, Douglas Keith (1977) *The History of Photography in Peru in the Nineteenth Century, 1839–1876*, unpublished PhD dissertation, Albuquerque: University of New Mexico.

McGowan, Kathleen (2003) 'The Art of Persuasion: Why do Thousands of Volunteers Take it off for Spencer Tunick?', *Psychology Today*, September/October.

McKean, John (1994) *Crystal Palace: Joseph Paxton and Charles Fox*, London: Phaidon.

McNeill, David (1992) *Hand and Mind: What Gestures Reveal about Thought*, Chicago: University of Chicago Press.

McQuire, Scott (1998) *Visions of Modernity*, London: Sage.

Merleau-Ponty, Maurice (1962) *The Phenomenology of Perception*, trans. Colin Smith, London: Routledge and Kegan Paul.

Meyer, James (2003) 'Outside the Box: James Meyer unpacks Craig Owens's Slide Library: Writing the 80s', *Artforum*, 41(7): 63–5.

Mieszkowski, Jan (2004) 'Art Forms', in David S. Ferris (ed.) *The Cambridge Companion to Walter Benjamin*, Cambridge and New York: Cambridge University Press.

Miller, D. A. (1992) *Bringing Out Roland Barthes*, Berkeley: University of California Press.

Miller, Daniel (ed.) (2005) *Materiality*, Durham and London: Duke University Press.

Mirzoeff, Nicholas (2005) *Watching Babylon: The War in Iraq and Global Visual Culture*, London: Routledge.

Mitchell, W. J. T. (2005) 'There Are No Visual Media', *Journal of Visual Culture*, 4(2): 257–66.

Monaghan, James (2004) 'London's Congestion Charge Cuts Traffic Jams by Thirty Percent', *City Mayors*, March.

Moravec, Hans (1988) *Mind Children: The Future of Robot and Human Intelligence*, Cambridge, MA: Harvard University Press.

Moten, Fred (2003) *In the Break: The Aesthetics of the Black Radical Tradition*, Minneapolis: University of Minnesota Press.

Murray, Isabel (2002) 'Brazilians Reveal their Parts for Art', BBC News, April 22. Available online: <http://news.bbc.co.uk/1/hi/world/americas/1955725.stm >.

Nägele, Rainer (2004) 'Body Politics: Benjamin's Dialectical Materialism between Brecht and the Frankfurt School', in David S. Ferris (ed.) *The Cambridge Companion to Walter Benjamin*, Cambridge and New York: Cambridge University Press.

Nancy, Jean-Luc (1991a) 'Of Being in Common', in Miami Theory Collective (eds) *Community At Loose Ends*, Minneapolis: University of Minnesota Press.

—— (1991b) *The Inoperative Community*, trans. Peter Connor, Minneapolis: University of Minnesota Press.

—— (1993a) *The Birth to Presence*, trans. Claudette Sartiliot, Stanford: Stanford University Press.

Nancy, Jean-Luc (1993b) *The Experience of Freedom*, trans. Bridget McDonald, Stanford: Stanford University Press.

—— (2000) *Being Singular Plural*, trans. Robert D. Richardson and Anne O'Byrne, Stanford, CA: Stanford University Press.

—— (2003) *A Finite Thinking*, ed. Simon Sparks, Stanford: Stanford University Press.

New Left Review (1968), Issue 51 (September/October).

Newhall, Beaumont (1982) *The History of Photography*, New York: Museum of Modern Art.

The Observer (2002) 'Chaos Hits London Traffic Charge Plan', 10 November.

O'Connell, Jamie (2005) 'Gambling with the Psyche: Does Prosecuting Human Rights Violators Console their Victims?', *Harvard International Law Journal*, 46(2): 295–345.

Olin, Margaret (2002) 'Touching Photographs: Roland Barthes's "Mistaken" Identification', *Representations*, 80: 99–118.

Ong, Walter (1970) *The Presence of the Word*, New York: Simon & Schuster.

—— (1982) *Orality and Literacy: Technologizing the Word*, London: Methuen.

Owens, Craig (1980a) 'The Allegorical Impulse: Toward a Theory of Postmodernism (Part I)', *October*, 12: 67–86.

—— (1980b) 'The Allegorical Impulse: Toward a Theory of Postmodernism (Part II)', *October*, 13: 58–80.

—— (1992) *Beyond Recognition: Representation, Power, and Culture*, ed. Scott Bryson, Barbara Kruger, Lynne Tillman and Jane Weinstock, Berkeley: University of California Press.

Peirce, C. S. (1985) 'Logic as Semiotic: The Theory of Signs', in Robert Innis (ed.) *Semiotics: An Introductory Anthology*, Bloomington: Indiana University Press.

Pietz, William (1993) 'Fetishism and Materialism: The Limits of Theory in Marx', in Emily Apter and William Pietz (eds) *Fetishism as Cultural Discourse*, Ithaca and London: Cornell University Press.

Pinney, Christopher (2001) 'Piercing the Skin of the Idol', in Christopher Pinney and Nicholas Thomas (eds) *Beyond Aesthetics*, Oxford: Berg.

—— (2003) 'Visual Culture', in Victor Buchli (ed.) *Material Culture Reader*, Oxford: Berg.

—— (2004) *Photos of the Gods: The Printed Image and Political Struggle in India*, London: Reaktion.

Poignant, Roslyn (1992) 'Wúrdayak/Baman (Life History) Photo Collection', *Australian Aboriginal Studies*, 2: 71–7.

—— (1996) *Encounter at Nagalarramba*, Canberra: National Library of Australia.

Pontbriand, Chantal (2000) 'Jean-Luc Nancy/Chantal Pontbriand: An Exchange', *Parachute: Contemporary Art Magazine*, 100: 2–4.

Poole, Deborah (1997) *Vision, Race, and Modernity: A Visual Economy of the Andean Image World*, Princeton, NJ: Princeton University Press.

Powell, Richard J. (2003) 'Linguists, Poets, and "Others" on African American Art', *American Art*, 17: 16–19.

Preziosi, Donald (1999) 'The Crystalline Veil and the Phallomorphic Imaginary: Walter Benjamin's Pantographic Riegl', in Alex Coles (ed.) *The Optic of Walter Benjamin*, special issue of *De-, Dis-, Ex-*, 3: 120–36.

—— (2003) *Brain of the Earth's Body: Art, Museums and the Phantasms of Modernity*, Minneapolis: University of Minnesota Press.

Rancière, Jacques (2004) *The Politics of Aesthetics*, trans. Gabriel Rockhill, London: Continuum.

Rich, Frank (2004) 'It Was the Porn That Made Them Do It', *New York Times*, May 30.

Richard, Nelly (2000a) 'Imagen-recuerdo y borraduras', in Nelly Richard (ed.) *Políticas y estéticas de la memoria*, Santiago de Chile: Cuarto Propio.

—— (2000b) 'Memoria, fotografía y desaparición: drama y tramas', *Punto de vista*, 68: 29–33.

Richardson, Alexia (2008) 'Traces of Terror: Photography and the Memory of Political Violence in Argentina and Peru', unpublished PhD thesis, Durham University.

Robben, Antonius, C. G. M. (2005) *Political Violence and Trauma in Argentina*, Philadelphia: University of Pennsylvania Press.

Rose, Gillian (2003) 'Family Photographs and Domestic Spacings', *Transactions of the Institute of British Geographers*, 28: 5–18.

—— (2004) '"Everyone's Cuddled Up And It Just Looks Really Nice": An Emotional Geography of Some Mums and Their Family Photos', *Social & Cultural Geography* 5(4): 549–64.

Rosenblum, Naomi (1997) *A World History of Photography*, New York: Abbeville Press.

Rosler, Martha (1989) 'In, Around and Afterthoughts (On Documentary Photography)', in Richard Bolton (ed.) *The Contest of Meaning: Critical Histories of Photography*, Cambridge, MA: The MIT Press.

Rouillé, André (1995) 'When I Was a Photographer: The Anatomy of a Myth', in Marie Morris Hambourg, Françoise Heilbrun and Philippe Neagu (eds) *Nadar*, New York: Metropolitan Museum of Art.

Rowlands, M. J. (2005) 'A Materialist Approach to Materiality', in Daniel Miller (ed.) *Materiality*, Durham and London: Duke University Press.

Ryan, Michael and Douglas Kellner (1988) *Camera Politica: The Politics and Ideology of Contemporary Hollywood Film*, Bloomington and Indianapolis: Indiana University Press.

Sagne, Jean (1998) 'All Kind of Portraits: The Photographer's Studio', in Michel Frizot (ed.) *A New History of Photography*, Cologne: Könemann.

Sandeen, Eric J. (1995) *Picturing an Exhibition: 'The Family of Man' and 1950s America*, Albuquerque: University of New Mexico Press.

Sartorti, Rosalinde and Henning Rogge (eds) (1975) *Sowjetische Fotografie 1928–1932*, Munich and Vienna: Hanser.

Saussure, Ferdinand de (n.d.) *Cours de linguistique générale*, Paris: Payot.

Scherer García, Julio and Carlos Monsiváis (2002) *Parte de Guerra: Los rostros del 68*, Mexico City: Nuevo Siglo/Aguilar.

—— (2004) *Los patriotas: De Tlatelolco a la guerra sucia*, Mexico City: Nuevo Siglo/Aguilar.

Schneider, Arnd and Christopher Wright (2006) 'The Challenge of Practice', in Arnd Schneider and Christopher Wright (eds) *Contemporary Art and Anthropology*, Oxford: Berg.

Scott, Clive (1999) *The Spoken Image: Photography and Language*, London: Reaktion.

Sekula, Allan ([1981] 2003) 'The Traffic in Photographs', in Coco Fusco and Brian Wallis (eds) *Only Skin Deep: Changing Visions of the American Self*, New York: Harry N. Abrams.

Seremetakis, C. Nadia (1993) 'Memory of the Senses: Historical Perception, Commensal Exchange and Modernity', *Visual Anthropology Review*, 9(2): 2–18.

—— (1996) *The Senses Still: Perception and Memory as Material Culture*, Chicago: Chicago University Press.

Shklovski, Viktor Borisovich (1973) *La Marche du cheval*, trans. Michel Pétris, Paris: Editions Champ Libre.

Solomon-Godeau, Abigail (1984) 'Photography after Art Photography', in Brian Wallis (ed.) *Art after Modernism: Rethinking Representation*, New York and Boston: The New Museum of Contemporary Art and Godine.

—— (1986) 'Canon Fodder: Authoring Eugene Atget', *Print Collector's Newsletter* 16 (January): 221–27.

—— (1991) *Photography at the Dock: Essays on Photographic History, Institutions, and Practices*, Minneapolis: Minnesota University Press.

Sontag, Susan (1977) *On Photography*, New York: Anchor Doubleday.

—— (2003) *Regarding the Pain of Others*, New York: Farrar, Straus and Giroux.

—— (2004) 'Regarding the Torture of Others: Notes on What Has Been Done – and Why – to Prisoners, by Americans', *New York Times Magazine*, 23 May.

Sparks, Amy Bracken (2004) 'Exposure: Spencer Tunick and a Cast of Thousands Published', *Angle Magazine*, 16 (September/October). Available online: <http://www.anglemagazine.org/articles/Exposure_Spencer_Tunick_and_a_2214.asp>.

Spence, Jo (1988) *Putting Myself in the Picture: A Political, Personal and Photographic Autobiography*, Seattle: Real Comet Press.

Spence, Jo and Patricia Holland (eds.) (1991) *Family Snaps: The Meaning of Domestic Photography*, London: Virago.

Stafford, Barbara (1997) *Good Looking: Essays on the Virtue of Image*, Cambridge, MA: The MIT Press.

Stallabrass, Julian (2004) *Art Incorporated: The Story of Contemporary Art*, Oxford and New York: Oxford University Press.

Steedman, Carolyn (2001) *Dust*, Manchester: Manchester University Press.

Steichen, Edward ([1955] 1996) *The Family of Man*, New York: MoMA.

Stewart, Susan (1993) *On Longing*, Durham and London: Duke University Press.

Stimson, Brian (2006) *The Pivot of the World: Photography and its Nation*, Cambridge, MA: The MIT Press.

Stoller, Paul (1989) *The Taste of Ethnographic Things: The Senses on Anthropology*, Philadelphia: University of Pennsylvania Press.

—— (1997) *Sensuous Scholarship*, Philadelphia: University of Pennsylvania Press.

Sturken, Marita (2007) *Tourists of History: Memory, Kitsch, and Consumerism from Oklahoma City to Ground Zero*, Durham and London: Duke University Press.

Sutton, Damien (2005) 'Nokia Moments', *Source*, 43: 44–7.

Szarkowski, John and Maria Morris Hambourg (eds) (1981–1985), *The Work of Atget*, New York: the Museum of Modern Art; and Boston: Little, Brown.

Tacchi, Jo (1998) 'Radio Texture: Between Self and Others', in Daniel Miller (ed.) *Material Cultures*, London: UCL Press.

Tagg, John (1980) 'Power and Photography – Part I. A Means of Surveillance: The Photograph as Evidence in Law', *Screen Education*, 36: 17–55.

—— (1982) 'The Currency of the Photograph', in Victor Burgin (ed.) *Thinking Photography*, London: Macmillan.

—— (1988) *The Burden of Representation: Essays on Photographies and Histories*, Amherst: The University of Massachusetts Press.

—— (1992) *Grounds of Dispute: Art History, Cultural Politics and the Discursive Field*, Basingstoke: Macmillan.

—— (1995) 'The Pencil of History', in Patrice Petro (ed.) *Fugitive Images: From*

Photography to Video, Bloomington: Indiana University Press.

Tagg, John (forthcoming) *The Disciplinary Frame: Photographic Regimens and the Capture of Meaning*, Minneapolis: University of Minnesota Press.

Taussig, Michael (1993) *Mimesis and Alterity: A Particular History of the Senses*, New York: Routledge.

Taylor, Diana (1994) 'Performing Gender: Las Madres de Plaza de Mayo', in Diana Taylor and Juan Villegas Morales (eds) *Negotiating Performance: Gender, Sexuality and Theatricality in Latin/o America*, Durham: Duke University Press.

—— (1997) *Disappearing Acts: Spectacles of Gender and Nationalism in Argentina's 'Dirty War'*, Durham: Duke University Press.

—— (2003) *The Archive and the Repertoire: Performing Cultural Memory in the Americas*, Durham and London: Duke University Press.

Taylor, Lucien (1994) 'Foreword', in Lucien Taylor (ed.) *Visualizing Theory: Selected Essays from V.A.R.*, New York: Routledge.

Tonkin, Elizabeth (1992) *Narrating Our Pasts*, Cambridge: Cambridge University Press.

Torres-Rivas, Edelberto (1999) 'Epilogue: Notes on Terror, Violence, Fear and Democracy', in Kees Koonings and Dirk Kruijt (eds) *Societies of Fear: The Legacy of Civil War, Violence and Terror in Latin America*, London: Zed Books.

Trachtenberg, Alan (ed.) (1980) *Classic Essays on Photography*, New Haven, CT: Leete's Island Books.

Tunick, Spencer (n.d.) Interview for the BBC. Available online: <http://www.naked-worlddoc.com/naked_world.swf>.

Weber, Samuel (1996) *Mass Mediauras: Form, Technics, Media*, Stanford: Stanford University Press.

Wells, Liz (1997) *Photography: A Critical Introduction*, London: Routledge.

—— (2003) *The Photography Reader*, London: Routledge.

West, Nancy Martha (2000) *Kodak and the Lens of Nostalgia*, Charlottesville: University of Virginia Press.

Wichard, Robin and Wichard, Carol (1999) *Victorian Cartes-de-Visite*, Princes Risborough: Shire Publications.

Williams, Carol (2003) *Framing the West: Race, Gender, and the Photographic Frontier in the Pacific Northwest*, New York: Oxford University Press.

Willis, Anne-Marie (1988) *Picturing Australia: A History of Photography*, Sydney: Angus & Robertson.

Willis, Deborah (2005) *Family, History, Memory*, Irvington, NY: Hylas Publishing.

Willis-Braithwaite, Deborah (1993) *VanDerZee, Photographer: 1886–1983*, New York: Harry N. Abrams/ The National Portrait Gallery, Smithsonian Institution.

Willumson, Glenn (2004) 'Making Meaning: Displaced Materiality in the Library and Art Museum', in Elizabeth Edwards and Janice Hart (eds) *Photographs Objects Histories: On the Materiality of Images*, London: Routledge.

Wood, Christopher (1976) *Victorian Panorama: Paintings of Victorian Life*, London: Faber and Faber.

Wood, Paul (1996) 'Commodity', in Robert Nelson and Richard Shiff (eds) *Critical Terms for Art History*, Chicago: University of Chicago Press.

Wood, Robin (2003) *Hollywood from Vietnam to Reagan ... and Beyond*, New York: Columbia University Press.

Worswick, Clark (ed.) (2002) *Berenice Abbott, Eugène Atget*, Santa Fe: Arena Editions.

Wright, Christopher (2004) 'Material and Memory: Photography in the Western Solomon Islands', *Journal of Material Culture*, 9(1): 73–85.

—— (2005) 'The Echo of Things: Photography in Roviana Lagoon, Solomon Islands', unpublished PhD thesis, University College London.

Wright, Philippa (2003) 'Little Pictures: Julia Margaret Cameron and Small-Format Photography', in Julian Cox and Colin Ford (eds) *Julia Margaret Cameron: The Complete Photographs*, Los Angeles: J. Paul Getty Museum/ The National Museum of Photography, Film & Television, Bradford.

Young, Alison (2005) *Judging the Image: Art, Value, Law*, New York: Routledge.

Younger, Dan (1987) *Cartes-de-Visite: Precedents and Social Influences*, Riverside, CA: California Museum of Photography.

Your Guide to the Central London Congestion Charge (2004), London: Mayor of London and Transport for London.

Žižek, Slavoj (2004) 'The Lesson of Rancière', in Jacques Rancière, *The Politics of Aesthetics: The Distribution of the Sensible*, New York: Continuum.

Index